The Elements of
LANDSCAPE OIL PAINTING

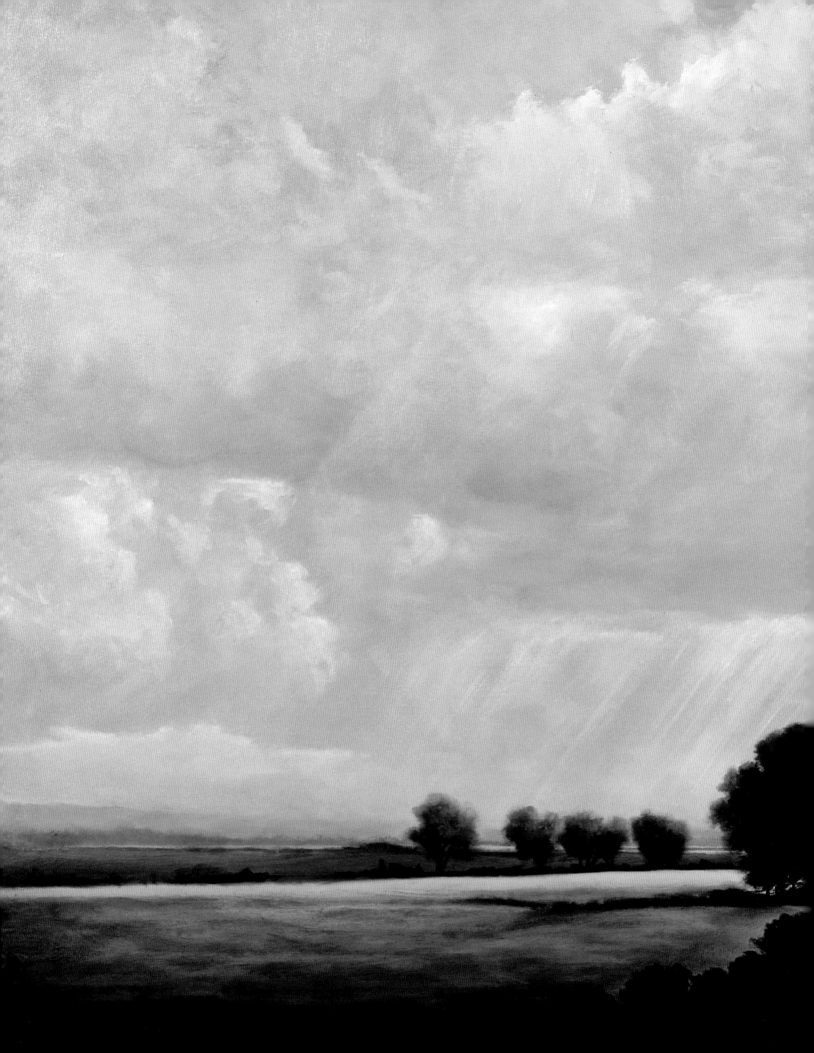

The Elements of
LANDSCAPE OIL PAINTING

TECHNIQUES FOR RENDERING SKY, TERRAIN, TREES, AND WATER

SUZANNE BROOKER

WATSON-GUPTILL PUBLICATIONS

BERKELEY

Published in the United States by Watson-Guptill Publications,
an imprint of the Crown Publishing Group, a division of Penguin Random
House LLC, New York.
www.crownpublishing.com
www.watsonguptill.com

WATSON-GUPTILL and the WG and Horse designs are registered
trademarks of Penguin Random House LLC

Library of Congress Cataloging-in-Publication Data

Brooker, Suzanne.
 The elements of landscape oil painting : techniques for rendering sky,
terrain, trees, and water / Suzanne Brooker. — First Edition.
 pages cm
 Includes bibliographical references and index.
1. Landscape painting—Technique. I. Title.
 ND1342.B766 2015
 741.45'436—dc23

 2014042195

Hardcover ISBN: 978-0-8041-3755-3
eBook ISBN: 978-0-8041-3756-0

Printed in China

Design by Rita Sowins/Sowins Design

10 9 8 7 6 5 4 3 2 1

First Edition

FRONT COVER IMAGE:
RENATO MUCCILLO, *THE UPWARD
PUSH*, 2010, OIL ON PANEL,
11 X 15 INCHES (27.9 X 38.1 CM).

BACK COVER IMAGE:
MARC BOHNE, *WINTER EVENING*,
2002, OIL ON PANEL, 20 X 24 INCHES
(50.8 X 61 CM).

TITLE PAGE:
VICTORIA ADAMS, *MINARET* (DETAIL),
2012, OIL ON LINEN, 60 X 60 INCHES
(152.4 X 152.4 CM). PHOTOGRAPHY BY
RIC PETERSON.

OPPOSITE:
SUSAN OLIVIER-HIRASAWA,
THREE STUDIES OF TREES,
2007, ACRYLIC ON CANVAS,
10¾ X 10¾ INCHES
(27.3 X 27.3 CM).

CONTENTS, LEFT TO RIGHT:
RENATO MUCCILLO, *SOUTHERN
FRONT*, 2012, OIL ON CANVAS,
18 X 18 INCHES (45.7 X 45.7 CM).

VICTORIA ADAMS, *CLOUD CHAMBER*
(DETAIL), 2012, OIL ON LINEN,
18 X 20 INCHES (45.7 X 50.8 CM).
PHOTOGRAPHY BY CHARLES BACKUS.

LOUISE BRITTON, *PILLAR (DETAIL)*,
2007, OIL ON CANVAS,
38 X 22 INCHES (96.5 X 55.9 CM).

MARC BOHNE, *PALOUSE
HILLSIDE*, 1999, OIL ON PANEL,
36 X 36 INCHES (91.4 X 91.4 CM).

KATE STARLING, *VIRGIN RIVER POOLS*
(DETAIL), 2012, OIL ON PANEL,
14 X 18 INCHES (35.6 X 45.7CM).

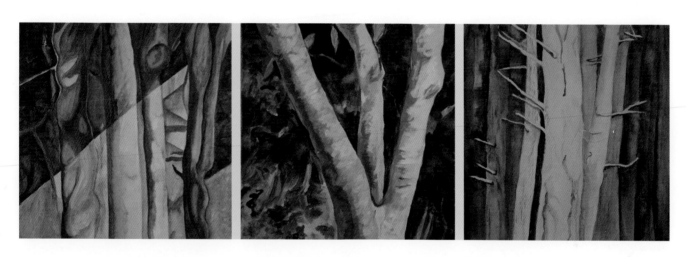

DEDICATION: **SUSAN JANE OLIVIER-HIRASAWA**

INSPIRING ARTIST, PASSIONATE WIFE AND MOTHER, DEAR FRIEND

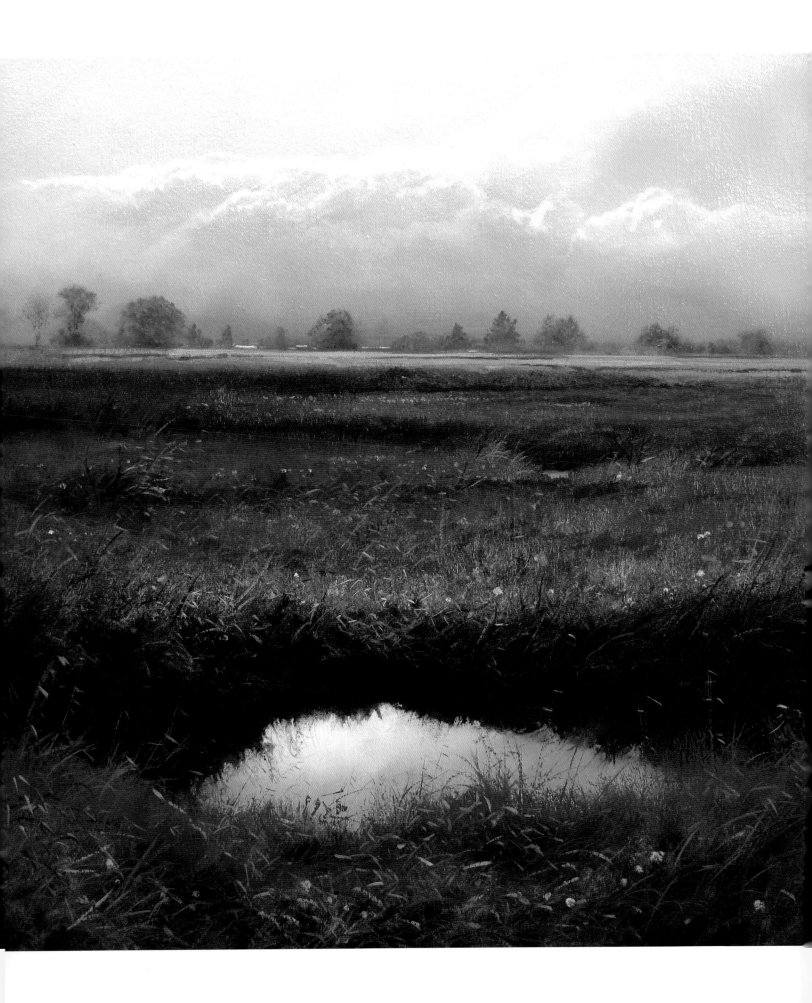

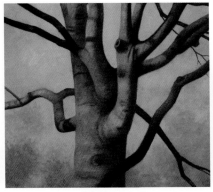
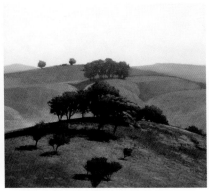
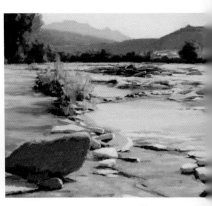

CONTENTS

FOREWORD: THE FICKLE ANGEL

As subject matter, landscape is a forgiving genre; one can greatly change color, shapes, and forms, and still have a verisimilitude in a given scene. I believe in thinking "abstractly" while painting "descriptively." It is my intent, though, to "convince" with my imagery. My traditional descriptive skills are reasonably good; however, I do not hesitate to make up imagery, move trees, buildings, hills, and change scale to achieve a certain "abstract" whole. So, while my overall painting has changed in form, my intent to evoke a sense of place and time has not.

Intent, both in form and expression, is important to the artist. However, *intent*, by itself, does not make good painting (one should keep in mind that most bad art is created by people who have serious intent). Good ideas and serious intent aren't *accomplishment*. By themselves, they are *not important*.

What is important is *how ideas are painted*. Everything one does is at the service of the painting. I believe the painting, "the thing itself," must succeed as a physical entity, independent and regardless of whatever other concerns may be in attendance.

So, for me, the problem was and is that of form. For me, it is best to set visual problems then solve them. The painting *Across Beaver Creek* (opposite) had pretty good form but wasn't right for me. Hard to explain, but all artists know the feeling. Good and correct form doesn't necessarily make for good painting. That is the problem—if a work is successful in all its formal components and *just sits there*, you cannot leave it at that; you haven't gone far enough.

Of course, you don't know how far "far enough" is until you've gone too far—a formidable problem. But you must do *something*, after you've tried everything you know. The "desperation approach" comes to mind—that is, throw in something very different from your approach so far. Sometimes this approach will work—not often though. *But*, when it *does* work, you've learned something and have moved ahead as an artist. I tried the desperation approach with this painting (I took out the creek, made a screen of trees across the foreground and changed the color of the fields). As a painting, I think now that it succeeds as "the thing itself." It is hard to tell, though, I'm still too close in time to see it objectively. I'll know in a couple months.

It's a messy process (literally and figuratively). When this "desperation approach" doesn't succeed (mostly it doesn't, it is desperate after all . . .), I throw the painting away. I am a big believer in throwing away paintings, even those that have successful form, especially those that *just sit there*. It is essential as a painter to learn to separate effort from accomplishment.

In painting, one must have ideas and occasional luck (with or without desperation attached). Ideas, skills, and luck may align themselves and your painting succeeds. But, for things to succeed, as Wallace Stevens wrote, you occasionally need the "Necessary Angel." That angel may start out sitting on your shoulder, your painting goes wonderfully, then it starts to go bad—you look to your shoulder and find that your angel has gone out for a pizza and a beer. Sometimes she returns, sometimes she doesn't. Angels tend to be fickle.

NORMAN LUNDIN *SEATTLE, 2014*

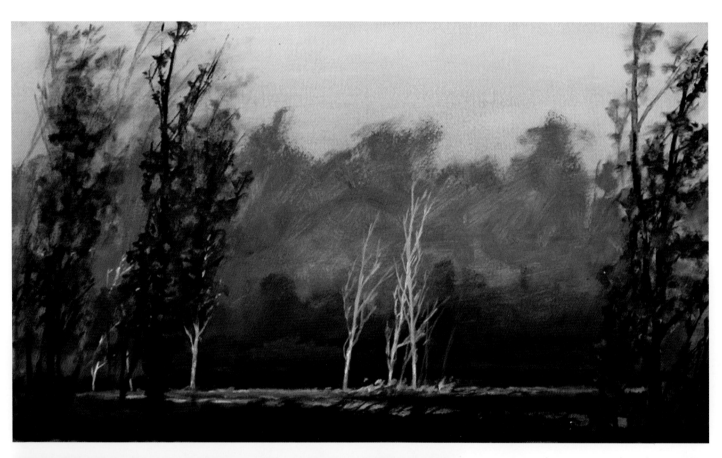

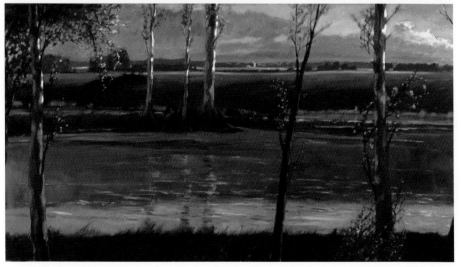

ABOVE:

NORMAN LUNDIN, *FARM EVENING, NO HUNTING*, 2011–13, OIL ON CANVAS, 36 X 66 INCHES (91.4 X 167.6 CM).

LEFT:

NORMAN LUNDIN, *ACROSS BEAVER CREEK*, 1999–2006, OIL ON CANVAS, 16 X 30 INCHES (40.6 X 76.2 CM).

This is an earlier version of a painting now much changed. One can still see, however, the early bits in the final version.

INTRODUCTION

If every kind of landscape—from the Grand Canyon to Mount Fuji—has already been painted, then what still makes painting a landscape interesting? The answer is you. You are the new and novel ingredient: how you see and respond to a scene, the way you translate and interpret the felt sensation of nature into a two-dimensional painted surface.

I love to paint, but landscape painting is a difficult craft to master. There are so many aspects to understand all at once. My challenge as a teaching artist is to break down the painting process into a logical progression that combines intuitive impulse with reasoned strategies. This book is based on a series of classes I teach at the Gage Academy of Art in Seattle. These classes focus on the major components of landscape painting: sky, terrain, trees, and water. The approaches and techniques described in each section offer intermediate-level painters tools for enhancing their painting process.

Landscape painting offers everything a painter could want—space and light, movement and solidity, color and shape, texture and atmosphere. I've included a number of pieces from fellow artists that provide a range of styles and practices. These demonstrate everything from direct observation *en plein air* to studio paintings based on sketches, studies, and photographs. Each of these artists' work reveals a kinship to the landscape, demonstrated through their personal approach toward building an expressive image in paint.

Evolving your own approach to landscape painting is a process of self-conscious observation. You should let your paintings tell you about what is working or not. Painters are easily saddled with poor results when they rely too heavily on an adopted stylistic approach toward painting. (Liking the look of another painter's work does not guarantee it's the right approach for you.) Preconceived ideas of what a painting should look like also hamper your possibilities for discovery.

Translating what you see into a painted image is a complex process, combining perception and the technical language of paint. It is never merely copying what you literally see. Every representational image, no matter how realistic, is still, at its heart, a translation, an abstraction of a felt experience and the artist's aesthetic sensibility. Your job as a painter is not to be literal, especially when working from

MARC BOHNE, *HEARTLAND*, 2006, OIL ON
PANEL, 48 X 60 INCHES (121.9 X 152.4 CM).

photographic sources in the studio; instead, you should think of yourself as a visual conductor, arranging, editing, and elaborating on the elements that present themselves in a scene.

The landscape links us to the earth and connects us to the natural world surrounding our lives. Modern life can dull our perceptions, causing us to only notice just enough to get by. We scan and glean information without really stopping to observe what we see. Observing nature involves recognizing the patterns that determine growth and movement, like the structure of a tree or the flow of a river. The practice of looking keenly at the landscape allows the artist to move from generic, symbolic representations toward a fuller understanding of depicting what is seen through direct observation and evoking that insight into painting. This why I begin each chapter with a section on observing nature, hoping to inspire your curiosity to look more closely at what you see.

At first, you might think the most challenging element of landscape painting is the paint itself: color mixing between pigments, or getting the feel for how the paint moves over the canvas. But undeveloped drawing skills can also get in your way: objects you want to appear dimensional seem flat, or your work misses a sense of atmosphere or space. In each chapter, I have included a section on drawing concepts that explain underlying ideas vital for painting. Foundational drawing skills, such as linear perspective or shading forms, are applied to rendering each component of the landscape. Even a sketchbook can aid you as a painter. Sometimes I do my best thinking when I'm drawing. So, it's no surprise that the best painters are also avid drawing fans.

Each chapter also covers the painting process itself with sections on toned grounds, palettes, and brush techniques, as they apply to each component of a landscape. The interaction of paint between the surface and the brush is critical to the final painted image. Does the paint glow or appear muddy, is it painterly or too cautious in its application, is it overworked or lively? Moving from painting on white gesso ground to a colored, toned ground provides the artist with possibilities for a richer interaction with the palette from optical color mixtures to simultaneous or complementary contrasts. These unexpected color effects can renew your sense of discovery. You'll also learn how to unify a painting, beginning with an overall color strategy that links color mixtures into a harmonious whole. The color charts in the chapters ahead show how to build a color palette that explores ideas, such as the dynamics of mixing between primary pigments, color temperature, neutrals, and glazing over an underpainting. Additionally, brush handling techniques illustrate distinct brush movements used to achieve different textural effects from the dappled foliage of a birch to the ruffled water of a lake. I've given each brush technique a nickname, such as "flicker stroke"

OPPOSITE:
CHRISTINE GEDYE,
REEDS AND FOG, 2011,
OIL ON PANEL, 20 X 16 INCHES
(50.8 X 40.6 CM).

A limited palette on a toned ground suggests the light and hazy atmosphere needed to convey the mood of the scene.

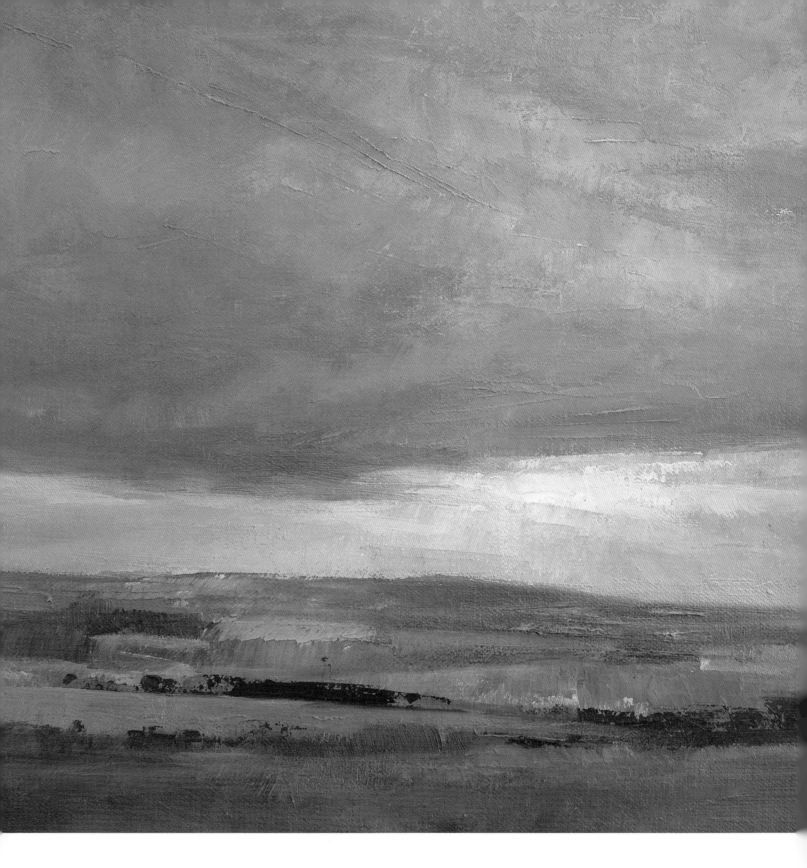

KEN BUSHE, *SKY AND LAND STUDY*, 2011,
OIL ON CANVAS, 8 X 10 INCHES (20.3 X 25.4 CM).

This plein air painting captures all the spontaneity of working
outdoors with fluid brush movement and subtle color choices.

or "side swish," so that you can easily identify the resulting mark with the angle, pressure, and direction of the brush.

At the end of each chapter, you will find step-by-step demonstration paintings following the painting processes covered in that chapter. These staged paintings illustrate how to build the landscapes from block-in drawing to finishing touches. They also include all the snags and second thoughts along the way. Hopefully, including these steps and missteps makes the painting process more transparent.

I love painting landscapes. I chase after the luminescent atmosphere of the sky, the contrast of moving water against solid shore, or the dappled light over foliage. Painting landscapes lets me explore my artistic sensibilities and ideas. In one series of paintings, I can work with the notion of flat pattern against atmospheric space; in the next, the interplay of a naturalistic palette with expressionistic color; in yet another, the abstraction of line surrounded by diffused shapes. But in the end, we paint what we know. The more I study nature, the greater my choices for moving between realism and expressive styles of painting become.

When I get to paint outdoors in the summer, I have to bring all my indoor studio skills into play, making fast decisions before the light changes. The excitement of "finding" the image within the chaos of nature is only the beginning of the process of capturing the moment in oils. When I am back in the studio, I build my repertoire with new color mixtures and brush techniques. The visual memories of my plein air summer paintings enhance my studio work, just as the plein air works rely on skills I've built in the studio. It's my hope that the following pages open the way for your own experimentation, and provide you with the skills required to develop a sound foundation for landscape oil painting.

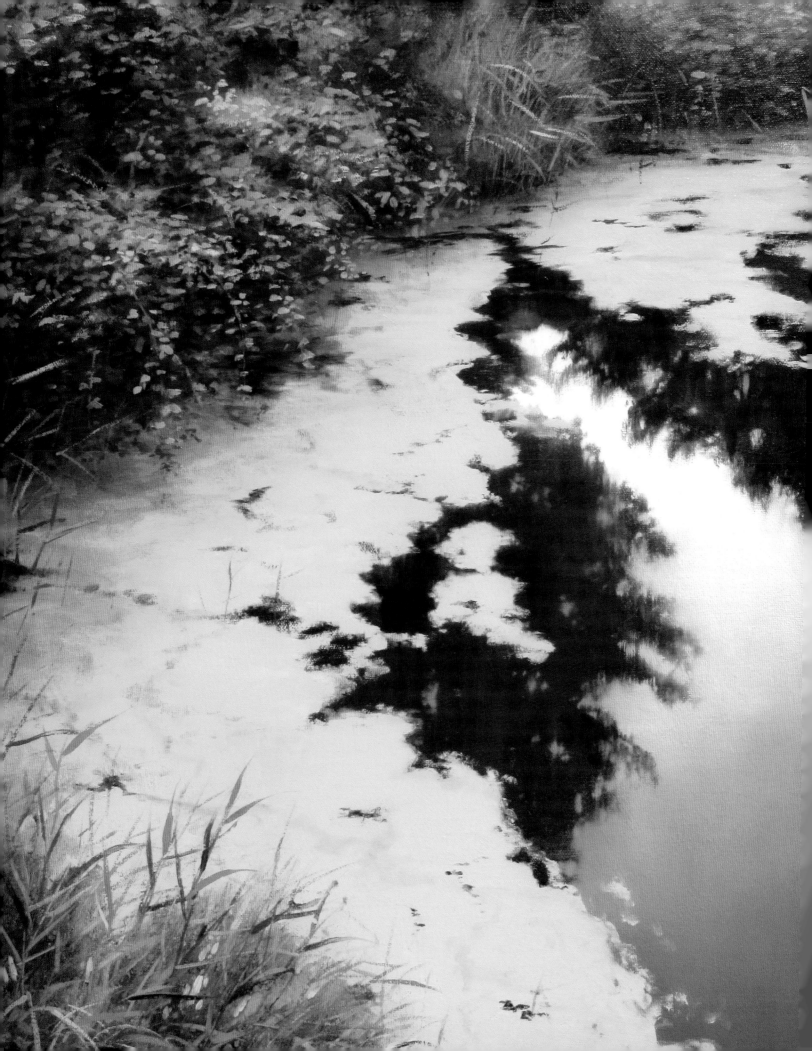

GETTING STARTED

In this chapter, I'll cover how to translate your perceptions of a scene into a painting strategy, and how to use the best tools and techniques to carry out your plan. Once you've surveyed this information, it'll be much each easier to incorporate the specific painting techniques within the following chapters. After all, a strong start to any painting goes a long way to ensuring its successful finish.

As an intermediate painter, your task is to be self-conscious of your process, mentally noting what works and why. Think of this stage in your painting experience as the time when you watch yourself and the results of your efforts. Remember, the ease and skill that you witness when watching more experienced painters derives from their dedicated application of these same methods. Intuition is based on experience and practice.

ABOVE:

MITCHELL ALBALA,
COLOR STUDIES,
2012, OIL ON PAPER,
4½ X 4 INCHES (11.4 X 10.2 CM).

OPPOSITE:

RENATO MUCCILLO, *ALOUETTE MUD RIVER FLATS,* 2011,
OIL ON MOUNTED CANVAS,
14 X 18 INCHES (35.6 X 45.7 CM).

Through the artist's ability to represent light, color, shape, and texture on the painted surface, an ordinary scene can be translated into a beautiful painting.

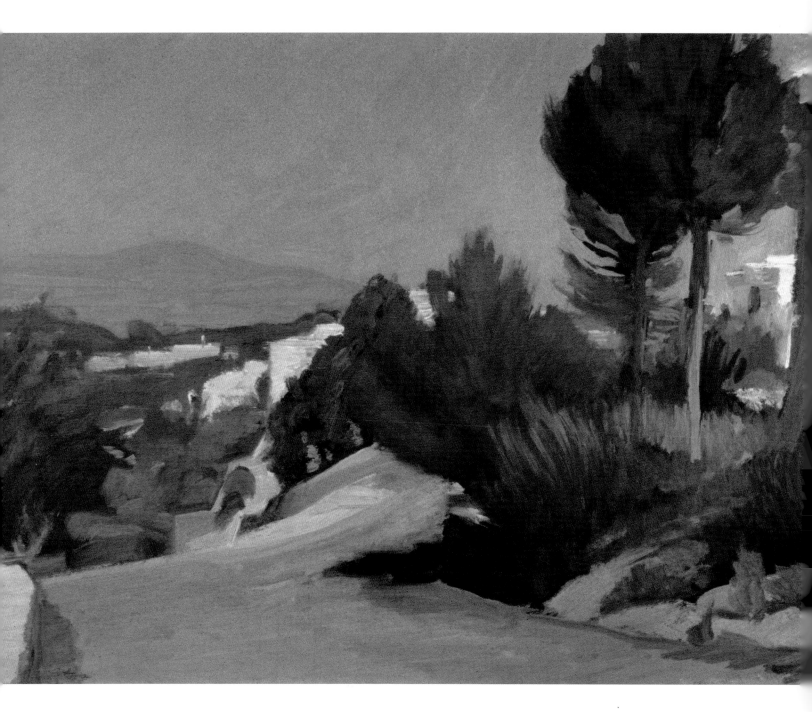

ABOVE:

DOMENIC CRETARA, *ROAD TO IBIZA*, 1977, OIL ON PAPER,
11 X 15 INCHES (27.9 X 38.1 CM).

A sketch of a new landscape view (opposite) first allows the
artist time to discover the compositional elements that are then
later refined in the oil painting (above).

OPPOSITE:

DOMENIC CRETARA, *ROAD TO IBIZA* (STUDY), 1977,
GRAPHITE ON PAPER, 11 X 14 INCHES (27.9 X 35.6 CM).

BEGINNING A PAINTING

Painting is a time-consuming activity that demands that artists focus on projects that will help them grow. Before starting a new work, it's important to identify your motive: *Am I learning a new technique, experimenting with a different palette, building a body of work, or enjoying a free moment to express myself?* Your motive becomes your artistic intention in the work and helps determine if you've reached your goal when a painting is finished.

DESCRIBE WHAT YOU SEE

Begin by answering the question *What do I see?* Is it a tree by the waterside or a rolling meadow leading off to distant hills? Describing what you see can help you start to organize your perceptions. It sounds easy, but it may prove more difficult

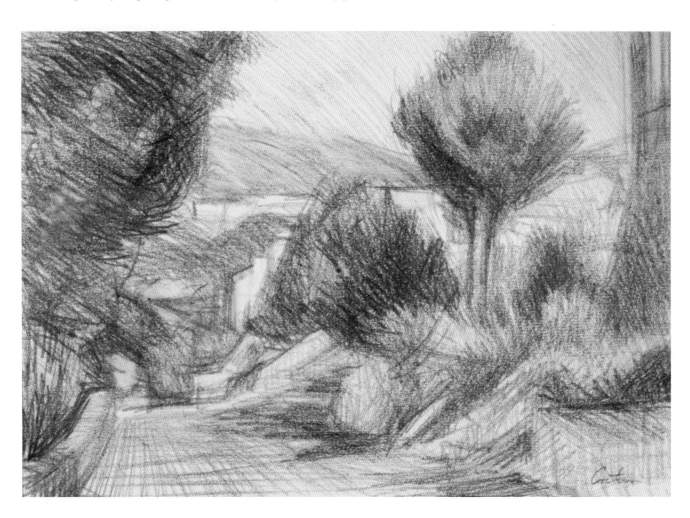

than you think—condensing the rich amount of detail into a bare-bones description. Simplification is the first step toward reducing the chaotic details of a view to overall shapes or a singular focal point.

Here, a viewfinder is helpful in locating the arrangement of landscape elements that will become your picture. A simple viewfinder can be your own hands held in front of your eyes (palms flat facing out in front of you and thumbs touching as they point at each other, rotating one hand so that the open space between your hands resembles a rectangle). Looking through the open space achieves a similar effect to looking through a camera lens—it frames a scene in a rectangular shape. In fact, an empty 35 mm slide mount or a plain piece of cardboard with a cutout window can also serve as your viewfinder.

Cropping a scene with a viewfinder is the same as taking a photograph. Imagine taking a photograph in a landscape setting: looking through the lens, you try to frame something of interest in an appealing way. You might have to swing the camera to the left or right, zoom in or out, trying to find just the right composition. In the beginning, you might be drawn to capturing what is picturesque or beautiful without really questioning why it appeals to you. Your eye will get keener when you learn to identify the visual elements for an interesting painting.

An aesthetic moment is one where the visual elements come together in a way that is pleasing to the eye. However, this painterly idea may not be the same as the subject matter! For example, let's say your subject is a holly tree at the edge of a woodland. Is it the red berries against the dark green foliage (color), the way the light dapples across the branches (form), the zigzag pattern of the branches (line), or the contour (shape) of the tree, or the spiky leaves (texture) contrasted against the background that makes your subject visually interesting? All of these components make up the *formal elements* that are used to create every image. Refer to the special feature "Formal Elements and Principles in a Composition" on page 14 for a fuller explanation of these concepts.

If the subject matter were the most important part of a painting, then you would no longer need to paint. Think of it this way: everything under the sun has already been painted—what's left? The humble holly tree is not itself important, but how your perceptions are used to interpret those impressions through paint is what matters most. Expression through painting allows you to give symbolic, emotional, or spiritual meaning to your uniquely individual insights as an artist. Therefore, your holly painting becomes as individual as you the painter.

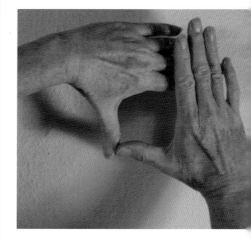

Hands held in L-shaped brackets act as a cropping tool (like a camera's viewfinder) to narrow down your focus when looking out into the landscape.

THE ARTIST'S SKETCHBOOK

Artist's sketchbooks are valuable tools for producing quick sketches that let you capture the essence of an idea, regardless of whether you make those sketches on site or later from photographs. These small thumbnail sketches, often only as big as 1 x 2 inches, are kernels of "good ideas" rather than very tiny drawings. By asking *Is this a line idea or a shape idea?* you eliminate any unnecessary details that may get in your way. The key is to focus on what element makes this a good painting composition—line, shape, color, form, or texture.

By drawing a smaller rectangle in the center of your sketchbook page, you'll have room to recrop your sketch into a square or change it from a vertical to a horizontal design. There will also be room on the side margins to take notes about location, time of day, weather, color references, botanical notes, and so on.

A drawing, like a photograph, is the result of a translating process by which you re-create the physical three-dimensional world onto a flat, two-dimensional surface. Drawing lets you enhance your visual memory through observational study. Your brain memorizes what it sees/draws in a manner that lets you recall its details with greater nuances than you would from any photograph. Unlike quick idea sketches, longer study drawings allow you to scrutinize what you see intensely: *How do these clumping rock forms make the cliff seem so jagged? What kind of markings does a birch tree have on its bark?*

Drawing techniques are essential for rendering forms with light and shadow values. The skills you practice in drawing inform your painting decisions: hillsides curve, rocks take on dimension, and shadows feel more convincing. Look for the drawing concepts discussed in each of the chapters ahead. When you draw from nature, it's not always immediately apparent how to draw what you see, so the more you know about drawing techniques, the better you can translate the scene onto paper.

WORKING FROM PHOTOGRAPHS

Photographs are a great aid to landscape painters because they capture fleeting moments of cloud formations, the flicker of water reflections, or simply the novelty of a new scene. However, your job as an artist is never to copy a photograph or attempt to match "Kodak" color in pigment form. Photographs are never a substitute for direct observation of nature or for developing your own visual sensibilities. However, you can use them effectively as memory aids, as sources of details, or as inspiration for creative interpretation. Remember, photographs convey a flatness by trying to make every part of an image in equal focus. What works in a photographic image does not work in a painting. By "looking into" a photograph, I try

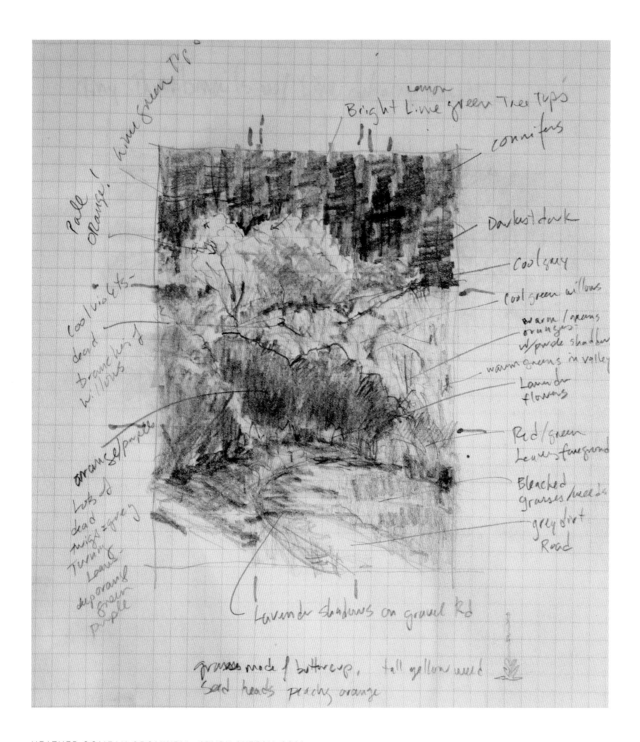

The following handwritten notes appear on the sketch:

- Pale Orange!
- lime green PP
- Bright Lime green Tree Tips
- lemon
- conifers
- Cool violets - dead branching willows
- Darkest dark
- Cool grey
- Cool green willows
- warm/greens oranges w/purple shadow
- warm greens in valley
- Lavender flowers
- orange/purple
- Red/green Leaves foreground
- Bleached grasses/weeds
- grey dirt Road
- Lots of dead twigs/grey Turning Leaves dry orange green purple
- Lavender shadows on gravel Rd
- grasses made of buttercup, tall yellow weed
- Seed heads peachy orange

HEATHER COMEAU CROMWELL, *STUDY SKETCH*, 2014,
GRAPHITE ON PAPER, 6 X 9 INCHES (15.2 X 22.9 CM).

Place your drawing in the center of your sketchbook so that you can not
only change the format but also write notes (plant types, color ideas,
location, etc.) in the margins.

to experience the dimensionality that has been lost by the equal focus of the camera. For instance, when I scrutinize a photographic image, I try to first understand what it is I'm trying to describe in paint: *Which of those mountain ridges is farthest away even though the photograph shows them all in focus?* When I look into the deep shadow areas: *Is that a steep bank or a grouping of small pine trees?* Painting techniques, such as atmospheric (aerial) perspective (discussed in depth on page 80 in chapter 3), help me translate photographic information into the "language" of painting.

POSITION YOURSELF IN RELATION TO THE SUN

Positioning yourself so that the sun is at the side of your head will allow you to take advantage of a strong light direction, regardless of whether you're taking photographs or setting up for a plein air painting. When facing into the sunlight, you view only the shadow side of any object and your pupils contract to avoid excessive light, making the shadows appear even darker. If the sun is directly behind you, everything in your view is bleached out in frontal lighting. Flat lighting, on the other hand, is the result of a bright but overcast sky that veils the sun. Without a balance of light and shadows, a painting lacks the value contrast necessary to create three-dimensional forms that generate the illusion of space.

Here in the Northwest where I live, the sky is often overcast, even when it's still bright outside. Even a single cloud covering the sun can create this effect. When I take photos under these conditions, I know the lighting will appear flat with few distinct shadows. In order to make these images usable for a painting, I have to impose a stronger light direction. I start by looking for hints of the sun's direction: shading on a tree trunk or the slightly darker side of a rock, for example. (Even vague shadows indicate the sun is on the opposite side of them.) I know that any object facing toward the sun or "upward" will be brighter. Likewise, the side of an object turned from the sun will be darker or cooler in color. I use this light "logic" to interpret what I'm seeing rather than simply copying the flat light of a photograph.

Flat Lighting

Not every day can be a sunny one. On a bright, hazy or overcast day, there are no strong contrasting light and shadow areas. This kind of "flat" light is welcomed by a photographer but cursed by the painter. In a photograph, you can always assume the sun is up in the sky and therefore surfaces that are tilted or facing upward must be brighter than those turned downward. When working outdoors, you get clues about light direction from facing south or north and judging the sun's angle by time of day. Regardless of method used, you need to decide where the sun is and impose more light and shadow than you may actually see.

Formal Elements and Principles in a Composition

Contemporary painters appreciate a painting on two levels: first, as an image (subject and content) and second, as a painted surface—the look of the paint and its overall compositional design. The thoughtful consideration of the compositional design separates the predictable from the inventive, unexpected painting. In other words, an ordinary view can be fascinating, when it is painted in an interesting way.

Painters create visual images using the five basic formal elements of composition: line, shape, color, form, and texture. Each of these elements is not only arranged as part of the surface, two-dimensional design or composition, but can also be used to create realistic illusions of three-dimensional space, or be emphasized for expressive purposes.

Line is directional in nature, leading the eye from one place to another, across the surface, or into or through a space. Line is also implied when edges meet, such as in the profile of a tree against the background (change of hue) or a dark tree seen against the sky (contrast of value). However, remember that a line has color (even a black line), and when pulled over a surface in a brush mark (cross contour), it can suggest form.

Shape is two-dimensional "flat" area when there are no variations in value. A shape is defined by its contour edge that creates a strong silhouette shape, such as a backlit mountain range or grouping of conifers. A variety in the size and contours of a shape's edge, including the interplay between positive and negative shapes, results in stronger visual interest.

Color, which seems so essential to a painting, also needs a line or shape to reside within it, giving it definition. The perception of color results from the activity of light over surfaces, stimulating optical sensations within the brain, making color a subjective experience. The visual quality of a paint pigment is the result of its intensity or dullness, its saturation or grayness, warm or cool temperatures, and light or darkness. Color changes in value or temperature create form and imply space, as in a background of "air" in a sky painting. Organizing a selection of paint pigments into a color schema, or strategy, determines if a painting will be based on a warm/cool relationship (sunset skies), an opposition of complements (autumn foliage), or analogous earth reds (rocky shorelines).

As soon as a change in value is seen on a shape, *form* is suggested—illumination (the presence of light) implies three dimensions. Close observation of relative light and dark values is translated through the conventions of rendering form: highlights, core shadow, cast shadow, and reflected light. Form created through shading generates visual solidity, and therefore mass and weight. Changes in value also indicate depth of space—where one area is nearer the viewer and another is farther away. Unlike still life paintings where dark values create a recession into space, landscape paintings employ paler, cooler, or neutral colors to create depth.

Think of *texture* as rendering the illusion of one surface in opposition to another (water versus grass), or as the literal "paint" texture—wet-on-wet paint versus chunky impasto or palette knife paint applications. The texture of paint can also imply space when the paint moves from transparent to opaque layers: transparent darks recede while opaque, thicker paint comes forward in space.

INTERACTIVE PRINCIPLES OF COMPOSITION

Combined together, these elements are used to build a painting's visual dynamic through balance, repetition, variety, dominance, and contrast.

When well-employed, these factors evoke a desired response from the viewer and sustain interest in the overall image. The painter's intuitive response helps determine how to orchestrate these elements and principles, rather than coming from fixed rules or guidelines. In fact, "do" and "don't" rules of composition often undermine experimentation. As with the formal elements, in a painting one of these principles is emphasized, even though all may be present.

You create **balance** in a landscape painting when an object like a river or a tree aligns with the halfway point of the horizontal and vertical axes, or is placed in the center of a rectangle. For instance, moving the tree more to the left or right side moves the visual weight to one side, changing the proportions of the canvas from equal halves. Balance evokes stability or equilibrium, but a small amount of visual tension can keep a composition from looking static.

You can express **repetition** in a number of ways to create a sense of movement, such as repeating a similar color note in several places. Your eye will connect similar elements (color or shape) using a perceptual sense of continuity. Likewise, repeating curved or arching lines (over the ground plane, across the hills, or around the shoreline) are visually linked together in one flowing line. Even the undulating surface in the water can set up a sense of rhythmic

intervals. Similarities visually linked across a composition create an eye path (see "The Eye Path" on page 21) and allow for a greater sense of unity in a painting.

Variety, on the other hand, is based on differences—changes in shape, size, direction, or edges. When composing your painting, look for variations in the shapes especially between the positive (the clouds) and negative (background sky) shapes. You can also express variety through changes in texture—from smooth to rough or changes in scale. Irregularity in a line generates variety—the contour edge of Ponderosa pine or a craggy cliff-side offer more visual excitement than a fast smooth line might.

Dominance refers to a focal point in a painting—all the elements work together to point the viewer's eye in its direction. Two examples of dominance in landscape painting are a human-made element (house, farm buildings, road) or a singular, isolated element. For instance, a viewer cannot be anything but curious when looking at the stuff of human activity or people themselves. Figures in a landscape give scale to the scenery and act as pointers directing the viewer's gaze into or out of the image. Likewise, a lonely tree on the hillside or another unique element has the ability to capture attention. However, a painting may have other counterpoints of interest that serve as secondary focal points,

moving our gaze around and through the composition (see "The Eye Path" on page 21).

Contrast creates a moment of detail or a dynamic that you can establish in a composition through a change of value, hue, texture, or scale. Contrast of value is heightened when an extremely light value is placed next to a very dark area, as with strong cast shadows. Besides a strong change in color or value, you can also express contrast through a neutral color juxtaposed with an intense color, saturated color next to a tint, or a cooler color next to a warmer one. Describing the changes in surface textures through brush handling (or via thickness of the paint itself) lets you achieve a contrast in texture.

Through the dynamic use of these design elements, your painting can communicate your expressive ideas in response to the landscape. Is your intention in this painting to emphasize the interesting shapes, the calligraphic linear direction of the river to the sweep of the clouds, or the brilliant notes of color that surround the autumn forest? Are you interested in a unified or harmonious balance or in an image filled with visual tension?

By keeping these principles firmly in mind at the beginning of a painting, you'll guarantee that the finished painting will not be a static or literal copy of a photograph.

PAINTING STRATEGIES

For a beginning painter, starting a new painting is as simple as reaching for a handy prestretched canvas and tearing off the wrapping. Yet as your ideas and ambitions for more complex images evolve, planning ahead becomes important. Developing a painting strategy begins with organizing your sketches (the idea) and photographs (the supporting details). It can also include preparing color studies and test swatches on a toned ground. I find keeping a painting journal is one way to track what pigments are used in any portion of the painting process for each of my paintings.First, I give each painting a working title, such as "Blue Sky with Hills," and note what toned ground I am using. I may have an overall color strategy, like R+Y+B (red + yellow + blue) for instance, but for each area of the painting I note which pigment is used, so I can re-create my color mixtures (e.g., "sky = Prussian blue + ultramarine blue").

Every painting begins with the painter identifying its intention and how best to arrive at the goal or the final "big effect." Are you trying to create a mystical forest scene with dappled textures of green, the drama of warring clouds with creamy lights and velvety purple darks, or the collision of water against a rocky shore with strong brush marks? In each case, the decisions of what size canvas, toned ground, brushwork, or color palette you will use support the final effect of the work.

A studio painting is developed in a number of stages that lead to the final painting through indirect means. *Indirect painting*, in contrast to direct painting (going to the finish directly), is a layered approach in which you build up from underpainting on a toned ground, using multiple layers of paint to achieve details and emphasis, and then ending with the final glazed color. Indirect painting often utilizes the color effects of working on a colored surface (a toned ground) rather than on white gesso. Combined with a color strategy, optical color effects (such as complementary contrast) can be achieved—for example, blue sky painted over an orange-toned ground or green foliage over a earth-red ground.

Once the toned ground is chosen, the block-in drawing establishes the composition. This is the "composing moment"—a good time to ask yourself such questions as, *Is this the painting I want to paint? Is the sky big enough? Is there a focal point?* The underpainting or block-in of color allows you to test your palette in the first thin layer of paint. Since the goal is to keep the shadows transparent and optimize the optical color effects from the ground, you should avoid applications of thick paint until the end. The painting develops with additional layers of paint that refine the form, texture, and detail of the painting. It concludes with thicker highlights and/or glazed color. Look at *Confluence at Dawn* on page 144 for an example of an indirect painting approach.

In the beginning stages, it's important to keep the whole of the painting in mind, even though you may only have time to paint one portion at a time. When there is some paint everywhere, you can readily view the interaction between the color and values as bigger masses rather than as small details. I never rush to the end of the painting or overwork an area that needs to rest or dry before I continue. I consider every part of the painting in context to its adjoining area so that any changes in my strategy are made toward my goal/intention.

A *direct painting*, on the other hand, is one that is associated with a plein air approach: I paint what I see all at once (*alla prima*). These are usually quickly painted on a white gesso ground, taking one to three hours. I apply paint in a thick manner, using wet-on-wet brush techniques. The goal is to capture the impression of the scene by simplifying details into larger shapes that convey the play of light over the landscape. Skillful brush handling is required to keep from overblending the paint into muddy neutrals or leaving the paint surface overworked. The freshness of color notes and the flourish of brushwork make these paintings gestural and expressive in style. See *Canyon Slope* on page 70.

When you combine both approaches, your painting benefits from the optical effects of a toned ground and places of transparency that contrast with the thicker paint applied in gestural fashion.

SCALE AND FORMAT

Without considering scale and format, it's likely you'll squeeze or stretch your image from the sketch or photo onto the canvas surface, thus causing the scene to lose the proportions and aesthetic relationships. For example, if you're planning a sunset painting, "epic grandeur" is difficult to convey on a small canvas. The same goes for an image on a canvas that's filled with fine detail—you'll slave away with a tiny brush rendering each wildflower. On the other hand, if your canvas is too big, you may not have enough information to fill larger areas, or you might lose steam midway through the painting. Choose the scale of your canvas based on what you're trying to paint and the time you'll need to finish the work.

All ready-made canvases (and canvas boards) are made in conventional ratios like 9 x 12 inches (3:4) or 16 x 20 inches (4:5). It's only when you begin building your own canvas that you can explore the possibilities of irregular proportions. For instance, a "golden rectangle" is not based on these common ratios but on a proportional relationship between a diagonal of a square (from a center point on one side) used to determine the length of the rectangle. Decide at the outset whether your painting is a vertical, horizontal, or square image by spending some time with your sketchbook trying out different possibilities for the composition.

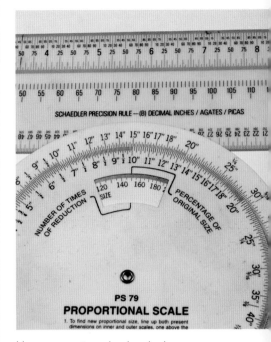

Use a proportion wheel and ruler to scale the original image to the proportions of the canvas.

If you're working from a photograph, use a cropping tool like strips of paper or an L-shaped bracket made from a paper mat to determine the right proportions for the final surface. Using a proportion wheel, as shown on page 17, can aid in scaling up a source image from a sketch to the final canvas dimensions.

A quick side note: the more you can visualize the painting—even before it's begun, the greater your ability to realize your intention and final goal as the painting progresses.

Cutting a ready-made framing mat diagonally makes a useful cropping tool that you can adjust into vertical, horizontal, or square formats.

CAN THIS BE PAINTED?

Nature has a way of tantalizing you with special effects that are difficult to render in paint. Before you begin a painting, it's helpful to stop and ask what techniques you will need to employ to paint a given scene. Water that is in constant motion, transparent water, sparkling snow, or backlit leaves and clouds are subjects that I call "fancy"—indicating a special effect that only succeeds with much technical proficiency. When first trying out a new subject or approach, it's better to select an image that is clear and personally known to you rather than one from someone else's professional photograph. This way you can focus all your attention on mastering the techniques rather than on struggling to interpret a vague (a low-resolution image downloaded from the Internet) or slick (a picturesque calendar) photograph.

Even something as common as a flowering tree can prove difficult to paint without insight and experience. Try examining historical paintings as a guide to uncovering another artist's process. By copying a van Gogh cherry tree in bloom, you'll discover much about the palette and how the tree was painted. Then use that experience, applying its lessons to your own painting.

PROPORTIONING THE CANVAS

Dividing the canvas into proportions by placing the horizon line high or low determines which area of your painting will dominate. For instance, if I draw the horizon line below the midpoint of the canvas, then I give the sky and its distant space more importance. If I raise the horizon line above the midpoint of the canvas, the foreground dominates the painting. In general, you should try to avoid placing the horizon in the center, cutting the canvas equally in half, as it tends to create a static composition (unless one side—top or bottom—of the painting is weighted with a stronger element).

When I want to emphasize the midground, I may show some sky and some foreground, but the center of painting is the largest area. When the region of the

CHRISTINE GEDYE,
TREE PORTRAIT FOR EVA, 2007,
OIL ON PANEL, 12 X 16 INCHES
(30.5 X 40.6 CM).

A russet-toned ground provides a glow for the late-afternoon light, unifying the painting. The artist's careful attention to detail creates the texture and form of the trunk, along with the lacy web of hanging branches. In this composition, notice how the vertical trunk divides the canvas proportionately from left and right, just as the autumn trees and reflections in the background divide the top to bottom portions. The resulting painting is a composition of smaller rectangles playing off the proportions of the larger format.

middle ground is the focus of a painting, a subject, such as the farmhouse, herd of cattle, a stand of large trees, reinforces its importance.

I also keep vertical elements, such as a group of trees or just a singular tree, from the exact center of the canvas so that they don't equally divide the left- and right-hand sides. Although this placement creates a sense of balance, it can also lead to a static composition—unless one side is more heavily weighted with an element, such as a rocky outcropping.

WHERE IS THE FOCAL POINT?

Determine the *focal point*, or center of interest, before you start painting. Ask yourself questions like these: *What part of the painting is most important? Where do I want the viewer to look first? Is there a center of interest?* All these questions are best considered at the outset and help you determine the focal point. The focal point is the place where you share your passion for a moment observed in nature—even if it is only a shadow cast from a cloud sailing by.

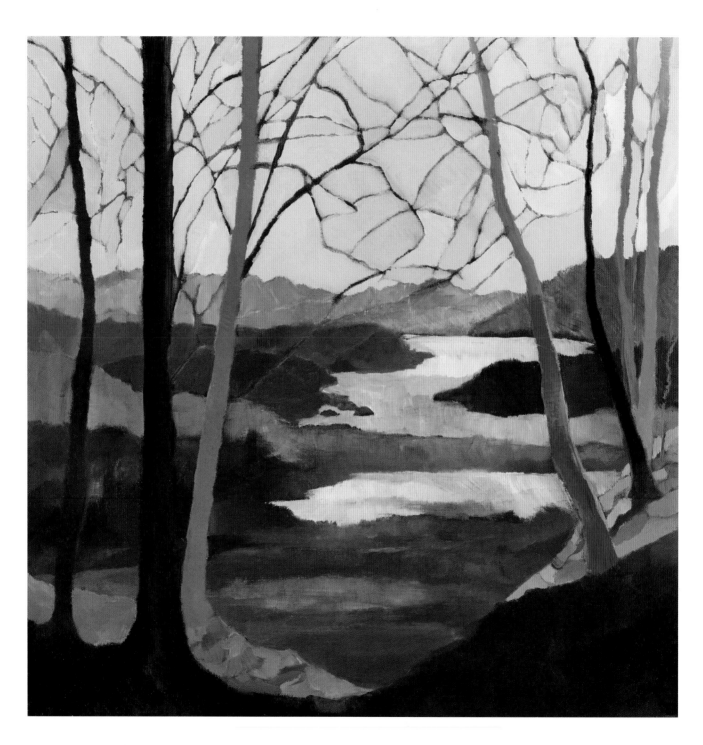

PATTY HALLER, *LAYERED VALLEY*, 2013, OIL ON WOOD PANEL,
14 X 14 INCHES (35.6 X 35.6 CM).

A palette of warm and cool complements unifies the overall color strategy.
In addition, the artist explores shape in relation to deep and shallow space.

Of course, while composition rules are made to be broken, here are a few reminders of what to generally avoid. Don't place your focal point in the center of the canvas. Placing an important or key element in the center reinforces the power of the center, especially if the shape is round. A round object like a stone or bush located in the center acts like a bull's-eye, keeping the viewer's gaze from traveling throughout your painting. Placing a small dot at the center when you first begin painting will help prevent you from letting elements drift toward the center. It's also advantageous to avoid isolating a triangle in the corners creating a dead spot or linear elements (like a tree branch that points diagonally to the outward corners, sending the viewer's eye out of the painting). When trying to maintain the "invisible" edges of the canvas, adjust the positioning of a vertical element like a tree trunk so that it isn't too parallel or too close to the canvas edge.

Some subject matter instantly pulls your attention: human-made objects, animals, and, of course, human figures. These items in your painting create a narrative tension: the viewer wants to know what they are doing! In order to keep them from overwhelming the painting, simplify these elements by reducing them to silhouettes or blocks of color. This way, the path of a bubbling creek or the intense autumn-gold leaves of aspen trees can take on the role of your focal point, even when a fisherman is standing in the creek in the same image.

THE EYE PATH

Once you've decided on a focal point, you need to plan an *eye path* (or the path used by the viewer to wander through your painting) on the two-dimensional surface design and through the illusion of three-dimensional spatial depth. A painting's entry point most often occurs at the bottom edge of the canvas by way of a diagonal element—for example, a stick, a shadow, a row of rocks—that points into the image. Notice how often a road, dirt path, stream, or fence line serves this function. Using a diagonal direction lets you keep the bottom edge of the canvas from becoming static. For example, a row of sage bushes or marsh cattails in the foreground, creating a parallel band at the bottom edge of the canvas, can easily form a visual "fence" that the viewer has to jump over.

One eye path strategy is to create a visual zigzag path that bounces from one side of the canvas to the other, so that as you move up the canvas you also move deeper into space. Elements at the sides of your painting function like "stops," keeping the eye from leaving the image. Even the clouds in your sky can help keep the viewer's eye roving around and returning into the painting. Remember, you want onlookers to linger as long as possible as they discover moments of detail and sensation in your landscape.

MARC BOHNE, *THREE TREES*,
2005, OIL ON CANVAS,
12 X 10 INCHES (30.5 X 25.4 CM).

The curving arc of the water
creates an eye path into the
painting: its soft, blurred edges
invite the viewer to wander
in slowly.

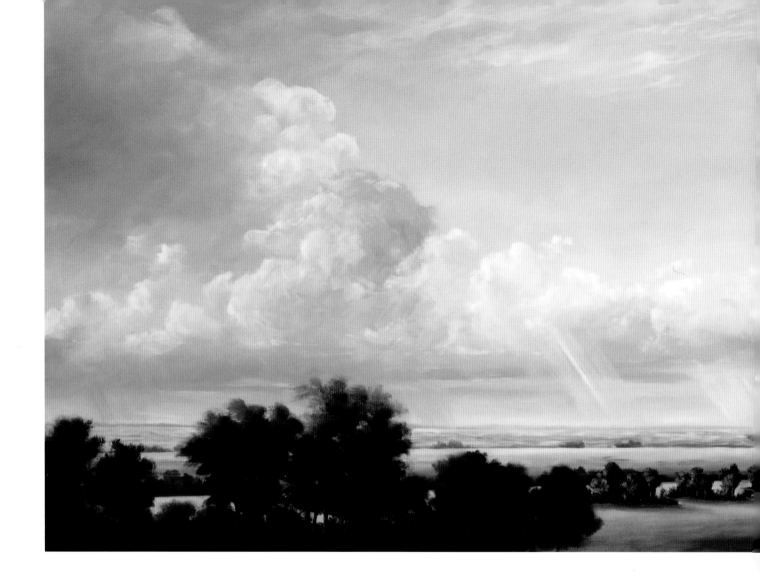

ORGANIZING PAINTING MATERIALS

The first rule regarding materials is to never let them get in the way of your success! Ultimately, what you are looking for is the best combination of surface, paint consistency, and brush application that gives you the results you want in any part of the painting process. Are you working on canvas boards where their deep texture or slick surfaces are making it harder to apply paint easily? Is your paint just too gooey or sticky to control? Is your brush too stiff and scratchy, removing as much paint as you put on the surface? If you answered yes, to any of these questions, then you are fighting against your materials.

PREPARING THE PAINTING SURFACE

You can enhance any surface greatly with the addition of gesso. Gesso acts as the barrier between your surface and the oil within your paint. It's absolutely necessary to double-coat any open surface, like watercolor paper, raw wood panel, or cardboard, with gesso. Gesso provides a dry, matte finish to a surface, making a

VICTORIA ADAMS, *UNSEEN RAIN VISTA*, 2012, OIL ON LINEN, 24 X 60 INCHES (61 X 152.4 CM). PHOTOGRAPHY BY DOUGLAS MESNEY.

A panoramic sky view has the greatest proportion of this canvas in comparison to the land below it. The billowing clouds direct the eye with curving arcs across the skyscape, even as the golden shape of grassland leads the viewer diagonally into the distance of the space.

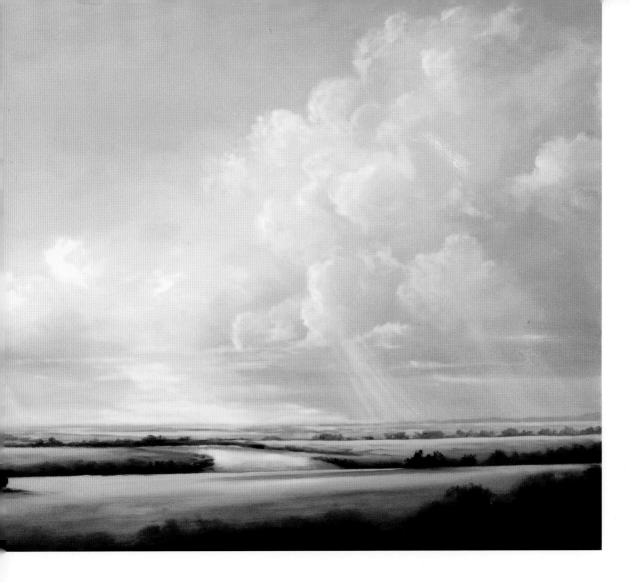

physical "tooth" and encouraging a better, mechanically adhesive surface when applied it in a criss-cross pattern. Only buy professional artist grade gesso, such as Golden or Daniel Smith brands. I've found that prepared surfaces labeled "ready-to-paint" are disappointing: they are either too slippery to work on or they have a machine-stamped texture that is difficult to cover with paint.

Mix gesso with water until it has a consistency of heavy cream and you can easily apply it with a house-painting brush over the surface without leaving any overt texture. You can easily store thinned gesso in a plastic container with a tight-fitting top for later use. Apply at least two coats of gesso, one over the short length of the surface and the second over the longer side, creating a criss-cross pattern. Each coat of gesso is applied horizontal to the surface's edge to fill in and disrupt the deep mechanical stamping of the canvas surface. Allow each coat to dry (typical drying time is between forty minutes to one hour) before adding additional layers of gesso. Use fine sandpaper (200–220 grit) to remove any bumps, hairs, or threads from the surface. Check the surface with your fingertips to ensure you haven't missed any spots. Once these coatings dry, the surface is ready for an additional color tone.

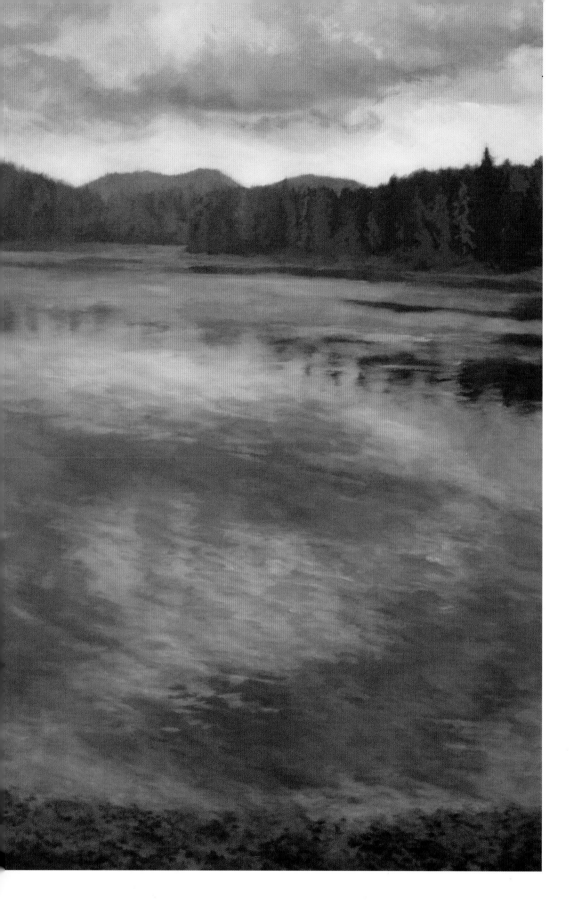

SUZANNE BROOKER, *INLAND SHORE*, 2009, OIL ON CANVAS, 36 X 24 INCHES (91.4 X 61 CM).

Over a toned ground of burnt sienna, thinly applied gray mixtures appear blue via a subtle optical effect of *simultaneous contrast*. This optical color effect was often used by Old Master painters to provoke a neutral gray pigment into appearing as its complement. Here the gray pigment appears blue because it's surrounded by an earthy red-orange pigment, but the same gray surrounded by violet would appear warm and yellowish.

TONED GROUNDS

A pure white ground offers the benefit of backlighting pigments on the canvas surface, especially if the first layer of paint is applied in a thin manner. The hazard of starting with a white surface is that small, white spots (remaining square "chicklets" of the white gesso) are created when the paint doesn't fill the deep texture. Toning the ground with a color before you begin a painting solves this problem and adds the possibility of optical color contrasts. Notice in the chapters on sky and water ahead, how often the toned grounds add to the luminous color effects shown in the demonstration paintings.

Creating a toned ground is easy. There are two approaches to toning a canvas: acrylic pigment (or tinted gesso) and thinned oil paint. The benefits of an acrylic toned ground are not only its fast drying time (two hours), but also that it keeps the initial surface "lean" so that paint solvent can be used in moderation with the first layers of pigment (see "Fat-Over-Lean" on page 34). However, when you make corrections, use care not to "scrub" the surface—and thus, accidentally remove the ground.

Using oil pigments and solvent to create a toned ground acts much like an *oil priming* (a custom mixture of white pigment and oil that is applied over gesso), lessening the effect of paint "sinking" into the absorbent gesso ground. This is often seen when dark or green pigment areas appear matte or lighter in value after the paint surface has dried. In a wipe-out approach, thinned oil paint acts like a stain, creating a movable ground where you can work additional paint into the wet ground and remove it to reveal the white gesso ground.

Whatever method you use, the ground must be beautifully painted to ensure that any thinly painted areas of transparency appear luminous. Mix a sufficient amount of paint to cover the entire surface, including the sides of the canvas. It's better to have too much than too little paint mixture. You can always use the leftover to tone canvas paper for quick study paintings or to test color swatches.

Applying Acrylic Toned Grounds

The acrylic paint used here should be matte, such as Golden Matte Acrylic (heavy body) that comes in small jars, because it is more economical and its unused portions are easier to preserve. You should avoid glossy acrylic paint, as it will make your final surface too slick, resulting in a poor bond between oil paint and canvas. You can make customized color mixtures in small plastic containers with tight-fitting lids. Using a palette knife, thoroughly mix the paint with a portion of water to achieve a loose creamy consistency. You do not want to cover the canvas with an opaque paint layer, but with a thin, transparent stain of pigment that allows the white of the gesso to glow through.

These traditional toned grounds are useful for landscape painting: a pearl gray made of Mars black and white, a cherrywood orange of burnt sienna, and a toasty brown of burnt umber.

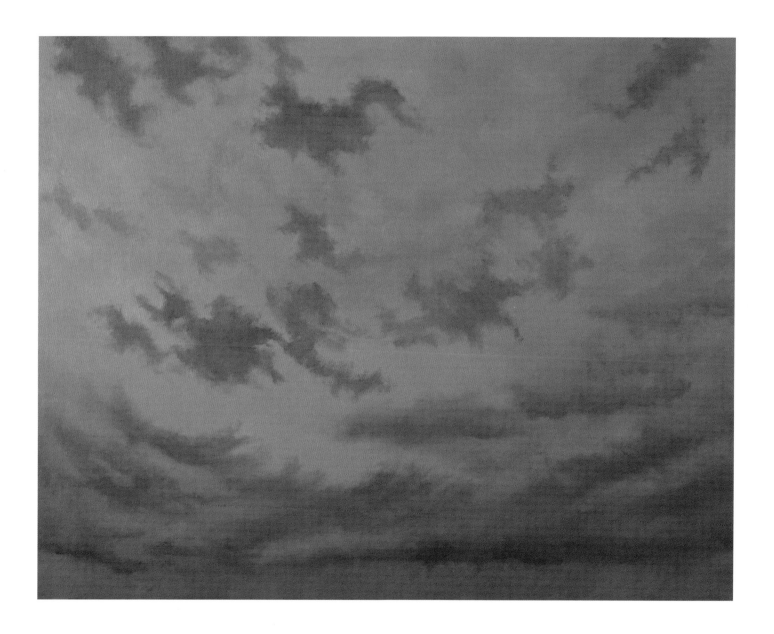

Use a flat, one-inch (or larger) nylon acrylic brush that has soft bristles. Start brushing across the entire shortest side of the rectangle using one continuous stroke. Try to avoid leaving brush marks, as brushing over areas that have already begun to dry will pull off the paint—leaving "blotches." If the color is too uneven or too pale, it is better to recoat the surface a second time once the paint has dried entirely. You should paint the sides of the canvas with the same care as you do the front surface. Wash the palette knife and brush with soap and water immediately after use, as the plastic polymer in acrylic paint will "glue" itself onto surfaces.

You can also apply a prepared, tinted gesso as a finishing coat to a well-primed white gesso canvas. This will render a lean surface, making oil pigments easier to apply; however, as opaque colors, they'll lack the vibrant color effect of a transparent pigment over gesso.

Applying Oil Toned Grounds

For toning the ground with oil pigments, create a mixture of oil paint plus high-quality odorless mineral spirits (see "Solvent" section on page 36) and linseed oil in a 50–50 blend. The solvent makes it easier to move the paint across the surface, and the oil component keeps the paint from becoming too lean (see page 34). This is a perfect time to use the inexpensive brands of paint you may have already rejected from your palette. Blend the mixture thoroughly with a palette knife on a glass palette.

If the brand of paint you use is already very oily, then just add some solvent to thin it. But if your paint is "tight" or sticky, add both oil and solvent. The resulting paint mixture should appear midvalue/semitransparent when brushed evenly over the white priming, with sufficient transparency to backlight the pigment from the white ground. Testing the transparency in a small area is a good idea, especially when you use high staining or opaque pigments. Adding white will only dull the color intensity of the pigment and should be reserved for semiopaque tinted grounds such as midvalue grays.

Use a large, synthetic nylon brush (at least one-inch wide) to apply the paint across the surface. First, work the thinned pigment thoroughly into the texture of the canvas. For an even toned ground, stroke the wide, flat tip of the brush across the entire wet surface—from edge to edge—parallel to the rectangle edges for a smooth coating. Evenly distribute the paint across the surface without leaving any brush marks. For a mottled surface with irregular areas of light or dark, or for changes in temperature (from warm to cool), work the oil stain mixtures into the canvas surface and then smooth them to blur any harsh edges.

Remember, you should paint the sides of the canvas with the same care as you do the front surface, especially the turn from the front to sides of the canvas. (This is where the most *abrasion* will occur, as the canvas rubs the easel shelf). You can then store the toned canvas against a wall or lay it flat on the floor until it is dry. Clean your brush in solvent and then with soap and water.

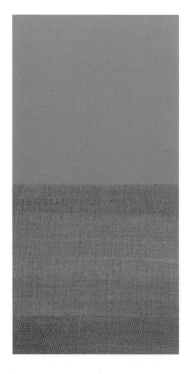

ABOVE:
Compare the effects of cadmium orange as a toned ground. At the top, pigment is mixed with gesso for a midvalue tint. Below that, a thin stain of pigment is placed over the dried white gesso.

OPPOSITE:
SUZANNE BROOKER,
LIFTING CLOUDS, 2014,
OIL ON CANVAS BOARD,
16 X 20 INCHES
(40.6 X 50.8 CM).

An intense orange ground of cadmium (tinted gesso) lends its color note to the layers of transparent white that build up the cloud forms in this sky painting.

PALETTE

The word *palette* is used in painting with two different meanings: it refers to the physical place where colors are mixed and to the choice of pigments used to create a painting. Plein air painters have a built-in surface for mixing paints as part of their easel stand, while studio painters enjoy a larger surface placed on a side table (*tabouret*). In either case, most painters would agree that when using a metal palette knife, a glass surface is the most efficient for manipulating pigments. For studio work, a glass surface combined with an airtight box, such as a Masterson palette box, provides means for preserving paint mixtures over the duration of a painting. Once your palette box is outfitted with a piece of glass, it will provide the best surface for mixing your pigments. (Storing your palette box in the freezer and/or taping a Q-tip soaked in clove oil on the lid of your storage container will help preserve the freshness of your paint palette.) For more portable situations, a simple plastic container with a piece of palette paper or waxed paper can be just as useful for storing or conveying pigments on site.

When laying out your tube colors on the palette, consider an arrangement that reinforces color relationships, such as complements or warm to cool colors. For instance, if you are working on a small outdoor palette, simply having a rainbow arc of warm yellow, orange, red, violet to cool blue and green may be enough to keep you organized with a simple light-to-dark palette. However, for studio painters, three sides of your rectangular palette can be designated with a primary color: yellow hues on the left, red above, and blues to the right. Then green can be on the bottom. This organization allows for the relation of warm colors opposite to cool colors as well as the opposition of complements.

Recall that it was difficult to spend money on good paint brands when you were just beginning and not sure what colors were important for a core palette. I always recommend upgrading to the best pigment brands you can afford now. These brands carry a denser quantity of pigment that lasts longer and creates a greater range of color mixtures. A small array of pigments starts with the basic palette of warm and cool primaries (Red, Yellow, Blue, Green), two earth reds, a black, and both titanium and zinc white. Check the pigment list on page 30 and compare it to the paints already in your studio. If you already have a warm lemony yellow, then you don't need to buy a cadmium yellow. Just make sure what you have is robust enough to make beautiful greens and russet oranges.

In each of the following chapters, look for color mixing charts and advice on exploring color arrangements. For instance, in the chapter on painting sky, you'll test out several blue pigments in order better generate the subtle tones of blue, and in the chapter on painting trees, I'll address how to create a broader variety of greens.

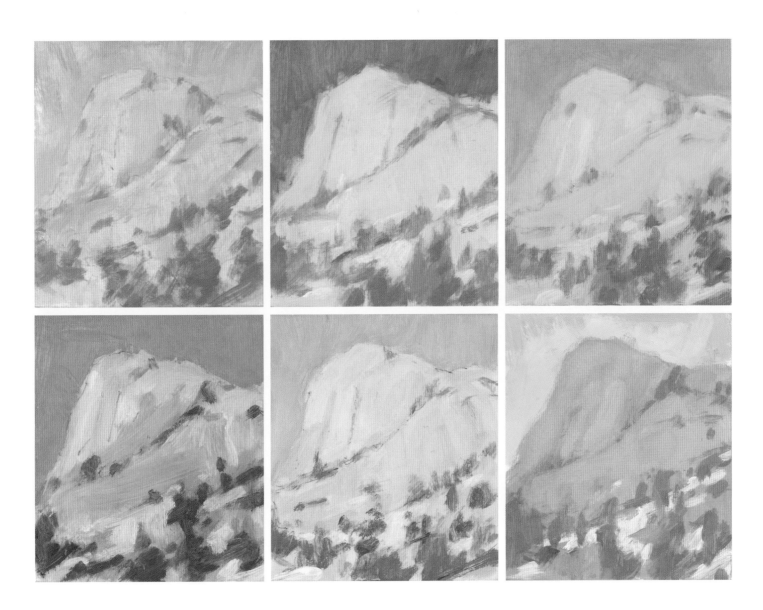

MITCHELL ALBALA, *COLOR STUDIES*, 2012,
OIL ON PAPER, 4½ X 4 INCHES (11.4 X 10.2 CM).

Developing a color strategy can lead an artist to be more inventive and original with color choices. In each of these studies, complementary relationships, analogous colors, saturated or neutral colors, or varying degrees of value contrast are used to create believable light without copying photographic color.

Pigment List

Pigments with a bullet indicate "core" colors for a basic palette, and include warm and cool pigments. Think of these pigments as the foundation for any limited palette that you can then expand once you understand the full range of the pigments' potentials in color mixing. (Paint brand when listed is noted in parenthesis.)

Place pigments from the tube on the perimeter of the box, while reserving the center as a mixing area and for lumps of custom colors used in painting. Palette layout: clockwise, yellow-orange on the left, earth reds to contemporary reds on top, blues and violets on the right side, and greens along the bottom.

WHITE
- titanium (opaque)
- zinc (transparent)

BLACK
- ivory black
- Mars or lamp black

COOL YELLOW
- yellow ocher
- transparent yellow oxide
- gold ocher
- raw sienna

WARM YELLOW
- cadmium yellow
- cadmium orange
- hansa yellow

COOL RED
- alizarin crimson
 rose madder

WARM RED
- cadmium red
- scarlet or vermilion red

EARTH RED
- burnt umber
- burnt sienna
- Venetian red or
 Indian red

COOL GREEN
- viridian green
- terre verte
- green ocher

- green umber
 (Old Holland)
- phthalo green
- raw umber
 (Old Holland)

WARM GREEN
- sap green or sap
 green lake extra
 (Old Holland)

COOL BLUE
- ultramarine blue
- cobalt blue
- indanthrene blue

WARM BLUE
- phthalo blue or
 Prussian blue
- indigo
- cerulean
- turquoise blue

VIOLET
- Mars violet
- ultramarine violet
- manganese violet

BRUSHES

You can improve your painting experience by using the best brushes at each stage of your work. Older, stiff-bristle brushes are excellent for rubbing in large areas of the canvas, especially if you're trying to cover over white gesso. Filbert-shaped brushes with soft tips are most useful for blending the soft edges of clouds or for gently placing wet paint onto a wet surface (as in water reflections). Use flat brushes to draw in the composition or to create a wide, flat stroke of pigment when painting rocky shores. Likewise, a fine, pointy round brush is handy for drawing details, like grasses and branches.

You can test out a new brush in the store by pressing it gently to the back of your hand: Is it soft enough to glide on wet paint without scraping it off? Is it firm enough to pick up a good-size nugget of paint when you want a thicker layer of paint? Choose a range of brush sizes, keeping the scale of what you're painting in mind. For example, if you're painting on small 8 x 10–inch panels on site, you'll need smaller brushes than those used to paint a larger canvas back in your studio.

Through the friction of painting, brushes are easily worn out, but even a cheap brush will last longer if it's well cleaned. At the end of a painting session, wipe all visible paint off with a rag or towel. Next, swish the brush through solvent, avoiding smashing the brush's tip on the bottom of the jar. Dry the brush off with a rag. Now, clean it with warm water and soap. Use your fingertips to loosen any visible paint from the brush. Rinse and apply more soap, until all the obvious paint has been removed from the brush's tip. Next, remove any paint lodged in the metal crimp (ferrule), by gently gripping the soapy brush tip and rotating the handle to loosen hidden paint. Then rinse again. These steps may need to be repeated several times so that you can remove all the hidden paint before pressing the brush tip back into shape.

In each of the following chapters, you will find a section on specific brush techniques related to the element covered. Instructions for how to hold the brush and movements involved in making each stroke accompany illustrations of the resulting brush mark. Because of the limits to still photography for showing action, some practice will be required so that you can gain proficiency. Experimentation is the key.

PAINTING MEDIUMS

Painting is a conditional process—"when this, then that"—which is especially true when you consider painting mediums. Because you want your finished painting to be as archival and durable as possible, care is needed in developing the paint layers, especially when adding mediums. Unfortunately, the information

Hand-over-brush: Pinching the brush handle with forefinger and thumb keeps the brush tip at a low angle.

Brush-over-hand: Holding the brush like a pencil or chopstick at the end of its handle, allows for a full range of motion through the wrist.

Anchor-grip: To steady your painting hand, place your other hand so that your fingers can pinch-grip the easel tray, and bend your wrist to create a bent support for your painting hand. Relax the support hand, but make sure it's firmly planted on the easel.

Essential Brush Techniques

Three factors work together to determine the outcome of every brush mark: angle of brush to canvas surface, pressure on brush tip, and direction of brush pull. Beginning painters often suffer poor painting results because they maintain the same approach for every brushstroke, leaving their painted surfaces dull and overworked. By holding the brush too close to the tip, at the same 90-degree angle, with firm pressure, their brush handling results in scratching off paint or overblending colors. By holding the brush toward the end of the handle, you can achieve a controlled, sensitive touch, allowing the paint to be "placed" in exactly the right manner (size and direction of the stroke). Combined with a low 45-degree angle, you can apply more pigment over areas on the wet paint surface quite easily.

Correctly loading the brush tip with the right amount of paint is equally important. Typical problems arise from too much paint on your brush when you are blending two areas together or from not having enough paint on the brush tip when you pull a thick, textured stroke.

In a world of right-handed painting, left-handed painters have the challenge of adapting techniques to their own bias. Lefties should consider their natural pull from top right to bottom left, and practice employing hand-over-brush (pinching the handle with forefinger and thumb), as an alternate means for controlling the placement of brushstrokes.

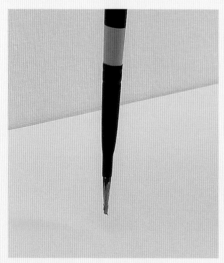

An upright brush at a 90-degree angle allows just the tip to touch the surface. This angle allows you to use the brush to draw thin lines or to make small, delicate marks. The stronger the pressure, the fatter the resulting lines or marks.

A 45-degree angle on the brush allows you to use the tip to gently blend paint together without excessively moving the paint from one area to another. Think of these as soft feathering strokes that blend the edges of two areas of different values or hues together.

A low-angle brush allows you to "place" the paint from the tip of brush onto the surface without scratching it off or mixing the new paint with the layer underneath.

You can draw narrow lines when the brush is upright, 90 degrees to the canvas surface so that only the tip of the brush touches the canvas.

You can place small, dappled strokes or lightly feather-blend on the canvas surface by holding the brush at a 45-degree angle.

You can drag broad areas of paint over the surface by holding the brush at a low angle to the canvas when the tip is charged with paint.

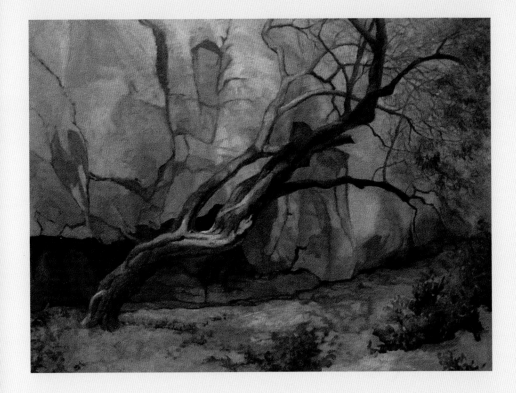

SUZANNE BROOKER,
DESERT CANYON WALL, 2007,
OIL ON CANVAS BOARD,
11 X 17 INCHES (27.9 X 43.2 CM).

A variety of brush marks are used to produce the textural surfaces here—from thin lines for the cracks in the wall and for the branches to flat, broad strokes used to trail along the ground plane to dappled brush marks for the foliage.

provided on a label can only relay facts concerning final results (shiny, quick-drying, and so on), but not the means needed to evaluate the correct method within the structure of your painting process. For instance, in which situations and in what quantity of should you use a quick-drying medium and at what stage in a painting's development? Painters are forced to rely on their own experiences and results discovered through trial and error. Regretfully, some errors may take a few years before they become apparent as yellowing, crackling, or peeling paint.

Keep your paint chemistry simple! Use the same oil that is already in your paint brand (usually refined linseed oil) to increase the creamy texture or transparency. If you have paint made from walnut oil, then use walnut oil as your medium. Even water-mixable oil paints have their own custom oil. Likewise, be careful when squeezing out a new tube of paint that has been stored flat or hung from its cap: often the oil and paint have separated. It's likely you'll squeeze out more oil than paint, leaving the rest of the tube dry. Store your new paints with the cap side down so that the oil will rise to the end of the tube.

FAT-OVER-LEAN

Let's assume you are familiar with the maxim of "fat-over-lean" where thicker, oily paint is worked over thinned or thinly applied layers. What does this really mean in terms of building up paint layers? When a one-hour painting session becomes a fifty hour, multilayered painting, following a fat-over-lean strategy is essential for building an enduring paint structure.

The leanest paint is a mixture of tube paint and a small amount of solvent, most often used to block in the drawing/composition. Let's call this "thinned" paint, because it reduces the amount of oil within the tube paint. It's quick drying and gives a washlike effect when applied in a broad fashion. However, remember that without oil—the binder in paint—there is no "stick 'em" to the surface of the canvas. Oil paint that is overdiluted with solvent will dry to fine dust that can be scratched, rubbed, or wiped off the canvas.

Lean paint can also mean tube paint mixed with quick-drying mediums, such as Liquin or Galkyd products. You can add quick-drying mediums to paints in the first, initial layers for a quick block-in or underpainting, but you should use them in a less than 50 percent ratio with the paint. Because they are quick drying, they also shorten open paint handling (twenty minutes to one hour), reducing the time for wipeouts and blending. As your painting develops past the underpainting, the amount of resin-based mediums should decrease, as they become replaced with oil mediums.

A thinly applied layer of tube paint is another way to build up the paint surface from thin-to-thick layers in the middle portion of a painting. The benefit of indirect painting methods comes from multiple layers of paint used. These not only give a richness to the paint surface, but also create optical color effects. Paint straight from the tube is lean when thinly applied, but when thickly applied, it's fat. This means that not only will thick paint take longer to dry, but to avoid paint crackling, no thin layers should be overpainted on those areas. Thinly applied layers of paint have the advantage of drying quickly even when additional linseed oil is added to increase their transparency. This is "oily" paint, but it is not a glaze. It's used in creating semitransparent dark shadow areas or for drawing in fine details, such as the texture of bark or the cracks on rocks. See examples of tube-to-oily paint on page 55.

OILING UP A PAINTING

Once you've attained an accumulation of paint layers through a series of painting sessions, it's a good idea to "oil up" your painting: wipe a simple layer of linseed oil over the entire dried paint surface leaving the sheerest amount of oil. It's important that your painting is dry—past the dry-to-touch stage where it no longer comes off on your fingertips. When the surface feels cool to your fingertips, the paint is not completely dry underneath but is still *curing*. (Remember oil paint does not evaporate to dry like acrylic paint, but instead, it cures by the oils absorbing oxygen molecules.) Cleaning or rubbing the paint surface at this point is likely to tear the surface film. Tilt your canvas and look across the surface to find areas that are shiny, these areas may need to be cleaned first, before you apply oil. Cleaning the surface with a mixture of diluted ammonia water (one part ammonia to five parts water) with a lint-free rag will help you avoid any "beading up" on shiny areas that resist further oil. You can then apply linseed oil over the entire painting with a large brush or lintless cloth. Keep in mind that any oiled painting must dry flat as even the sheerest layer of oil will tend to drag into dip marks when left vertically upright!

Oiling up a painting will even its reflective surface, restoring the deepness of the dark pigments (resulting from the paint oil sinking in) and the true color contrasts. It also provides a moist surface, allowing the brush to glide when you add new paint over older, dried paint. From this point onward, paint mixtures have an increasing amount of oil or thickness, and fast-drying mediums should no longer be used.

To make a pounce, gather up the edges of a small square of lint-less cloth into a tear-drop shape. You can use your pounce to clean a surface with diluted ammonia water, to apply an oil-stained ground, or to oil up a painting.

Applying a thin veneer of linseed oil over a matte surface restores the contrast between the darks and other color notes.

SOLVENT

You should only use high-quality refined odorless mineral spirits (OMS) in your paint mixtures. These come under the brand names of Turpenoid, Sansodor, and Gamasol, all found in art supply stores. Less refined solvents found at the hardware store are best reserved for cleaning your brushes. Do not mix dirty solvent into your paint mixtures—doing so will muddy your colors! You should always cover solvent jars to minimize any overexposure to volatiles, and solvent should be used with good ventilation. To avoid contact with your skin, apply a barrier cream (found in hardware stores as "liquid gloves") to your hands before a painting session. Always wash your hands with soap after a painting session!

You can recycle solvent through a decanting process, allowing the muddy solvent to settle and then pouring off the clarified solvent into a new jar. You can wipe out the solid paint mud at the bottom with paper towel, and throw it into the trash, recycling the old jar for future use.

KIMBERLY CLARK, *TOMORROW THEY WOULD FALL*, 2012, OIL ON CANVAS, 52 X 46 INCHES (132.1 X 116.8 CM).

A dense accumulation of brushstrokes creates the textural effects of autumn foliage. Notice how the brushstrokes are "placed" so that the purity of each color note is not lost through overblending.

Fat-over-Lean Guidelines for Building a Solid Painting

- **PIGMENT PLUS SOLVENT:** Block-in drawing over white gesso ground or tinted gesso.

- **PIGMENT PLUS SOLVENT AND OIL:** Block-in drawing over an oil-toned ground or used in a wipeout approach.

- **TUBE PAINT:** Thinly applied scumbles, followed by thin applications of paint, only mixing white (titanium and zinc) is modified with additional linseed oil.

- **OILY PAINT:** Color mixtures adjusted discreetly with additional linseed oil to a semitransparency, especially recommended for dark pigments, drawing thin-line details.

- **OILING UP:** Sheer application of linseed oil to restore dark values and color contrast toward the finish of a painting, applied as an overall treatment on the canvas surface.

- **THICK PAINT:** Applied at the end of a painting as opaque accents.

- **GLAZE:** Stand oil (another type of linseed oil) thinned with solvent plus transparent pigments for tinting, such as warming, cooling, or enriching color over areas of a painting.

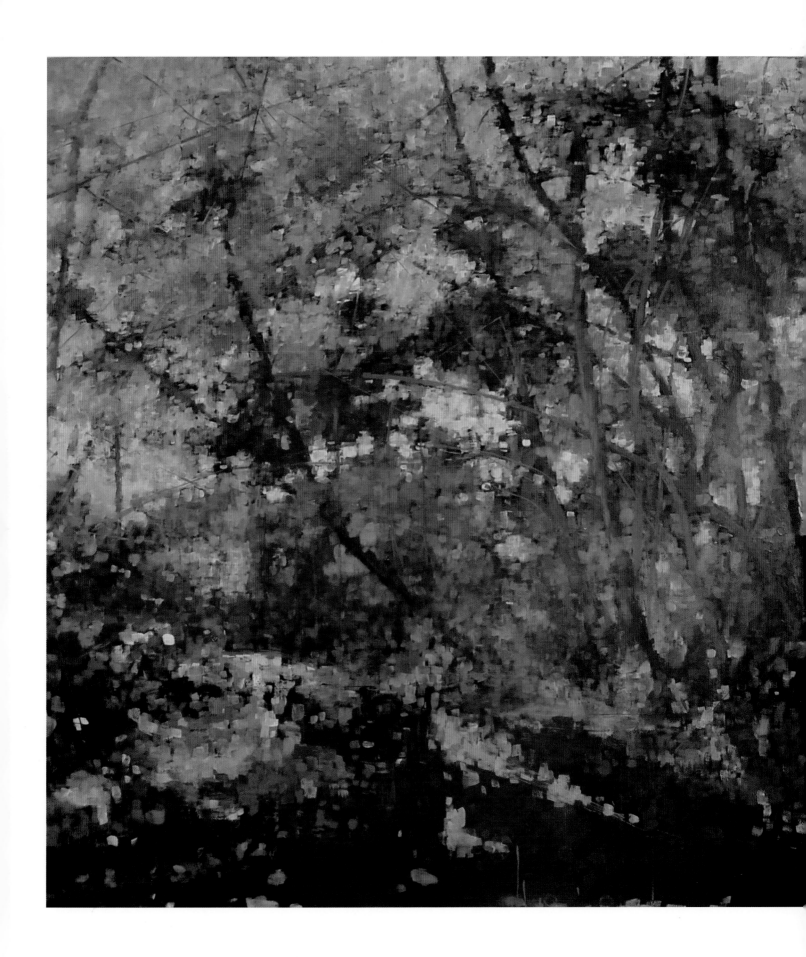

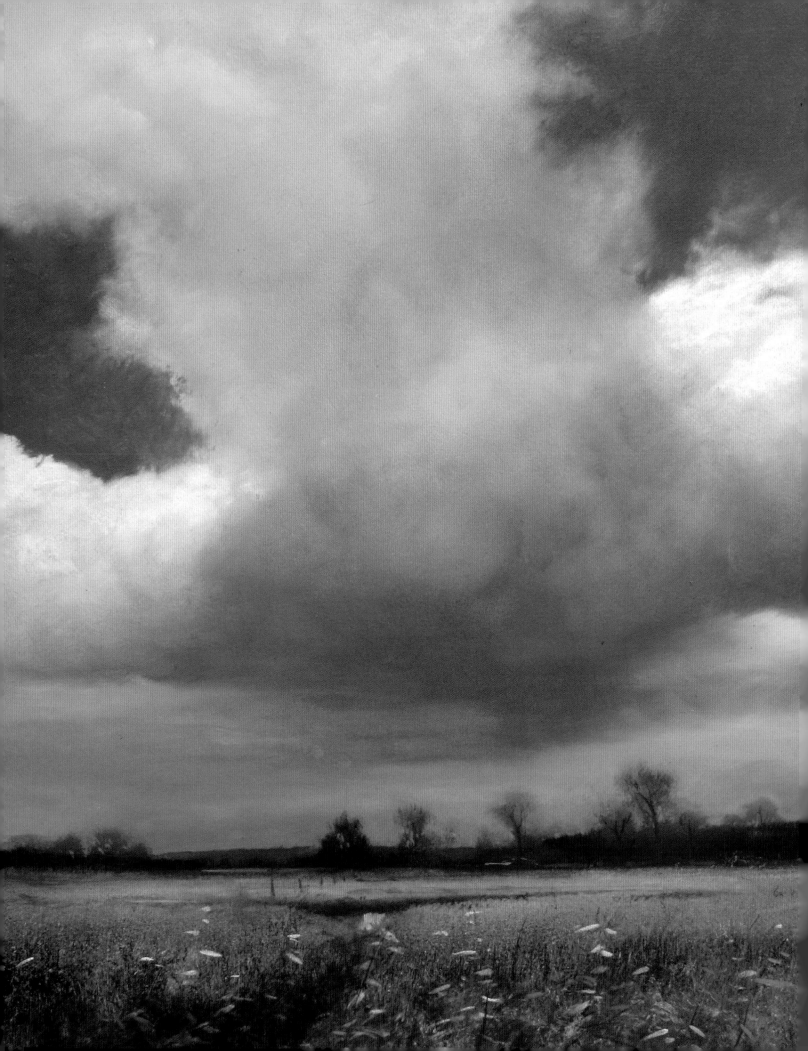

CHAPTER TWO

SKY

The sky is the curving arc of heaven, the airy realm of wind and space. I can vividly recall humid summer afternoons christened with thundershowers, which left the air hanging with moisture that the departing sun turned golden. If I hurried outside with my water-color box, I could capture the light lingering on the clouds as the sky changed from orange to violet—each painting "alive" until the water dried on the paper.

It is one of our oldest instincts to know where the sun is in the sky—the sun's life-giving energy is felt even when obscured by clouds. We march through seasons set by the pace of the sun, and measure the length of a month by the phases of its sister, the moon. At dawn or sunset, we swoon with delight at the sublime beauty that fills the sky, the carousel of lush color—the magical transformation from light to dark.

Clouds travel across the sky's vastness—flung out in tails of high ice crystals, piled up into fluffy mountains, or as floating ships of incoming rain. Clouds animate the sky, especially in the stormy spring weather here in the Northwest. No matter how many photographs I take, it's impossible for me to capture the depth and vastness of this complex sky.

ABOVE:

VICTORIA ADAMS,
AFRICAN LIGHT, 2011,
OIL ON LINEN, 69 X 79 INCHES
(175.3 X 200.7 CM).
PHOTOGRAPHY BY
CHARLES BACKUS.

OPPOSITE:

RENATO MUCCILLO,
THE UPWARD PUSH, 2010,
OIL ON PANEL, 11 X 15 INCHES
(27.9 X 38.1 CM).

A dynamic cloud form animates the stillness of the landscape below.

It's more vivid when I create an image from memory. The sensation of the sky—radiant light and dancing clouds—is what painters bring to the easel.

Capturing the vigor, charms, or dimensions of the sky seems beyond the capabilities of mere paint. Yet painters do succeed in depicting the glory of the sky. Consider Frederic Church and the spiritual intensity he brought to his work, or Thomas Cole, founder of the Hudson River School, who evoked poetic suggestions from breathtaking vistas. On the other hand, John Constable studied the sky and changing weather like a scientist in his cigar-box-top plein air paintings, noting the wind direction, humidity, and season as lessons applied to his formal studio works. Contemporary painters build from these traditions to create works of both emotional intensity and abstract expression.

OBSERVING THE SKY

To make the sky more than a backdrop in your painting, you need to interpret the conditions that affect its appearance, such as weather, season, wind, humidity, and time of day. Observing the sky is already a part of your daily routine—you ask yourself, for example, *Will it rain today?* But the sky also has a deep psychological effect on emotional states of contentment, anticipation, or foreboding. When the sun refuses to shine, the lack of shadows results in a flat world that lacks dimension, which is created by the contrast of light and dark. This is why brightening the sky is often a simple fix to a gloomy painting.

The sky is a vast space of color until it meets the earth at the horizon, yet it never appears solid with the same value or color temperature. When you look out to the horizon and peer through the denser moist atmosphere, smog, or dust, the sky takes on a lighter, warmer turquoise color note. When you look up and away from the sun, the sky seems a darker, cooler, and often more violet-blue.

Nor is the sky always the same blue. Conditions, such as time of day or year, weather, and even local climate conditions (humidity), can affect the way you perceive the color "blue." For example, the early morning sky takes on a cool transparent blue like a robin's egg, in comparison to the deep, smoky blue left after the sun sinks below the horizon. The blue of winter skies is often masked with a thin layer of pearly gray–violet clouds unlike bright summer skies of pure cobalt. In humid climates, the sky takes on a distinctly cooler blue note in contrast to a drier, more desertlike atmosphere where the sky is a warmer, richer turquoise blue.

How much of a change from lighter/warmer blue to cooler/darker blue is determined by how large of an arc of the sky you view from the bottom to the top of the sky. For example, when you stand on a beach or flat desert and look out, you'll

Limits of Cameras

Beware! The camera is not able to capture the nuances your eyes can perceive! When I say "eyes," I really mean your brain. After all, color is in the mind of the viewer. The more you study color in your painting practice, the more your brain will develop greater color sensitivity.

On the other hand, cameras (using autofocus and autoexposure) are designed to capture only a certain gamut of color, neither too bright nor too intense.

Notice that on a sunny day your camera provides an unrealistically saturated blue sky. And on a hazy, overcast day, the sky is likely to be bleached out to white. A camera is best at reading midvalue light conditions. Trying to match a color print of the sky with oil paint is a bad idea, since you're duplicating the limits of the camera instead of expressing the felt experience of your own perceptions. *Trust yourself!*

The low-slanting angle of the sun when you look southeast tints the clouds from a warm white to creamy peach in a darkening blue sky. Looking westward into the sun, the clouds are backlit and appear a darker violet gray when compared to the lighter values of the sky.

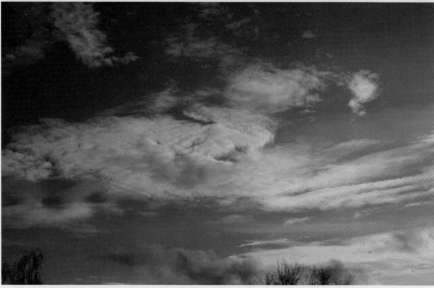

see the sky from the horizon to above your head (a 90-degree arc). The difference in value from top to bottom is noticeable. But if you just look out the window, perhaps you can view a 20- to 45-degree arc, so the value difference is subtler. However, it's always important to create some value change in order to keep the sky from resembling a flat blue wall.

The angle of the sun also plays an important role in how you interpret the sky and its cloudscape. For the greater part of the day (from 10 a.m. to 2 p.m.), the sun is directionally "up," or at a high arc, giving a downward-slanting light that illuminates the tops of objects (all planes turning upward toward the sun), including clouds. As the sun sinks lower, you encounter sidelighting, such as the long, lingering light of a summer afternoon. This light is most noticeable on the tinted golden clouds and the long, slanting shadows. Once the sun is even lower, the changes from light to dark in the sky will be at an upward diagonal. For example, the bottom right corner of the sky closest to the setting sun will be lightest compared to the diagonal top left, which will be the darkest part of the sky. Clouds at this time of day take on color along their bellies from the long (red) rays of light coming from the low angle of the sun below.

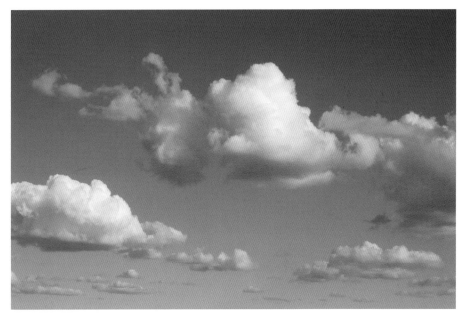

Low cumulus clouds are separated by areas of blue sky.

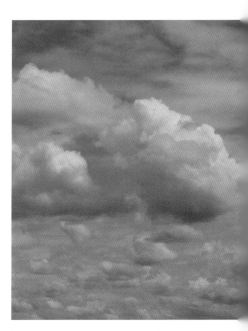

Here's an example of a complex sky where layers of clouds are displayed from near to far into the distance.

SKY CONDITIONS

There are three basic groupings of sky conditions that you can use to determine the best approach for rendering their effects: simple, complex, or dramatic. This is especially important when the sky takes up a majority of the painting or acts as a significant symbol or metaphor in the work. Planning ahead will help you achieve a glowing light and sparkle regardless of your sky conditions.

Simple Sky

A simple sky is easy to recognize. It's clear, blue, and has singular clouds that rarely overlap one another. You often witness this sky in the first warm days of spring, on sunny, dry summer days or in the crisp days of early autumn. The blue space between the clouds provides an interaction between the positive cloud shapes and the negative space of the blue sky. Because the sun is in its upward arc from 10:30 a.m. to 2:30 p.m., it is a rich, even blue that pales to a warmer color closer to the horizon. This type of sky is the one most often painted in plein air sessions: a few strokes of pure white pigment dragged over the wet blue sky in a quick and gestural fashion suggest the fleeting action of the clouds. Studio painters have also used this skyscape as an opportunity to create abstract compositions of pure shapes with multiple layers of sheer paint.

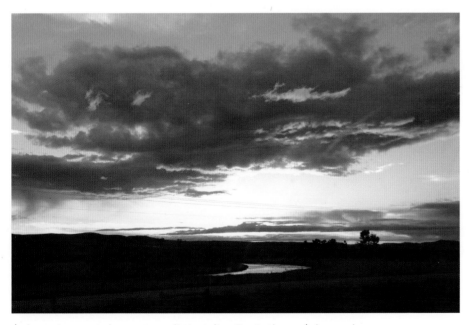

A dramatic sunset sky creates a distinct direction in the sun's low angle.

Complex Sky

The complex sky is comprised of several layers of clouds at differing altitudes that overlap one another. When looking at photographs, this is the most challenging of skies to interpret without some knowledge of what kind of clouds belong in what depth of space. When you observe long distances but also look upward at the same time, a complex sky can be part of a grand sky view. Examples include skies near the ocean or in the desert. Often stormy rain or snow days are filled with layers of clouds that seem to melt or blur into one another, juxtaposed with the firm shapes of lower clouds. Studio painters can find a staged, layered approach helpful by painting everything from back-to-front: first the sky itself, then the highest/farthest clouds, all the way to the closest, nearest cloud forms. By allowing the paint layers to dry between sessions, greater control is gained in blending and softening edges. Plein air painters who enjoy an *alla prima* (directly painting all-at-once) approach will use the physical texture/density of the paint to suggest an impressionistic space.

Dramatic Sky

A dramatic sky is one filled with grandeur, where the extremes of natural forces collide to create contrast. You can convey this effect through towering forms of cumulonimbus clouds set against a slim edge of horizon, storm clouds charged with thunder and lightning with a small slice of blue peeking through, or a color-saturated sunset next to a darkly backlit mountain range. As painters, we plan how to interpret visual drama by utilizing the contrast of value and color.

Looking away from the sun near the end of the day, notice the deep rich blueness of the sky. White cloud forms posed against a dark blue make a striking contrast in value. The same clouds would appear less majestic against a paler, blue sky. On the other hand, color contrast can be either a subtle play of color temperature (like the pale peach clouds against violet-blue in a sunrise sky) or a dynamic color contrast (such as peacock blue, saffron, and salmon-pink clouds depicted in a sunset painting).

Thick and gestural paint applied with vigor is one means for capturing the changing light in the sky. Painting directly means that the color mixtures need to be predetermined, as there is little tolerance for "fiddling" with the paint without a loss of color purity. If your approach is indirect, then you'll want to begin with an intensely toned ground that optically shines from beneath transparent layers of pigment.

OPPOSITE TOP:

KEN BUSHE, *SEPTEMBER*, 2010, OIL ON CANVAS, 17 X 23 INCHES (43.2 X 58.4 CM).

The rising orb of the sun is suggested in the luminous sky, but blocked from view by the diagonal clouds.

OPPOSITE BELOW:

KEN BUSHE, *CLOUDSCAPE*, 2011, OIL ON CANVAS, 20 X 30 INCHES (50.8 X 76.2 CM).

The diagonal arms of the clouds reach outward and, at the same time, pull us into the painting.

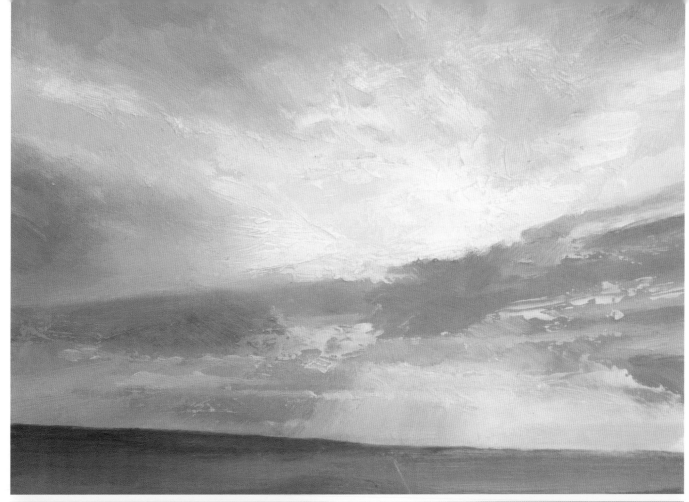

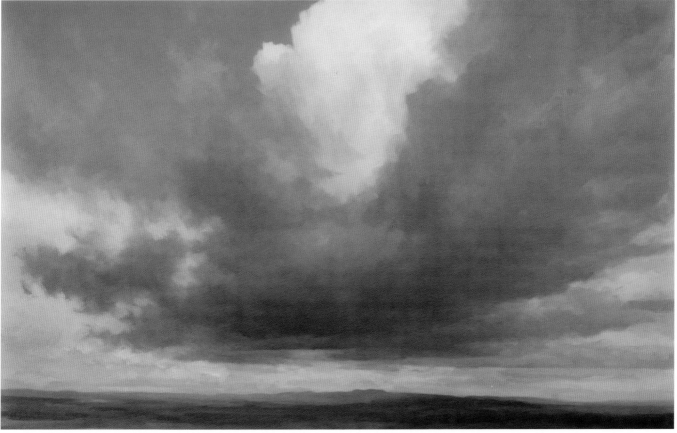

A Bit of Cloud Science

There are four basic cloud formations found at differing altitudes in the sky. Each has a characteristic shape and density that makes it recognizable, even as it appears to overlap or merge together with other clouds.

VICTORIA ADAMS, *VANTAGE*, 2009, OIL ON CANVAS, 60 X 60 INCHES (152.4 X 152.4 CM). PHOTOGRAPHY BY CHARLES BACKUS.

Rain-filled nimbus clouds shower down on the autumn landscape. Notice the nuances between values. Crisper and softer edges establish the overlapping of the cloud layers.

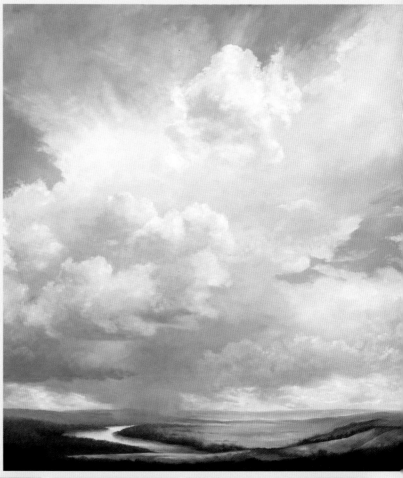

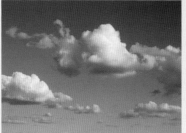

CIRRUS

These are the highest clouds, formed of ice crystals, fanned out in long wisps, feathers, or horsetails by the dominant wind current.

CUMULUS

These are fair-weather, fluffy clouds with arched tops like bunched cauliflower and relatively flat bottoms. They have a density that changes value with subtle increments of gray, depending on the angle of the sun. This often creates a darkening effect along their bases, and casts shadows on the ground plane.

STRATUS

Stratus are low clouds that are fairly even in density, without a flat base or distinct form, much like soft cotton balls, with wispy transparent edges. They vary in color from dark gray to pearly white, depending on the sun's angle.

NIMBUS

These are the massive gray clouds that fuse together in a thick layer that hangs low to the ground. These clouds are most often associated with rain, fog, and snow.

DRAWING CONCEPTS

Translating perceivable distances in a photograph of the sky into a painting takes some practice in observation. Consider the sky as an arc or as the inside curve of a bowl that begins farther away at the horizon and curves upward overhead to the top of your photographic image. (Try holding your photo at eye level, and tilt it so that the top is closer to you.) The clouds at the top of the photograph are the ones closer, almost over your head. In fact, you are probably looking at their bottoms compared to the ones seen farther away at the horizon where you view their sides, along with the top and bottom edges.

Make the clouds in your painting serve a purpose: to animate the sky. Don't get lost in painting the subject "clouds"—in lieu of the overall compositional effect—unless the cloudscape is the subject of your painting. Clouds act as dynamic animators of the sky space, leading the eye from one side of the canvas to the other in arcs or in diagonal configurations that move deeper into space. Composing your clouds sometimes means eliminating conflicting or confusing elements (simplifying the image), exaggerating the sense of wind in the sky (diagonals), and searching for the most interesting positive (cloud) to negative (sky) shapes. Clouds can also imply depth in space. Ask yourself, *Are the clouds over distant mountains or directly above me?*

Bending a photograph of the sky can help reinforce the perspective of the clouds as they move closer to your point of view.

Cloud Formations

Basic cloud formations combine at varying altitudes to create the texture of the complex sky. For instance, high clouds (25,000 feet and above) take the form of cirrus (horsetail clouds), cirrocumulus (mackerel sky), and cirrostratus (hazy clouds that form halos when they appear in front of the sun or moon). Middle clouds (from 15,000 to 20,000 feet) are called altocumulus (fluffy cotton clouds appearing in rows or ragged patches) and altostratus (blurred sheets of clouds as in a bright hazy day). In contrast, low clouds hover near the ground level as fog, rain, or fair-weather clouds. From 5,000 to 10,000 feet, you find nimbostratus, (snow or rain clouds) and stratocumulus clouds, a formation of rolled, rounded shapes. The most dramatic cloud form is cumulonimbus, a vertical tower of clouds from low to high altitudes that may be topped with an "anvil head," caused by radical changes in pressure or temperature.

Cloud Carpet

Unfortunately, today's cameras are designed to make every area of a photograph appear equally sharp and clear, making it more difficult for painters to interpret clouds in a complex sky. Notice in the photograph at right, how even the distant clouds over the hills appear equally in focus as the ones at the top that are closer to you. It also doesn't help that restless eyes are capable of quickly moving focus from one place to another, zooming in and out from near to far in an instant, causing you to keep the entire world in focus. One of our jobs as artists is to interpret the visual world through the language of paint. When you're looking at the sky in a photograph, allow yourself to stop and decide how close or far away the clouds you see are from your point of view.

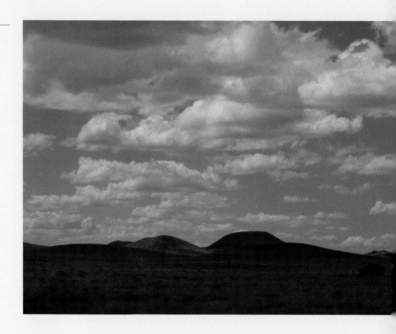

DEPICTING THE ILLUSION OF DEPTH

Atmospheric (aerial) perspective is the effect of the atmosphere to diminish detail and contrast in color/value on objects viewed at a distance. Particles in the atmosphere tend to blur objects seen in the distance, compared to how the viewer perceives elements in the foreground. It is used most often for depicting the ground plane (see chapter 3). For example, when you look across a valley, the foreground grasses are crisp and full of detail, while distant mountains are violet-gray and lack contrast or details. What about the clouds in the sky?

The effect of atmospheric (aerial) perspective is also used when depicting the cloudscape. Let's look at the banks of cumulus clouds in the photograph above. The clouds over the far hills are still far away, so they should be treated with the same degree of detail you intend to paint the background hillsides. The clouds that are closer have more contrast, sharper edges, and are painted with more textural paint.

You can also employ *organic perspective*—using such techniques as varying line widths, shading, and cross contours—to convey form and distance. For instance, the use of overlapping gives an intuitive sense of space—just as one thing in front of another implies depth. Without overlapping, two clouds painted with the same degree of detail will seem to float at the same distance in space. You can also imply depth by changing the scale of similar types of clouds. Smaller clouds belong

OPPOSITE:

HEATHER COMEAU CROMWELL, *CLOUDY SCENE*, 2013, GRAPHITE ON PAPER, 9 X 6 INCHES (22.9 X 15.2 CM).

Study sketches of clouds over the landscape like this one are a means to practice overlapping a complex carpet of clouds.

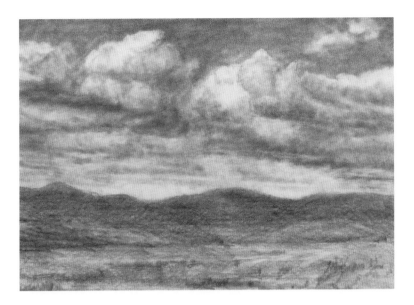

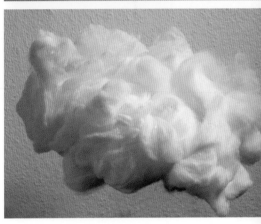

in the background and larger clouds belong nearer and higher up on the canvas. The visible texture of paint contributes to the illusion of nearness and farness. Thick paint is layered over thinner paint: thicker paint comes forward and "pops" outward, compared to paint that is smoothly blended. And lastly, cloud banks that retreat in a diagonal path move deeper into space compared to a horizontal stripe that simply moves from side to side across the canvas.

DRAWING CLOUDS

Drawing cloud forms can seem difficult when you are limited to a simple black-and-white interpretation. Compare that to the separation that happens naturally when the sky is blue and the clouds range from white to gray. Since we tend to think of the sky as being a darker value than the clouds, it can help to begin with a gray tone of graphite dust, rubbing it onto the paper surface and erasing it to form the cloud shapes. With this approach, the clouds' tone matches the white paper. For complex cloud forms like cumulus clusters, beginning on a white paper ground allows for the gradual build up of light to dark values, with sky value added afterward as in *Cloudy Scene* (above). You may also find that using a white pastel pencil and gray or black charcoal on pale blue paper is a better method for practicing the variety of cloud shapes and patterns. In this way, the cloud forms are built up by the application of white, then softened with black. By practicing drawing clouds, you'll get a better feeling for how to shade the light and dark transitions in these translucent forms. If you can do it in pencil, you can do it in paint!

Clouds at the same height in the sky usually group into clusters, drifts, or banks that congregate in patterns. Like flying carpets, these groupings are tilted planes, so the bottom edge is the part that is farthest away. The hardest part of drawing clouds is resisting the temptation to make clouds line up in a horizontal band while making them all appear the same size.

You can visualize something vaporous like cumulus clouds as a solid form like a loaf of bread floating in space. In the top image, a curvy-top loaf is lit from above so that the shadow patterns are clearly defined. Notice how each puff has a bright and shadow side, even while the whole loaf is altogether brighter on one side than the other. Seen from below (center), look for the dark edge that signals the bottom plane. In the bottom image, a puff cloud of cotton balls shows this same lighting dynamic on a soft-edged form.

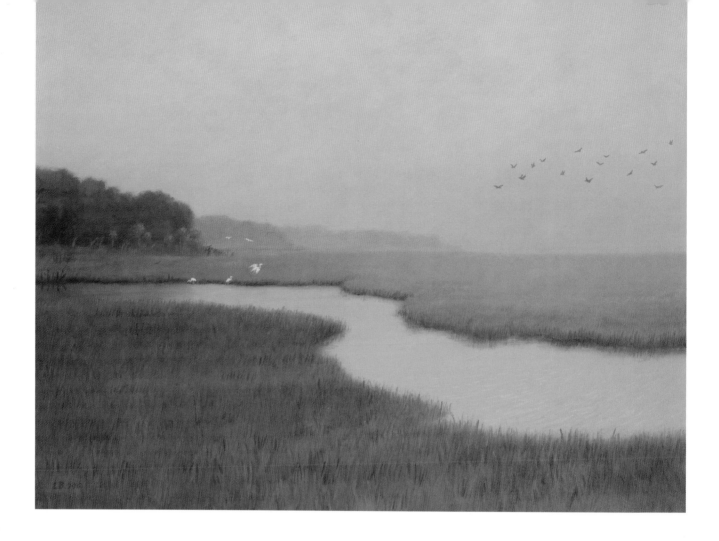

TONED GROUNDS

Although the white of a gesso ground will illuminate the blue of the sky, nothing makes the sky brighter or more colorful than painting a blue-sky color over an orange-toned ground. Complementary contrast makes even a dull blue appear more intense, especially when the toned ground and the sky-blue are close in value. On the other hand, simultaneous contrast is provoked by the use of a neutral middle-value gray paint mixture thinly applied (scumbled) over an orange-toned surface. The resulting blue color you see is created optically as your eyes try to neutralize the intensity of the orange, causing the gray to appear blue.

When pigment mixtures are applied in a thin manner, optical color effects enrich a painting by creating greater depth and luminosity. Painting thin-to-thick changes the appearance of a paint mixture. Thinly applied pigment is influenced by what lies underneath, and a thicker application of pigment reveals its true color note. Adding linseed oil to a paint mixture increases its transparency, allowing what was previously painted to affect the appearance of the new color.

For intense contrast, you can use an orangey ground that you apply with matte acrylic paints or thinned oil paints (see page 25). Some pigment choices to consider include cadmium orange, mixtures of yellow plus red, or other intense

LOUISE BRITTON,
PINK SKY MEMORY,
2012, OIL ON CANVAS,
16 X 20 INCHES (40.6 X 50.8 CM).
COURTESY OF FOUNTAINHEAD
GALLERY.

The artist used scumbled (where paint is thinly rubbed over the canvas) layers of paint and glazes to capture the sensation of a unique time and place embedded in her visual memory. The sky conveys a sense of luminous light that washes the scene in a pink glow. Notice how unnecessary details have been subdued, replaced by abstract shapes of color.

pigments, such as Sennelier's oriental orange—a transparent, high-staining pigment. For a soft, muted ground tone, mix a portion of orange acrylic and gesso, and apply it as an opaque tint.

For sunset skies, a yellow toned ground can re-create the intensity of light when the lowering sun is seen between the clouds. This ground can vary from cadmium yellow to a soft buttery Naples yellow, depending on the dramatic contrast needed. A violet gray (ivory black plus ultramarine violet) can reinforce the coolness of a winter sky while a toasty burnt umber ground can darken gray clouds to imitate a stormy day.

PALETTES

From noon in Tucson to a foggy morning in London, which blue would you choose? There is not a perfect sky-blue color that comes out of a tube that can match the lifting light of a spring morning. Instead, you have to find ways to adjust pigments to realize the nuances seen in nature.

WARM AND COOL BLUE

Successful color mixing begins with an understanding of the physical properties of a pigment: Is it opaque or transparent? Does it have a high- or low-tinting strength? A pigment—such as phthalo blue—can be transparent but still have a high-tinting strength. One way to judge this quality is by adding a portion of white to a pigment: Does it disappear? Then it's transparent and low tinting. Does it barely change value? Then it's opaque or high tinting. The second set of characteristics to consider is the pigment's inherent value (light or dark), its intensity (bright or dull), and its temperature (warm or cool). For instance, cerulean blue is midvalue, dull, warm, and semiopaque.

When mixing color, color temperature is one of the hardest concepts to understand. Generally, you can say blue is a cool color, just as yellow is a warm color. However, generalities are not helpful when dealing with pigments. Instead, consider that every pigment has a bias or tendency toward warmth or coolness.

You would think that all blue pigments are cool colors. But like any other primary, even yellow, there are both warm and cool variations. Determining warmth or coolness in a pigment is easier when you compare two or more similar colors. For example, look at the comparison chart on the right that shows two drastically different blue pigments tested side by side: phthalo turquoise is a warm blue compared to the French ultramarine blue. How do I know which is which? A warmer

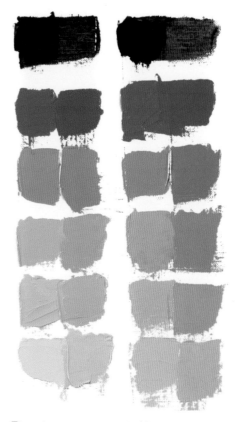

The inherent temperature bias of two blues, phthalo turquoise and French ultramarine blue, are compared side by side. (In each column, the tint is on the left and the tone is on the right side.) Turquoise is a warm blue with its tendency toward teal green, while the secret red in the ultramarine leans it toward violet.

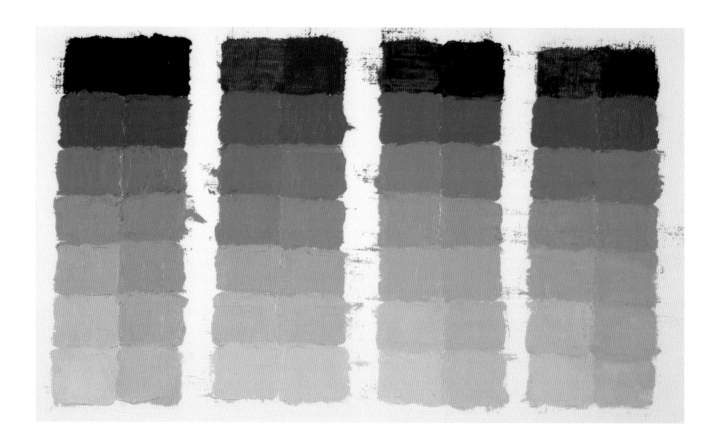

color will always have a greater portion of yellow, so I ask myself, *Which looks more lemon-y?* For blue pigments, I look for a turquoise-to-green bias. If there is a secret red in the blue pigment, it appears more purple, just like French ultramarine blue.

You can also expand the sensation of blueness by considering it a harmony of analogous color. From green-blue to violet-blue, a connecting thread of blue weaves together color harmony rather than color contrast. You will notice more of the individual color notes by keeping the values similar. In the color chart on page 51, an assortment of various blue pigments is compared against similar values. Notice how the addition of viridian green generates a cool green-blue, while a dot of ultramarine violet in the color mixtures bends the color note toward violet.

Across the top of each column, the palette knife first scrapes a thin layer of pure pigment and then a thick layer is used to reveal transparency or opacity in the paint. From left to right, indigo (Old Holland), cobalt (Rembrandt), Sennelier blue (Sennelier), and ultramarine blue (Williamsburg) are used to compare tints and tones. The left side of each column is the tint and the right side shows a tone, using ivory black to mute the color note.

BLUES: TINT, TONE, AND SHADE

You can change the character of any blue with the addition of white, gray, or black pigments (creating a tint, tone, or shade of that color, respectively). Looking over at the color chart [on the opposite page], notice that four different pigments are tested beginning with 100 percent of the hue across the top of each.

To test a pigment's opacity, first apply the pigment by scraping it gently with a palette knife (this is known as a "draw-down") over the canvas paper to test its transparency and then apply a thicker block of paint. The more you can see the white paper through the pigment, the more transparent it is. Thick paint shows the overtone of the color and its inherent value, while the thin layer reveals the color's undertone or bias in temperature toward warmth/coolness.

Within the squares of each hue, the left row shows pure tints (hue plus increasing amounts of white) while tones of the blue (tints plus midvalue gray) are on the right side. Notice how the gray (ivory black and mixing white) not only darkens the color slightly but also dulls it. The pure tint of a blue is sometimes too bright and chromatic, which will make the sky pop out in an unrealistic manner. Each of these blue pigments looks very similar straight from the tube. It's only when you "crack" open the color note by adding white that you can perceive each blue's distinct character. By comparing the blue pigments, you'll get a better feeling for which blue suggests an early-morning sky versus one to use for a sunny afternoon.

ADJUSTING WHITE

When white pigments are used in the greatest proportion to mix the pale blue tints of the sky, choosing which white pigment to use and how to adjust its viscosity is important. Novice painters tend to think of whites as all the same, but a closer study of this pigment reveals that there are four types to choose from: flake white, cremintz, titanium, and zinc.

Flake white and cremintz are lead-based paints, appearing semiopaque to opaque. Their unique quality of not absorbing a hue's intensity or color note even when mixed to a high tint made them valuable to the Old Masters. Today flake white is rare because its production was halted due to health and material costs. (For a limited time, cremintz still remains available on the market.) Read the paint's label carefully: Is it really flake white or is it a flake white *hue*, and hence a blend of titanium and zinc? Titanium is an opaque, nonlead white (think of the appearance of ground up clam shells) with a tendency to dull and make colors chalky. Zinc, on the other hand, is transparent and tends to be milled to an oily consistency that makes it a natural partner with titanium, which is often stiff or chunky, dry in texture. Mixing one-third part titanium to two-thirds parts zinc

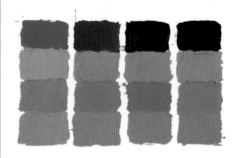

Four different pigments (top row, across): turquoise blue (Rembrandt), cobalt blue (Old Holland), Sennelier blue (Sennelier) and indigo (Old Holland). In the second row, these colors are mixed with white to a midvalue tint. Then ultramarine blue (Williamsburg) is mixed into the same tints in the third row to create a violet tendency, while in the bottom row, viridian (Sennelier) has been added to the tints to make a slightly greener color note.

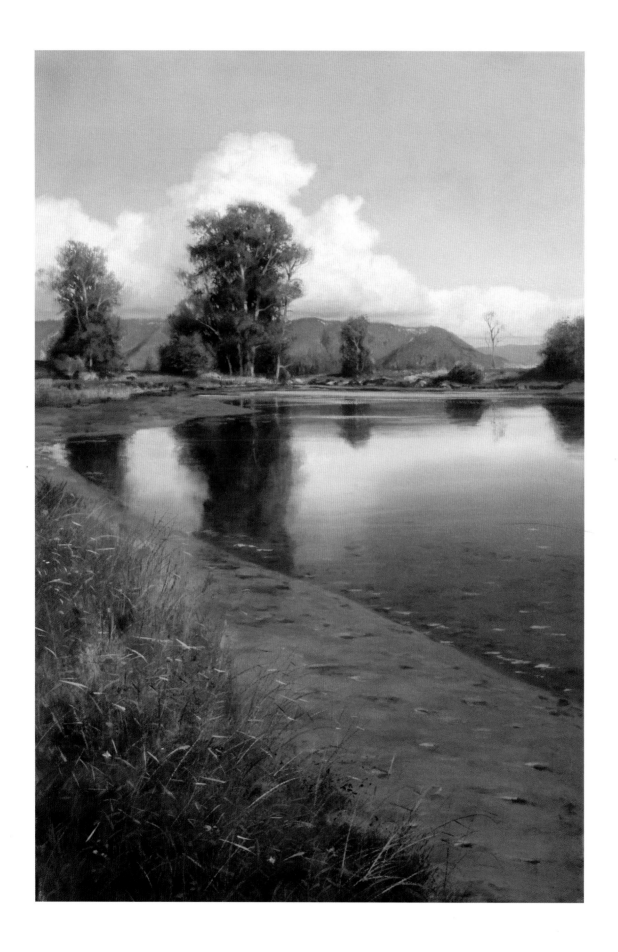

THE ELEMENTS OF LANDSCAPE OIL PAINTING

Adding linseed oil to a pigment changes its viscosity (texture), transparency, and flow over a surface. Here, a mixing white of titanium and zinc white (Winsor & Newton flake white hue) is adjusted with varying amounts of linseed oil. On the far left, pigment from the tube is stiff and tight, and in the second lump a dot of oil is blended into the white for a thick but creamier texture. In the third mixture, the increased proportion of oil to pigment ratio results in a softer, blendable mixture. In the fourth mixture, the amount of increased oil results in greater transparency, but also a loss of texture.

is one way to get a mixing white that is a close approximation of the semitransparent appearance of flake white. For instance, Winsor & Newton's flake white hue is a ready-made, semitransparent mixing white that uses proportions of zinc and titanium.

White pigments are milled with several different kinds of oils—from safflower to poppy to walnut. Each kind of oil contributes a slightly different quality—such as less yellowing, quicker drying, creamy texture, or blendability. It's good to remember that faster-drying whites belong at the beginning of a painting, while fat, oily whites that are slower drying (especially if thickly painted) belong at the finish of a work. Testing between brands is the most reliable way to arrive at your own preferences for brands. Manufacturers, such as Blockx, Permalba, and Natural Pigments, offer the artist a range of white pigments with moderate drying times, nonyellowing oils, and creamy consistencies.

When I squeeze some white pigment onto my palette surface, I first check to see if it is shiny, indicating a good amount of oil in the paint. If my paint looks dry or matte, then I know I need to add a drop or two of linseed oil to gain a smoother, creamier consistency. I mix the white pigments and oil together thoroughly with a palette knife and then move the knife through the paint, testing to see if there is any resistance. If I have to tug or push the palette knife, then the white needs another drop of oil. The knife should easily glide through the paint with enough body to create swirls and peaks like cake icing. Remember to add the oil slowly, one drop at a time. If you add too much oil, it's likely your paint mixture will be "soupy," and will melt into a flat puddle.

OPPOSITE:

RENATO MUCCILLO,
THE RECEDING POOL,
2012, OIL ON CANVAS,
24 X 16 INCHES (61 X 40.6 CM).

Here the golden russet colors of the trees and vegetation are set off by the rich harmony of blues in the sky and water reflections. Notice the curving arc of the shoreline as it draws the eye back into the distance.

BRUSH TECHNIQUES

In a landscape, the blue of the sky is always the element that appears farther away (in the illusion of three-dimensional space) than any other part of the composition. Since clouds are the textured, positive elements, and the sky itself is seamless with no texture, applying the sky-blue paint in a smooth fashion aids in creating this illusion. Two important brush techniques for painting the blue of the sky are *scumbling* and blending. A *flicker stroke* is a technique used for directing the light reflecting off the painted surface to create an atmospheric effect in the sky. Other brushstrokes such as the *trailing stroke*, *C-curving stroke*, and *horsetail* are used to describe the volume and animation of cloud forms.

For scumbling rub the brush tip into the canvas texture at a high angle.

SCUMBLING

Scumbling is a vigorous rubbing action in which the tip of the brush is held at a high angle from the canvas surface. Scumbling introduces paint into the texture of the canvas, leaving a thin layer onto which you can apply more paint easily. Often a well-worn brush is perfect for this task as the friction of rubbing will abrade the soft bristles of a new brush. Notice that if you simply glide your brush at a low angle over the deep texture of the canvas, the resulting color is peppered with small white spots that appear as square "chicklets." You can avoid this problem by angling the tip of the brush into the texture of the canvas and checking to see if your paint mixture is too stiff or too tight. Remember to adjust your mixing white before mixing tints of blue.

Scumble from the center and then sweep the brush outward for soft edges.

BLENDING

Blending is more a brush action than a visible brushstroke. It is used to make a surface feel continuous without hard or abrupt edges. You achieve this by feathering with a soft-tipped filbert between two areas of different paint values so that they appear as one smooth transition. It is the skill of applying only so much pressure on the tip of the brush to move just the right amount of paint in the best direction. (Remember that a blending brush is only another tool and not the solution for the required patience and skill needed to paint a beautiful sky.)

Without the right approach, you might be tempted to blend between two color values by simply pushing and pulling the paint with your brush. Creating subtle transitions between values often fails when you only agitate the brush back and forth between two colors mixtures, leading to a loss of distinction in color and value. A better strategy is to premix the bigger changes in temperature and value

into a few color mixtures on your palette, and then create more discreet transitional mixtures with the brush on the palette before applying them to the canvas. In this way, you only have to tease the two edges of slightly different values together with brush tip.

FLICKER STROKE

Brush marks that are too evident make the sky appear as a "something" rather than the ether of air. When thick paint is applied all in one direction like you are buttering bread, it flattens the sky into a blue wall. Paint that's applied in a consistent horizontal or vertical direction also creates a flattening effect even though the value changes. This is because the reflective surface of a painting is generated by light bouncing off the painted brushstrokes, so strokes all going in the same direction reflect the same light. By pulling short brushstrokes into a starburst pattern as shown in the image at right, light striking the canvas bounces and reflects in a scintillating fashion. This flickering surface is subtle when applied over a thin scumble of pigment and more apparent when a thicker paint is employed. The key is keeping the brush marks short and their direction random.

TRAILING STROKE

You can create fast-moving stratus clouds with creamy paint (mixing white adjusted with a dot of linseed oil) and pulling it in one long stroke. First, the brush must be sufficiently charged with a nugget of paint on its tip, and the angle of the brush must remain low to the canvas surface using the hand-over-brush technique. Dragging or gliding the brush across the surface and rocking the brush tip from side to side leaves a scattered brush mark. This is one way to increase the random effect of dots of thick paint and thin vaporous clouds. Think of trying to stretch the paint as far as possible, even as the brush lifts in a rounded or arched direction. The spontaneous, free-flowing quality of the drawn brush line conveys the idea of the winds blowing the clouds across the sky. This method of gliding the brush across the surface works well for both a plein air, wet paint approach and a layered approach where the clouds are painted over a completely dry blue sky.

Blend between values with the brush tip.

Use a flicker stroke pattern after paint has been scumbled over the surface.

Trailing brushstrokes are kept at a low angle and dragged across the surface.

C-CURVING STROKE

You can enhance the painting of puffy cumulus clouds with brushstrokes pulled in a curving stroke. As the brush handle rests on your middle finger, use your thumb to roll the brush, creating a rounded mark without excessive pressure on the soft brush tip. Keep the brush tip loaded with paint to place the stroke, and then use the empty brush to further blend and soften edges where needed.

HORSETAIL

High cirrus clouds of late spring and summer harken fair weather with their long wispy trails. Using an oil mixing white and the tip of the brush, long strokes are pulled outward in a curving fashion so that the brush first deposits a denser layer of paint that transitions to a transparent mark. Once the cloud pattern has been established, further overbrushing with a dry empty brush can feather out painted tips of the clouds.

DEMONSTRATION PAINTINGS

You can practice the brush techniques for rendering simple to complex skies with small study paintings. These paintings can help you discover how the particular blueness of a sky works with the kind of cloudscape you want to depict, and each study builds your repertoire.

CLOUD CROSSING

The most common sky you'll paint is the blue, daylight, "happy" sky, where the sun contributes to the sky's brightness and determines the overall contrast of the landscape (strong sunlight means strong shadow contrasts). For plein air painters, this sky can be achieved through a simple mixture of a high midvalue blue (think baby blue) used to block in the sky; however, for a large-format studio painting in which the sky takes up one-third or more of the composition, four or more value steps may be needed.

Start by creating a color mixture for the darkest value of the sky (color A) and one for the palest, warmest area near the horizon (color B). Be sure to make a quantity of color mixtures for at least two transitional colors by mixing different proportions of the light and dark mixtures together: two parts of color A + one part B; next, one part color A + two parts color B. Photos of the palettes on page 61 show how lumps of color mixtures are used to mix transitional values. The

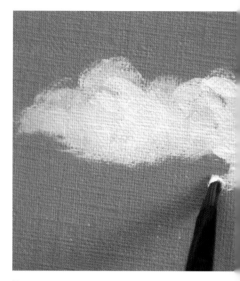

Build the volume of cumulus clouds with a curling stroke.

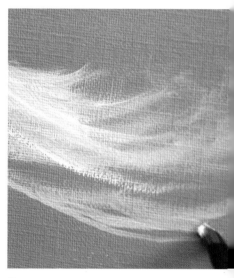

For the horsetail, pull the brush in long curving strokes that go from thick to thin paint.

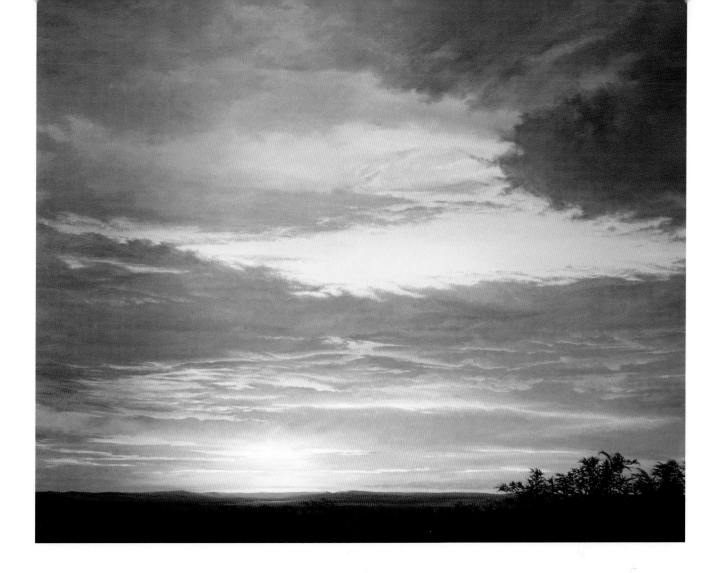

more sky that's visible in the painting and the greater depth implied (as in a sky over mountains), the more variations in color mixtures needed.

At the top of the daylight sky, scumble the darkest paint mixture (color A) across the entire horizontal length of the canvas, leaving a ragged bottom edge. Depending on the scale of the painting, this band of blue might be as small as one-half to one inch wide. Scumbling has now moistened the canvas surface, so you can apply additional paint and then "smooth" it by changing the direction of the brushstrokes (see "Flicker Stroke" on page 57).

Once that step is completed, make the second color mixture by combining some of color A with a few dabs of the next lighter mixture with your brush so that it's slightly lighter than the first paint applied. It's important that the darkest part of the sky begin to change value quickly so that it doesn't appear as a dark band across the top of your canvas. (Notice how I've placed this new transition mixture in a separate place on my palette on page 61.) Again, begin in a horizontal manner across the canvas below the first band (but leaving no space between the old and new paint), and continue in the same fashion as before. To blend between the two bands, pull the brush upward with a short trailing stroke with light pressure into the wet paint above, but resist pulling the brush down. Pulling

VICTORIA ADAMS,
AFRICAN LIGHT, 2011,
OIL ON LINEN, 69 X 79 INCHES
(175.3 X 200.7 CM).
PHOTOGRAPHY BY
CHARLES BACKUS.

A dramatic sunset infused with the play of warm and cool color notes. Notice how the red within the violet and orange mixtures links together, creating the subtle blended transitions between the warmer and cooler color notes.

the brush downward will bring the darker paint into the lighter paint, causing you to lose the subtle change in value. For the third row, add more of the lighter color into your brush-mixed blue puddle as shown in palette photos. Continue working in this fashion until you are only using the palest value at the bottom of the sky.

Here are some things to keep in mind as you work on your blue sky: As additional layers of blue are applied, stand back and see if your sky appears flat (that is, with too large an area of the same value) or if it seems like striped blue ribbons (not enough blending between layers of paint). If your paint gets too thickly applied, the texture will suggest it is "something" besides the ether of air. The more you leave big nuggets of orange peeping through the blue, the less natural the sky appears. Paint the sky lower than you think you need, leaving yourself flexibility to change the horizon line.

Resist adding solvent to your paint mixture to make it spread more easily. Instead, remember to adjust the oil in your mixing white. Often the sky will take two sessions to paint. In the first painting session, you establish the transitions from dark to light, cool to warm, blending as you go. And in the second pass, you smooth any rough transitions that become more apparent as the first layer dries. To avoid turning your clouds a pale blue, wait until the surface dries completely before painting them. On a dry blue sky, you'll be able to easily remove and adjust your cloud formations.

SUZANNE BROOKER,
CLOUD CROSSING, 2013,
OIL ON CANVAS PANEL,
10 X 20 INCHES
(25.4 X 50.8 CM).

Flares of high cirrus clouds are brushed in over the dried blue sky with oily paint and feather strokes. This allows the clouds to keep their edges soft and animated. The lower cumulus clouds are worked in with blended C-curving strokes, creating their puffy forms with layers of more opaque paint. Waiting for each layer to dry allows changes to the clouds without spoiling a perfect blue sky!

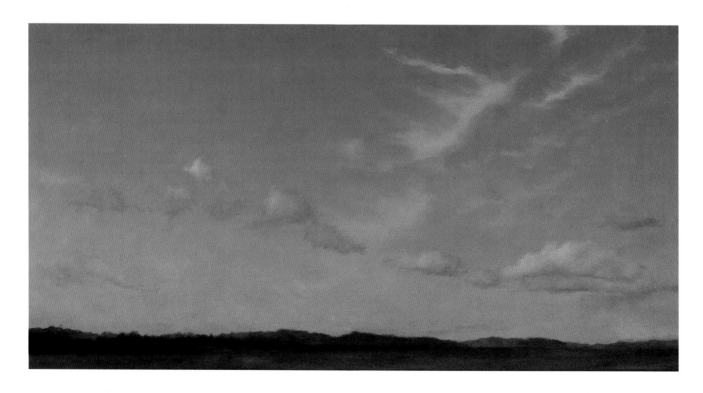

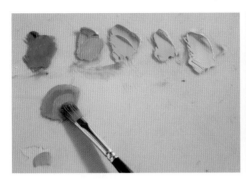

Lighten darker blue value with a midvalue blue.

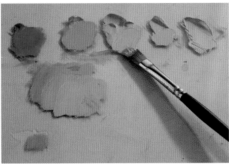

Lighten midvalue blue with paler tint mixture of blue.

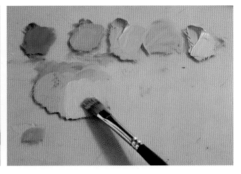

Transition to lightest value near horizon.

Top of the sky

Middle of the sky

Bottom of the sky

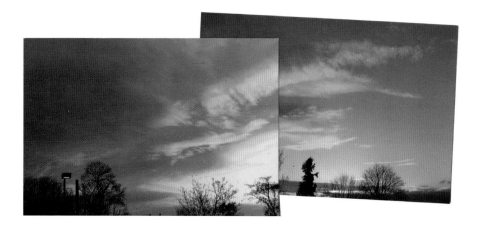

SLANTING SUNSET SKY

It's hard to resist the dramatic color of a sunset sky—its dance of colors delights the eye, even as the colors swirl and fade away with advancing night. On afternoons in late winter, I run out to the parking lot just in time to catch the flickering saffron and sherbet colors before they've disappeared. In contrast, the sky itself is turquoise on one side and royal blue on the other.

To achieve the boldest color note, I start with an intense cadmium orange (Old Holland) pigment for the toned ground to represent the brightest illumination in the painting while also stimulating strong optical color effects. Once this oil stain has dried completely, I block in the sky, using a combination of ultramarine blue (Williamsburg), phthalo turquoise (Rembrandt), and manganese blue (Old Holland)—a harmony of blues that flutter from cool to warm. Instead of painting straight across (as in a midday sky) from dark to light, I block in the sky values in an arc so that the brightest, warmest area of the sky is located on the bottom right corner.

During the second session, I apply another layer to the sky, smoothing the transition from dark to light. After this layer of paint dries, I prepare some variations of an orangey mixture for blocking in the cloud pattern. Varying proportions of rose madder (Winsor & Newton), transparent red ocher, and a dot of ultramarine blue create a violet-to-rosy color mixture. Designing the shape and direction of the cloud pattern begins with a transparent orange applied with feather strokes to keep the edges soft. Next, I apply an oily, thin scumble of violet-blue for the diaphanous clouds that lift upward across the upper left part of the sky. At this stage, I want the value of blue behind the clouds to affect the color note, so I avoid painting too thickly or opaquely.

Each successive layer brightens and builds up the color note, as the paint layers become denser on the bottom right sides of the cloud forms. The key is allowing each paint layer to "rest" between painting sessions. This approach lets me judge how the color or value might change as the paint dries. I look for ragged edges that need further blending or isolated shapes of blue that pop forward. The final affect of luminous color derives from the multiple layers of transparent paint.

ABOVE:
A dramatic sunset is visually compelling with its intense complementary and temperature contrasts.

OPPOSITE BOTTOM:
SUZANNE BROOKER, *SLANTING SUNSET II,* 2013, OIL ON CANVAS PANEL, 10 X 20 INCHES (25.4 X 50.8 CM).

At a low sunset angle, the sky changes value and temperature in a curving arc rather than from top to bottom, as in a daylight sky. The amount of color intensity also changes relative to the angle at which the sun touches the cloud bellies.

Establish the low angle of the sun in a curving arc.

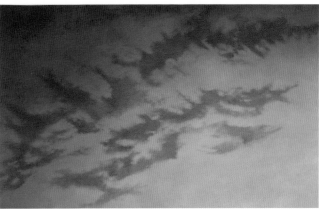

Block in the pattern of cloud shapes over dry sky blues.

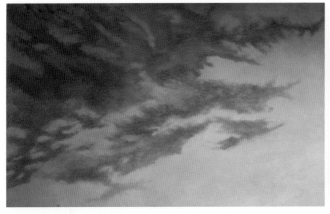

Create lifting dark clouds with oily mixtures of dark violet.

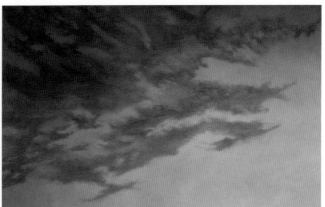

Build up color note with multiple layers of orange.

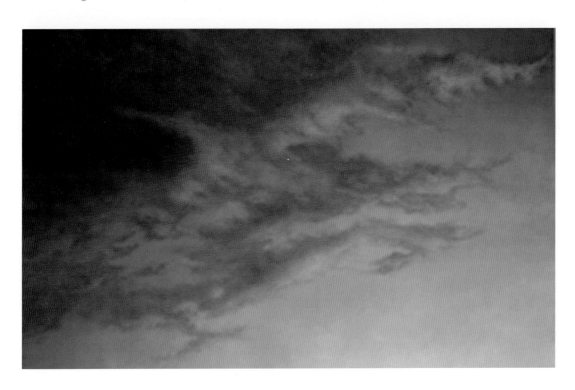

BLUE EYE

On the first nice day in early spring, massive cumulus clouds appear overhead like giant pillows. As the clouds shift and expand, an opening in the clouds reveals an incredibly rich sapphire blue that reminds me of the purity of cobalt blue. For this study, I select a canvas board, one prepared with multiple coats of water-thinned gesso and then lightly sanded. The thinned gesso sinks into the deep texture of the canvas without leaving brush marks that could appear later and disrupt the puffy illusion of the clouds.

I begin with cobalt blue and add a small portion of mixing white resulting in a lighter value that reveals the color note of the blue without washing it out. Since I'm looking at a small arc of the sky, I don't need to create many changes in value or color temperature as I would if it were a larger portion of the sky. I cover the entire canvas with blue pigment using flicker brushstrokes and allow it to dry completely. This is all done before I begin the cloud forms.

Next, I modify my mixing white of titanium and zinc so that it's creamier and oilier than usual, making it easier to apply in a semitransparent manner. My goal is to allow the blue to show through the white pigment, mimicking the shadows of the clouds, especially at their vaporous edges. I scumble this layer using C-curving strokes with my brush tip. Notice how the clouds in the first step seem bluish, although no blue has been added to my white paint. I keep working directly on the wet paint surface, building the density of the paint until it appears brighter.

The bunching quality of cumulus clouds is difficult to paint unless I do some editing to simplify their complexity. The idea of simplifying is to perceive the underlying structure without getting caught up in the details. The photograph is my aid to keeping the pattern irregular and naturalistic, since I know how easy it is for the forms to become too similar in size and shape. I look for the larger masses of clouds, grouping together smaller areas, and locating landmarks by noticing the light edges against the shadowed areas.

I apply a pale gray to reinforce the shadow areas and the vaporous clouds suspended from the top that represent the clouds hanging overhead. I return to the lower clouds, slowly building up the density of white and looking for places of overlapping. Within a cloud cluster, I carefully blend the values with a soft-tip filbert, using a C-curving brushstroke over the clouds.

In the final stages, an oily dark gray increases the contrast of the shadow side of the clouds, improving the dimensional volume of the clouds. For the final touch, I paint the broken streak of white clouds diagonally across the open field of blue. I pull an irregular line (trailing stroke) with a nugget of white paint on the brush tip.

OPPOSITE BOTTOM RIGHT:
SUZANNE BROOKER, *BLUE EYE*, 2013, OIL ON CANVAS PANEL, 11 X 14 INCHES (27.9 X 35.6 CM).

Delicate layers of semitransparent white are applied over a completely blue ground and then blended with pale grays to add dimension to the emerging cloud forms.

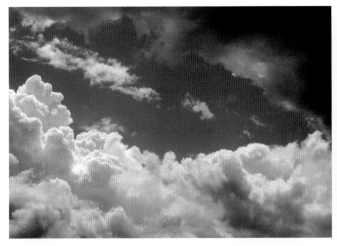

An opening between cumulus clouds creates an eye-shaped piece of blue sky.

Over the dried blue ground, block in cloud formations using thinly applied paint.

Increase density of white pigment to build up brighter white cloud forms.

Blend darker values in clouds to create greater forms.

Adjust values to increase overlapping between clouds.

EASTERN SUNSET

Looking out my east-facing studio windows, I can often observe the cloud layers at the end of the day, bunching up as they hit the mountain range beyond. The sun is low in the opposite side of the sky, so only the clouds are touched with color while the sky is a darkening royal blue. A complex sky like this one is always a test of patience, it requires building up the cloud layers without losing sight of the painting as a whole image.

Here I choose a linen-wrapped panel toned with a neutral midvalue gray using oil pigments in an opaque fashion rather than a stain of color. For the first layer, I focus on establishing the dark to light values of the sky mixed from indigo to Sennelier blue. I paint the lower cloud bank directly on the gray ground, using pale tints of cadmium orange and gray to shape and design its form. I indicate the higher cirrus clouds with mixing white applied directly onto the wet blue surface, giving the clouds soft vaporous edges. It's important at this stage to design clouds carefully, since I won't be able to match the sky-blue colors exactly if I need to repair this blue sky.

Once the first layer dries, I continue to build up the high cirrus clouds, still keeping their edges soft and wispy. The upper clouds carry the sense of motion with a tilting diagonal direction and begin to establish the overlapping that develops with the darker gray clouds in the mid-sky. The lower cloud bank also receives an additional layer of color that molds it to the direction of the sun.

I wait patiently for all of my previous work to dry before adding the next layer of clouds, giving the paint time to cure and bond to the canvas surface. The literal layering of the paint supports the illusion I want to create—that of deep space. When I return a few days later, I review the blending between values and the softness of the edges. The lower cloud bank seems too dark, and I brighten it with an oily zinc white, while finishing the bottom edge. Once again, I let this dry before painting the gray clouds, so I can simply wipe them off if their shapes become awkward or clumsy.

Moving back to the top of the canvas, the near clouds start to take form. From my photographic source image, I extract the cloud shapes that feel most interesting and irregular. I incorporate them as I design the positive and negative spaces. When I step back to review the overall effect, my goal is to have the dark clouds appear animated. The finishing step is oiling up the entire painting once the clouds are completely dry. This protects the delicate paint layers and also restores any areas of dark pigment that have sunk into the canvas.

OPPOSITE BOTTOM RIGHT:
SUZANNE BROOKER,
EASTERN SUNSET,
2011, OIL ON LINEN PANEL,
12 X 16 INCHES
(30.5 X 40.6 CM).

A complex cloudscape is built up from a number of paint layers that enforce the overlapping types of clouds.

Complex, overlapping cloud formations show the dark blue of sky contrasted to the golden color of distant clouds.

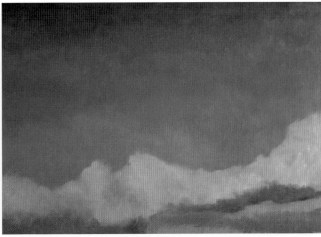

Block in blue sky and lower clouds over a gray ground.

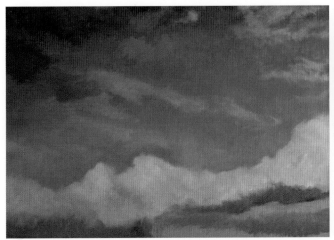

Design upper clouds over the wet blue ground, adding color to lower clouds.

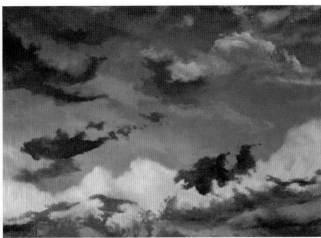

Add closer dark clouds over dry background painting.

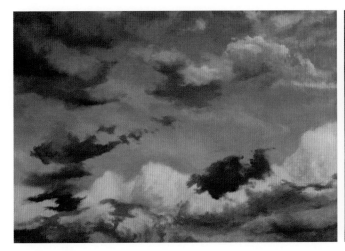

Refine and adjust values overall.

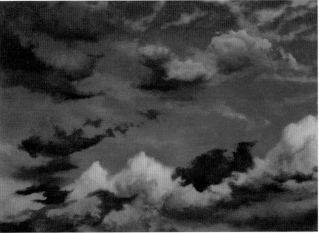

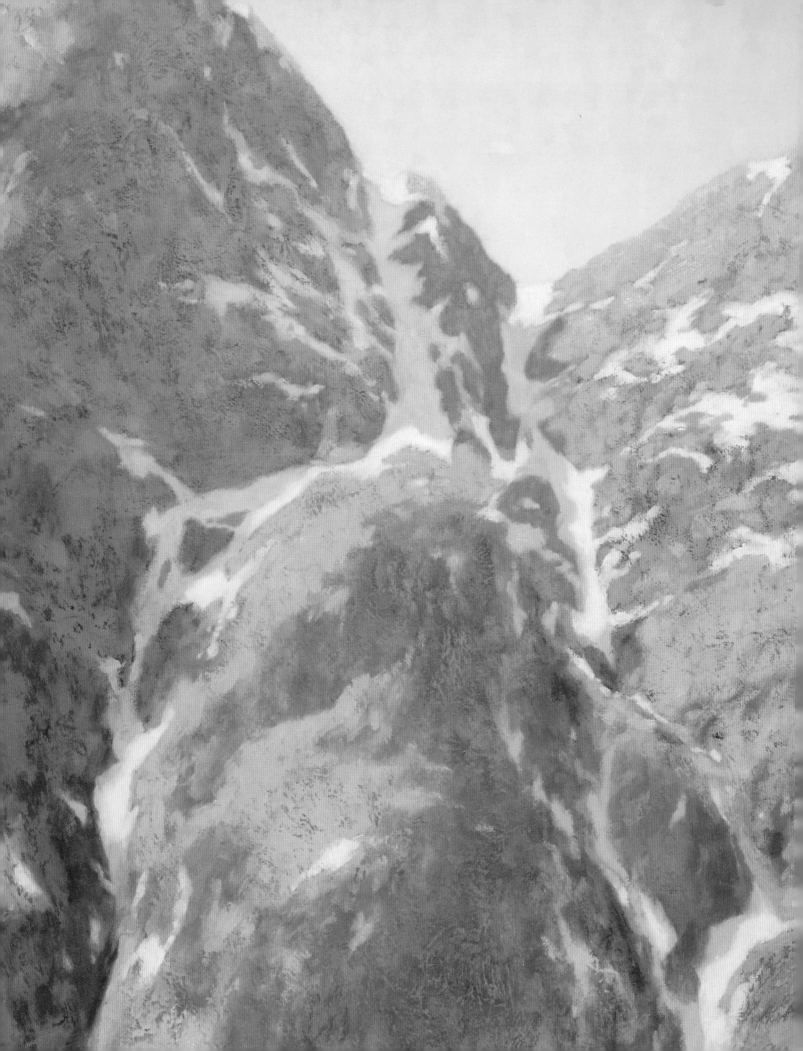

TERRAIN

W hat a simple pleasure it is to walk: whether through the swish of knee-high grasses, the gentle rise and fall of sand dunes, the ascent up the woodland trail, or clambering over the rock-strewn hillsides. Wherever we go, the contours of the ground offer us a connectedness to the solidity of the earth. My best memories of the land come from running full tilt down long grassy slopes like an antelope, racing my sisters to the playground swings, the scent of the bruised greenness on our bare feet.

The terrain in which we live informs our identity—are we flatland people or ones who coexist near mountains? Do we live in river valleys or on hillsides? Landmarks are personal markers of the ground planes of our environment. When you live near a mountain, it becomes your reference point—you always know which way is south.

The earth's evolution is seen in the raw ingredients revealed by the soil: igneous volcanic basalt, sedimentary sandstone layers of quartz, and conglomerate formations where clast fragments of feldspar are glued together in a matrix of sand via heat and pressure.

ABOVE:

NADIA HAKKI,
UMPTANUM RIDGE I, 2008,
OIL ON PANEL,
17½ X 30 INCHES
(44.4 X 76.2 CM).

OPPOSITE:

MITCHELL ALBALA, *SNOW RIVERS IN HALF LIGHT*, 2010, OIL ON PANEL, 18 X 15 INCHES (45.7 X 38.1 CM).

The suggestion of depth in this painting is supported by varying degrees of paint texture, ranging from highly textured to transparent. The thickest paint is reserved for the texture of the rock, especially at the bottom where it is closest to the viewer. The snow is opaque and has less texture than the rock, while the sky is painted thinly and transparently to help set it back in the composition.

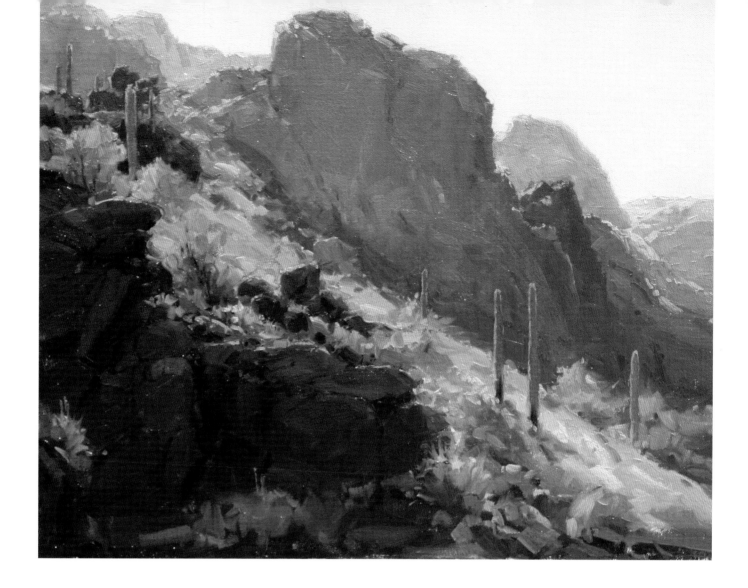

The earth's history is also marked by dramatic events, such as earthquakes and volcanic eruptions, that are contrasted to the slow sculpting of erosion over millennia. The results of both leave formations like crags, gorges, mesas, canyons, and ravines; the stuff of visual poetry. Land formations also take on symbolic meaning as enduring exhibits of time compared to our brief moments of existence.

The beauty of land continues a visual lineage in art that reappears in new variations again and again. Giotto di Bondone's imaginary rocky outcrops provided a backdrop to the human drama depicted in early frescoes, mimicking the formations seen from Persian illuminated manuscripts to inked Chinese scrolls. Giorgione's figures in the landscape began a motif that suggested a longing for a revised Eden, where church spirals in the distance guarantee a safe return to civilization. Pastoral interpretations of the landscape abound with mythic figures and Greek temples, as seen in paintings by Nicolas Poussin. For Camille Pissarro and Jean-François Millet, depicting the honest toil of cultivating fields and harvesting orchards reflected the noble soul bound to the earth. You can look to these and other historical paintings that regard the landscape as not only a source of natural beauty but also of divine order, melding the personal with the universal.

KATE STARLING, *CANYON SLOPE*, 2007, OIL ON LINEN, 16 X 20 INCHES (40.6 X 50.8 CM).

The upthrust of volcanic rock formations resist the power of erosion, leaving towers that dominate the landscape. The artist's bold handling of the paint conveys the directionality of the landforms from vertical to diagonal, to the chunky clusters of boulders.

OBSERVING THE TERRAIN

The ground is *not* perfectly flat. This is difficult to notice when so much of the ground cover—sage, cactus, grass, stones, underbrush, and trees—can obscure the sight of the upward and downward movement of the ground itself. Describing landforms from their steepest projections to their most level conditions can help you identify some common characteristics to look for when painting the land.

HIGHLANDS

Whether it's a solo peak resulting from volcanic activity or a range of mountains created by shifting tectonic plates or the uprising of a fault block, you can think of mountains as the highest evidence of elevated landforms. Highlands can also be the result of erosion—when rivers carve away softer stone leaving behind harder material to become mountains in context with the remaining river valleys.

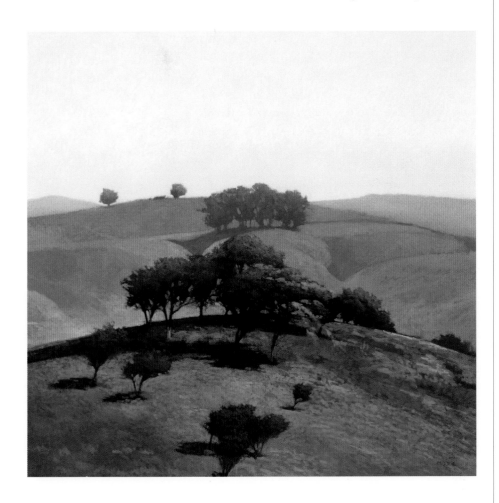

MARC BOHNE, *PALOUSE HILLSIDE*, 1999, OIL ON PANEL, 36 X 36 INCHES (91.4 X 91.4 CM).

The smooth curves of the rolling hillsides are enhanced by the use of atmospheric (aerial) perspective (discussed in detail on page 80), allowing the background hills to recede in the distance in comparison to the sharp contrast of the foreground. Notice how the cast shadows from the trees curve along the contours of the ground plane.

Your point of view contributes to the appearance of the height of any mountain—the lower your point of view, the higher the mountain appears. The jagged, sharp edges of newer volcanic mountains contrast to the contours of older mountainous forms that have softened with time. Think of a mountain as a "cone," wider at the base and narrowing toward the tip, regardless if it's rugged or blunted in its contour-silhouette outline. By first establishing the overall proportions of height to width, you will find it easier to then place distinct ridges or outcroppings. Make sure to consider the transition from the mountain itself to the surrounding foothills (even if they're covered in trees) so that the mountain doesn't seem to float above the middle ground. You can soften the contrast between snow-covered peaks and stark ridges in shadow or cast shadows by lightening the shadow values. Use sharply painted edges as the means to project areas that are closer.

ROLLING HILLS

Foothills act as transition points from mountain peaks to lowlands, providing the most common backdrop for a landscape view. Foothill contours are just as identifiable as their mountain cousins and contribute to a sense of location. The overlapping of several hills creates an opportunity for an artist to create depth in a painting through atmospheric (aerial) perspective, described in detail on page 80.

You can compare curving contours of hillsides to waves of water that flow in slowly mounding swells. The more you observe the rise and fall of these hills—through cast shadows on the ground or the pattern of ground cover, the more you can re-create their contours as high-altitude scrublands or rolling grasslands.

Notice that when the sloping ground rises upward toward the sun, the ground appears brighter. When it tilts away from the light, it dims in value. By placing brushstrokes along the cross contours, the resulting marks help the viewer see how steep or gentle the slope of the ground plane is. Establishing the ground plane first and then painting in the ground cover and singular trees will make more sense because now these elements will be anchored to landforms.

CANYONS AND CLIFFS

The dramatic transition from rocky bluffs or cliffs to canyon and bottomlands presents a unique challenge to the artist for rendering the correct point of view. When standing in the canyon, your view is outward, creating a simple diminishment of the receding ground planes. Overlapping is the key here. But when your view is upward, then what is closer to your point of view—such objects as tumbled

KATE STARLING, *ROCK CREEK VALLEY*, 2010, OIL ON LINEN, 20 X 24 INCHES (50.8 X 61 CM).

Strong light challenges the artist to control the cool darks against the warm lights while maintaining the effects of atmospheric (aerial) perspective. Notice how the shadow values change from the foreground to background, compared to the contrast of darks next to places of bright light.

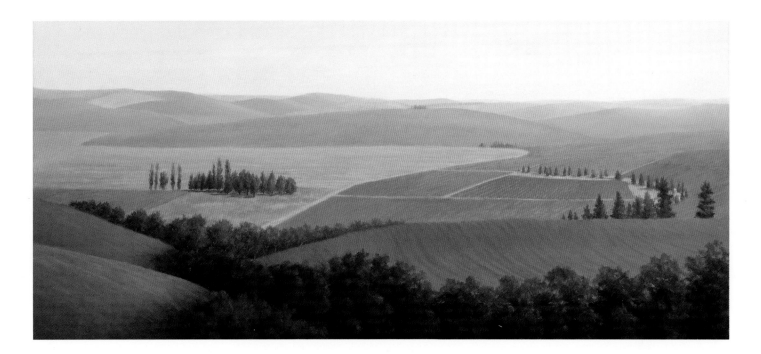

boulders on the canyon floor—are sharper in detail and value contrast than the upper edges of the canyon walls. Atmospheric (aerial) perspective is useful for rendering the sense of distance.

Looking downward from a higher elevation is the most difficult point of view to paint. Usually a platform is established in the lower part of the painting, indicating where the viewer is positioned. The receding ground plane then needs to be well-planned, with the painter using both overlapping planes and atmospheric (aerial) perspective to create a greater depth in space. These guidelines are also useful for painting rocky cliffs at the waterside.

LOWLANDS

Subtle ground changes are best noted in the early stages of your block-in drawing. Using a neutral pigment mixture plus linseed oil and solvent, you can draw thin, transparent lines that establish the changing contours of the ground. Study the positioning of the sun: planes titling up to the sun have brighter values than those turned away.

Valleys seen from a high vantage point provide an opening into the distance where curves on the ground can be observed. Focal points dot the landscape—a grouping of trees, a cluster of boulders, a wandering stream, and so on. Cultivated farmlands evoke a sense of peace and order, harnessing the fertility of the ground via the rhythm of plowed rows that lead the eye across the ground plane. On the other hand, marshlands combine surface water with sporadic bursts of vegetation—such as cattails and hummocks of long grasses—that reveal the wandering watercourse.

CHRISTINE GEDYE, *VALLEY IDYLL*, 2013, OIL ON MOUNTED LINEN, 16 X 36 INCHES (40.6 X 91.4 CM).

A soft palette of harmonious greens and blues creates a sense of calm and order in the cultivated fields.

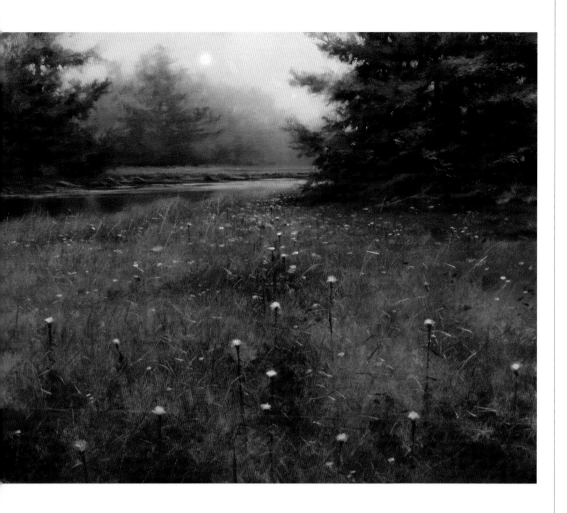

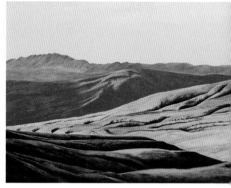

FLATLANDS

Without an elevated view (eye level), the distances observed over a flat ground plane are deceptive. The foreground merges quickly into the far background, collapsing the middle ground into a horizontal band. This is especially true for flat desert lands where the clarity of the air also contributes to making distant forms feel closer than they really are. Without distinct landmarks, flat sandy beaches or tidal areas can also present this same problem.

Photographs taken at a low eye level also tend to deceive, making the foreground as equally in focus as the far distance. This is where you must impose a choice in creating a focal distance, such as detailing the foreground foliage and blurring the distant mountains or abstracting the foreground to bring the middle ground into focus.

DRAWING CONCEPTS

Usually it's the objects on the ground that have visual interest rather than the ground itself; even grass is more interesting than dirt. However, understanding the dynamics of the ground plane is essential for creating the illusion of depth in a painting. Not only is it important to distinguish between the fore-, mid-, and background as affected by atmospheric (aerial) perspective, but it's also important to observe the curving, tilting, or upright nature of the ground itself.

The positioning of the sun influences which planes will be lighter in value (those facing upward or tilting toward the sun) compared to those facing away from the light (which are darker in value, more neutral or cooler in color). When the ground is cut with sharp changes in direction, illustrated in the first image below, then the pattern of light and shadowed areas is clear. But when irregular folds in the ground plane occur, these confuse the overall organization in a blur of detail as shown in the second image below. The key is to look for the orientation of the biggest mass tilted toward the light, and then include as many smaller details as needed.

The changes in value are even more subtle when the ground curves gently, creating a blended transition from light to dark. Compare the sharp contrasts of value changes from the folded-fan illustrations to the curving surface of a cone shown in the third image below. Note the interaction between the brightest light, the core shadow (the transition from light to shadow), and the reflected light. When rolling cone shapes are linked together as shown in the illustration of folded cloth, look for the rhythm of contrasting edges where the shapes overlap.

Simple models as shown in these illustrations are useful tools that you can easily create yourself with bent paper, molded cloth, or a pile of stones from the garden. By clearly lighting your model with a strong light source from a high slanting angle, you can mimic the sun's position. Study drawings will build your skills for observing the play of light and shadow directly, and can be employed toward your painting experience. Once studied, the logic of light and shadow patterns can be more easily applied to diffused or flat lighting, as often occurs on cloudy days.

In the first image below, a piece of paper is folded to represent sharp changes in direction on the ground, facing up or tilting away from the light. Notice the values are clearly separated compared to the same fan in the next image, now crunched into a more complicated surface pattern.

Next a gently curving surface like a sloping hillside is first imitated by a paper cone, where the soft transitions from light to dark are clearly seen. A cloth draped like the sides of a mountain illustrates this same dynamic in a more complex form.

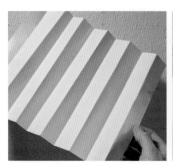
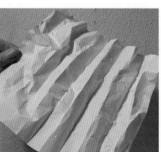

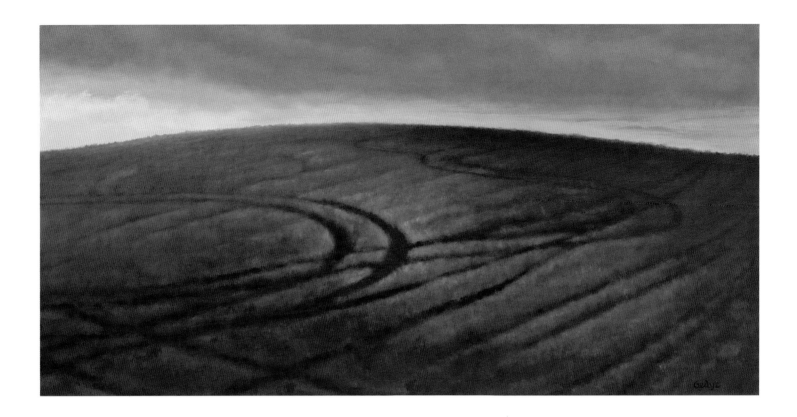

CROSS CONTOUR

You can map out the landscape using contour lines—not the contour lines used to define the outside, silhouette edges of an object, but those used for the *surface* of a form. To keep the purpose of these lines clear, let's refer to them as "a-cross contour" lines when they run over the surfaces of the ground plane. Look at the drawing opposite and observe a-cross contour lines in action.

During the initial block-in of a drawing, some a-cross contour lines placed in a dotted line can help indicate which way the hillside slants and demonstrate its steep or slowly curving character. Likewise, when the side of a mountain is rugged and has sharp folds, a-cross contour lines are useful for locating which planes angle outward versus those that fold inward. Avoid drawing lines that simply duplicate the outside edges of the silhouette, as they will not increase your understanding of the ground's surface direction.

Using broken dotted or dashed lines keeps the silhouette edges separate from those marking the a-cross contours. Imagine these lines as ants marching up and down the slopes. Are they moving up the slopes toward the light side or tilted away from the sun? Only a few dashed lines are needed to map out surface contours. You'll notice right away if they give you positive information. If not, erase them and try again.

Studying the ground plane may be dull in and of itself, but when you consider that everything—trees, water, stones—is anchored to the ground, then it becomes essential to an understanding of the landscape.

CHRISTINE GEDYE, *TRACKS,*
2010, OIL ON PANEL,
12 X 24 INCHES (30.5 X 61 CM).

Tracks over the ground plane—regardless if caused by machines or animal trails—reveal the undulating nature of the earth's contours. Notice how the artist uses both the accent of light and the linear perspective of the tracks to create the mounding form of the hillside.

SHADING FORMS ON THE GROUND

From rendering boulders to pebbles, shading techniques provide the means for making simple cubic or spherical forms feel dimensional. A volumetric rendering of an object dictates that there be a strong single light source—in a landscape drawing that source is the sun. Drawing techniques for the placement of shadows, relationships between the highlights and reflected lights, and so on have worked together for centuries to create the illusion of form. Although these ideal concepts are difficult to perceive in the complex conditions of nature, they are still the most effective means for conveying volume in space. Once learned, these techniques sharpen your eyes to what you may have missed when first observing the natural world. You learn to combine what you see with what you know (to look for).

Cubic forms have flat sides like a box. Though stones and boulders appear to have irregular, lumpy surfaces, they too have basic guidelines for light and shadow. First, notice how the top plane of a stone upturned to the sun has the lightest value. Its sides tilted along the angle of the light are somewhat at a middle value. And any sides turned away from the sun are dark in shadow. On page 79 you can see a basic cubic form and a stone. Notice how the darkest place is noted where the sharp edge of the lit side meets the shadow side. The place where light and shadow meet is called the "core of the shadow," or the terminating edge between light and dark. This is the darkest value on the object (form shadow) compared to the cast shadow, which is thrown on the ground or on other surrounding objects. Reflected light opens up the shadow side with a slight illumination that never competes with the lit side. Where the form shadow and cast shadow meet—in a double shadow—there is often a dark underlining that adds a sense of weight to the object.

HEATHER COMEAU CROMWELL, *CROSS CONTOUR DRAWING*, 2014, GRAPHITE ON PAPER, 8½ X 11 INCHES (21.6 X 27.9 CM).

A detailed preparation drawing studies the ground contours when the direction of the sun is vague. Mapping out the a-cross contours of the ground planes allows the artist to impose a stronger light direction using the logic of tilting planes.

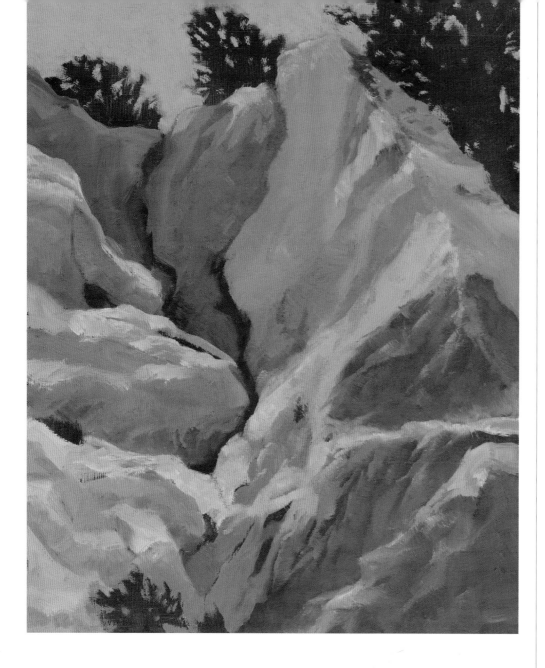

Spherical forms like round pebbles or boulders react to the presence of light
in a slightly different way. Notice how the curving surface of a rounded form has
a subtle transition from light to dark compared to the sharp edges of a cube. (See
opposite.) On a sphere, there is one place that faces the light source at a 90-degree
angle, creating a highlight that is the lightest value on the surface. As the light
glances across the surface of the object, the intensity diminishes, reducing its
value until the surface turns away from the light. Like the cube, this is the place
for the core shadow. Observing a round object in nature, the surrounding light
can fool your eyes and appear to darken the shadow edge. However, making the
shadowed silhouette edge darker than the core shadow is a sure way to flatten a
round form. Reflected light serves to open the shadow values, keeping the shadow
side from appearing flat. Look for the meeting point between the cast and form
shadow as a distinct underlining where the form meets the ground plane.

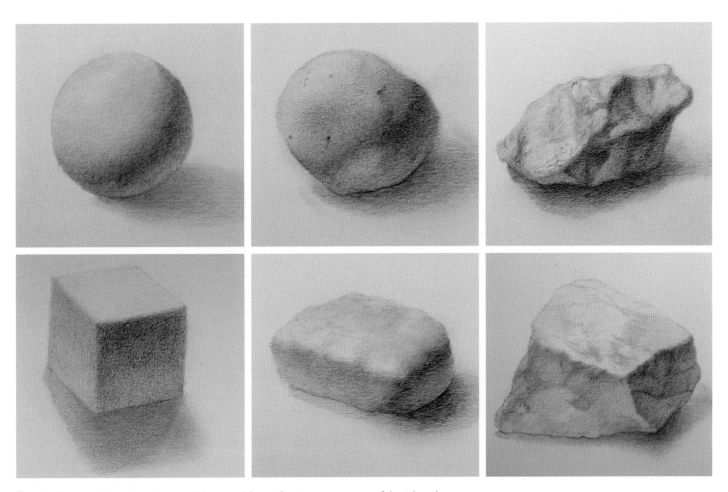

The idealized shading of a sphere and the round form of a stone serve as useful guides when rendering the more complex and irregular forms found in nature.

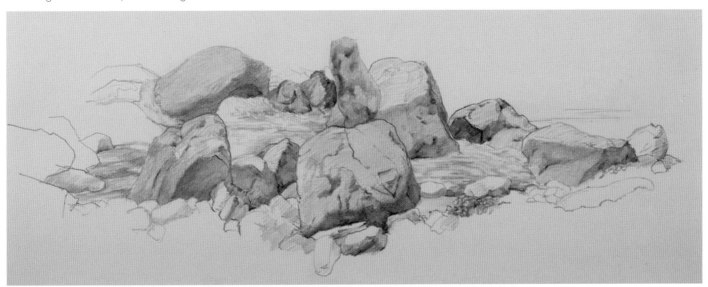

The Illusion of Space

Artists employ two methods for creating the illusion of depth on a two-dimensional surface: linear and atmospheric (aerial) perspective. When combined, they provide a powerful means for depicting space on a flat surface. Consider that viewers utilize their understanding of these techniques (through Western visual traditions) when appreciating paintings. It's your task as an artist to master how to use these methods for your own expressive purposes.

LINEAR PERSPECTIVE

The mathematical system of linear perspective that was developed during the Renaissance by Filippo Brunelleschi helped organize direct visual experience as oriented from a single, fixed (that of the artist) point of view. Looking outward and straight ahead, the artist's eye level became the horizon line. This created a 45-degree cone of vision that limited distortion and allowed for a consistent diminishment in scale as objects receded into space toward a vanishing point located on a horizon line. This is why a viewfinder is helpful for restraining your gaze. It helps you resist the temptation to include things too close to your feet or in your peripheral vision.

The visual tradition of linear perspective also enforces the notion that objects placed in the lower portion of the canvas are closer to us than those placed higher up. To test this idea, imagine your canvas tilted like a table. When you place one pebble at the bottom (nearer you) and another farther away, the sense of distance is directly felt. Now imagine the canvas vertically upright with the pebbles (magically) still in place, one higher than the other. When this is combined with a diminishment of scale, an even greater sense of space is created.

Think of a fence as an element within your painting. If you stood parallel to the front of the fence, the height of the posts would appear equal, just like the spacing between each post. But when you gaze at a slanted angle, the fence recedes at a diagonal. The vertical posts seem to diminish in height and width toward the horizon. The spaces between the posts likewise seem to decrease.

Now if you look at a cubic object like a barn, shed, or large boulder when you stand directly in front, seeing only one side, that object will appear flat as a square or rectangle. But if you view it from a corner, where you see two sides (two-point perspective), then the farthest edges (horizontal roof and ground lines) pinch closer together and will seem to be smaller as they retreat into the distance.

In landscape painting, the general rules of linear perspective are useful for positioning barns, fences, and other human-made objects in a scene. But you can also use them as a guide for establishing objects resting on the ground, like paths and streams. A path on the ground appears wider (closer to you) and begins to narrow in width as it moves farther away into the distance. By angling the course of the path upward in an irregular zigzag line, like a stairway, you lead the viewer into the distant space.

ATMOSPHERIC PERSPECTIVE

Atmospheric perspective (also known as aerial perspective) is another method for generating a sense of space in a painting. It is based on a reduction of value contrast and details as objects recede from the observer, and is caused by the increasing presence of water particles, dust, and pollution (the atmosphere) between the viewer and what is observed. A typical example: when you observe a pine tree in the foreground, you can see individual details in its branching structure, needles, and bark. But looking into the middle distance, the same pine tree is now a simple silhouette shape with no detail to its branches or texture. When the same tree appears on a distant hillside, it is blurred to

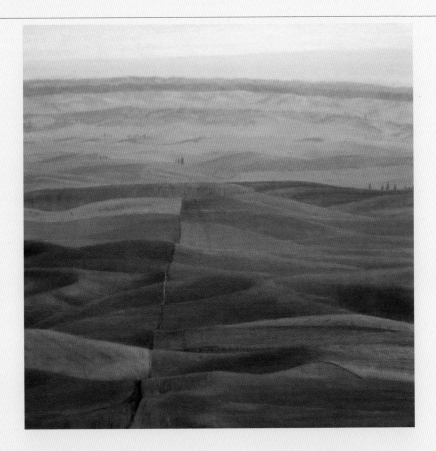

CHRISTINE GEDYE, *FROM STEPTOE BUTTE,*
2012, OIL ON LINEN ON PANEL,
18 X 18 INCHES (45.7 X 45.7 CM).

From a high eye level, the tapestry
of cultivated land reveals the weave of
the ground plane, emphasizing its
abstract quality.

a general mass of green-ness with
no individual detail. Even farther
away, the tree loses its local color
and seems more blue-violet than
green. This example assumes that
the focal plane is in the foreground,
but understanding atmospheric
(aerial) perspective will allow you to
manipulate the positioning of the
focal plane. The following are some
general guidelines for controlling the
focus in your painting.

PROPORTION OF THE CANVAS
Determine at the outset how much
territory each part (fore-, mid-,
background) will be given to the
canvas. When it's a sky painting, the
upper portion of the landscape will
be largest, compared to the meadow
in the foreground.

SHARPER EDGES
It's a trick of vision that makes the
brain assume objects with sharp,
crisp edges come forward (in focus),
while the same object with softer,
blurred edges seems to recede in
space. For instance, if the moun-
tains are a backdrop in your paint-
ing, then making their silhouette
edge sharp against the sky will bring
them forward. This effect also hap-
pens when the value contrast is high
(such as dark mountains against a
bright pale sky). You can use sharp
edges to separate one object from a
group when forms overlap: a single
tree with sharper edges appears
distinct from a general grouping
of trees.

VALUE CONTRAST
Strong value contrast in light and
dark creates a sense of visual detail
and pulls that object forward as a
focal point. In comparison, objects of
similar value appear to be located in
the same distance in space. When a
painting lacks contrast and has too
much of the same value, it tends to
appear flat, emphasizing the flatness
of the canvas surface. Squinting at
your painting as you stand away from
the easel can help you determine
where the value contrast has been
lost or where it appears too strongly.

(continued)

The Illusion of Space (continued)

COLOR CONTRAST

Color contrast creates a focal point of interest by using complementary contrast, like pink flowers on a green tree. By controlling the intensity or dullness of a color, you can also indicate a sense of depth. For instance, when painting a large green meadow, dull the grasses in the background by adding the green's complement (plus a dot of red-orange and white). The grass in the foreground will be a pure, bright green. When color temperature is employed, the warmer color (plus yellow) will advance and the cooler color (plus blue) recedes. Atmospheric (aerial) perspective in color interprets distant objects as grayed or neutral, even as they lighten in value. This is accomplished by the addition of a pale gray into the color mixture, adding white plus violet, or white and a cool blue, such as ultramarine blue.

TEXTURE

Think of texture not only as the illusion of an object's texture (such as bark versus water), but also as the actual texture or surface of your paint. Brushstrokes play an important part in conveying the details of a surface. When the surface of a painting is covered with brush marks of the same shape and in the same direction, the painting assumes a kind of undifferentiated flatness. For example, if the sky is painted with the same chunky brush technique as water in the foreground, the thing farthest away in this painting shares the same quality as the closest. Thick, chunky deposits of paint visibly come forward compared to blended areas that recede.

Greater visual interest is gained when there is a variety in your brush handling—changing the size, shape, and direction of your painted marks. Using the wrong size brush for an entire painting can present problems—for example, a small brush attempting to cover a large area with tiny, overworked marks. The direction of the brushstroke also plays a part in reflecting the character of what you see. Water glides along the horizontal surface, grass grows upright, clouds are fluffy: each of these components in a landscape benefits from the specific direction of a brush mark.

TRANSPARENT OR OPAQUE PAINT APPLICATION

Master painters worked with a limited range of colors on toned grounds, using various densities of paint to create optical color effects. Varying the density of a paint mixture from thick to thinly applied changes its perceived color. On a toned ground, thinly applied paint takes on a transparent quality influenced by the underlying color and value of the ground. A sheer layer of paint recedes in space in contrast to opaque paint, which appears to come forward. Shadows are best painted in a transparent manner using thinned paint (plus oil) or thinly applied (scumbled). At a great distance, shadows in the background appear cooler (cool blue-violet) compared to shadows in the foreground (warmer blue like phthalo). However, overall shadows remain constant, regardless of the local color of the object. So, for instance, trees don't have a different shadow color than boulders. Let's remember that shadows are only colored "air," and once they appear solid and opaque, they can easily become separate objects. Don't be confused by reflected light in the shadows. That can be warm or colorful depending on the source of the reflection. Cast shadows also benefit from appearing transparent. They often become diffuse at their edges because of reflected light.

When a painting is structured from darks to lights, the brightest areas of a painting are the most thickly painted, using opaque pigments. Now the color intensity, paint thickness, and visible paint texture all come together to create a sense of closeness.

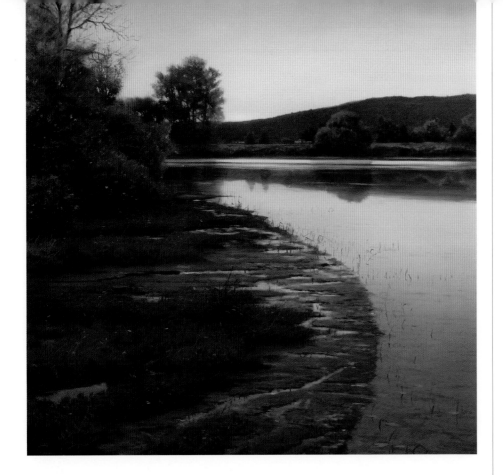

RENATO MUCCILLO,
CONFLUENCE IN JULY, 2013,
OIL ON BIRCH PANEL,
24 X 24 INCHES (61 X 61 CM).

A golden yellow toned ground
infuses the painting with a
warm light; then multiple
layers of paint and glaze
define its details.

ABOVE:
A sampling of four pigments as
the sheer warm colors over an
opaque cool gray toned ground.
From the top left: burnt umber
(Old Holland), raw umber (Old
Holland), bottom row: burnt sienna
(Sennelier), and Mars brown
(Sennelier). On the left side of
each block, the warm stain is
applied more thickly, and on the
right, it's wiped off to a very sheer
layer allowing the gray undertone
to appear.

TONED GROUNDS

One subtle but effective way to begin a painting in which bare rocky ground is the primary element is to use a warm-cool toned ground. Begin by painting the canvas a cool gray that is slightly lighter than midvalue. Ivory black plus mixing white generates a cool, bluish gray. You can also add a dot of ultramarine blue into Mars or lamp black. The presence of white pigments results in an opaque color mixture, which you should apply in an even layer. If acrylic paints are used, make sure not to add too much water. Unlike a sheer transparent tone, the gray needs to be opaque. If oil paints are used, let them dry completely—past "dry to touch." (See page 25 for detailed instructions on preparing toned grounds.)

Once the ground is firmly dry, apply a second sheer layer of oil pigment over the entire surface. Pigment choices might include Mars brown (Sennelier) for a golden color note, transparent burnt sienna (Sennelier) for a rusty orange effect, burnt umber (Old Holland) for a toasty brown, or raw umber (Old Holland) for a greenish cast that suggests lichen or moss. On your palette, thin the pigment with odorless mineral spirits and a bit of linseed oil to reach a loose, oily consistency. Beware of adding too much solvent! For a small panel, you can use a broad flat brush to apply the toned ground, but on a larger surface, a cloth *pounce* (a square of lintless cloth, raw edges drawn together to form a teardrop shape) will be more

effective. First test your color density in the corner: Is it sheer enough? Are you getting the right color effect? Adjust your pigment as needed. The results should suggest the cool gray flickering through the warm color.

There are two approaches for working a double-toned ground. In the first method, you can simply wait for the ground to dry completely. Then you can draw freely on the dry surface with more control, making corrections to the design as you go without disturbing the ground color. This is done best with a pigment (plus oil, not odorless mineral spirits) close in color and value to the toned ground so that any changes wiped away will meld into the surface. The second method involves working directly into the wet ground, wiping out areas where more gray is needed and painting darker areas with additional paint, wet-on-wet. This approach generates a loose underpainting only when the second ground color is wet and movable.

The beauty of a double-toned ground must be anticipated as part of the value and color needed for executing the final painting. As a transparent middle value, the toned ground serves as a transition between the thicker painted lights and the transparent darks. If the entire surface is covered in opaque paint, you've lost the luminous moment in the painting.

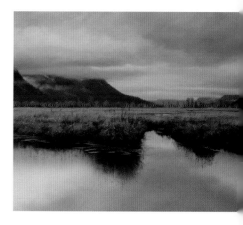

RENATO MUCCILLO, *SANCTUARY*, 2012, OIL ON CANVAS, 36 X 36 INCHES (91.44 X 91.44 CM).

Black pigments can be used to create neutral grays that create the moody lighting of low clouds over the tidal watercourse.

PALETTES

When vegetation on the ground is sparse, the local color of the soil plays a key role in determining whether you see an iron-rich arid soil, fertile farmland, or rocky shoreline.

NEUTRAL GRAYS

Black is more often than not banned from the landscape palette and with good reason. Without a firm control on this pigment's ability to neutralize and darken color, you will find that it runs amuck, making a painting look dull and flabby. But black can be your friend, once you understand how to utilize its potential to create beautiful neutrals that activate your chosen color palette.

Black pigments are generally milled with an increased amount of oil to reduce their tendency to "sink in" after paint has dried. When mixed with a pigment without white, the resulting mixture produces a shade, which gives the black pigment an undertone of colorfulness—for instance, when black is mixed with viridian for a cool, deep green or with alizarin crimson for a deep red color note.

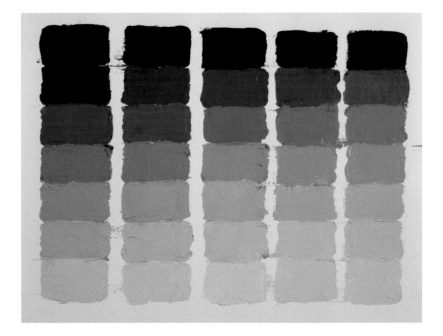

A comparison of black pigments reveals the color bias. On the top of each column, the pure tube color seems identical when the dark value masks its undertone. When increasing amounts of white are added, the character of each black is visible. From the left: Mars black (Old Holland), ivory black (Winsor & Newton), peche de noir (Sennelier), Roman earth black (Williamsburg), and slate black (Williamsburg).

Without a clear understanding of which pigments are opaque or high staining, you should add black to a pigment one pepper crumb at a time (as it can easily swallow up the color note of a transparent, low-staining pigment).

Black pigments are not all the same. Each has a bias toward warmth or coolness. Ivory black mixed with white creates a cool black gray. Lamp black appears slightly violet. Peche de noir (Sennelier) and white produce a slate green–gray. Roman earth black (Williamsburg) is warm and earthy. You can also alter any black pigment mixture with the addition of another pigment. When a gray mixed from ivory black is mixed with yellow ocher, it produces a dull putty-green gray. However, when burnt umber is mixed with ivory-black gray, it tends toward a warmer color note. See the figure on page above for a comparison of black pigments.

Another alternative to black pigments is a chromatic "black," generated when three primary pigments (R+Y+B) are mixed together. A greater visual unity is created when the same primaries are used in other parts of the painting to generate secondary colors. The color temperature, opacity, and relative darkness of a chromatic black are determined by the pigments selected. For example, all cool colors (alizarin crimson, ultramarine blue, yellow ocher) will create a different temperature bias than warm pigments (cadmium red, turquoise blue, hansa yellow). The key is balancing the proportions of each primary pigment. To test their color notes, add a dot of white into a small portion of the mixture to reveal its color bias toward violet, orange, or green. See the color chart on page 87.

A neutral gray (black plus white) mixed to a midvalue has the ability to stimulate optical color effects depending on its context. Gray placed next to an intense orange seems bluish, but the same gray placed next to a bright green takes on a reddish quality. Generally, neutrals in a painting make even not-so-bright color mixtures appear more intense in contrast. A painting filled with only intense color fatigues the eye, as it tries optically to produce gray, a natural tendency in vision. So, as much as we may delight in colorfulness, our eyes enjoy moments of quiet neutrals.

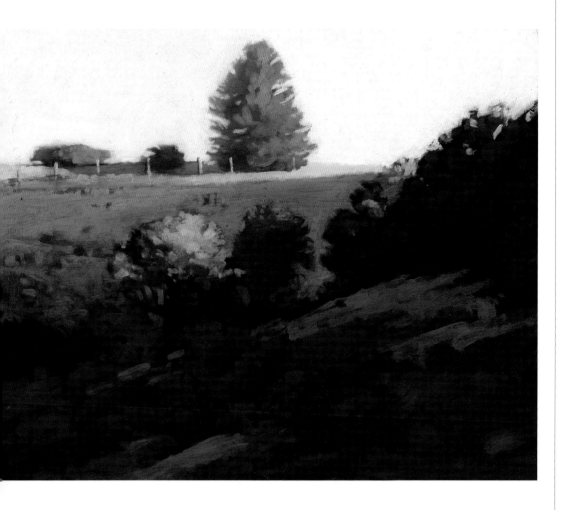

LEFT:

MARC BOHNE, *OUTSIDE
SAN FRANCISCO*, 2004,
OIL ON PANEL, 8 X 10 INCHES
(20.3 X 25.4 CM).

A balance of darks and lights
creates visual interest in this small
painting. Although bright colors
are instantly pleasing, they can
easily overwhelm the eye. It takes
greater skill to keep the dark
values colorful and lively.

ABOVE:
An alternative to using black is
the creation of dark neutrals from
mixtures of red, yellow, and blue.
On the far left, warm primaries
(cadmium red light, turquoise
blue, hansa yellow light) are first
combined as pure tube pigments,
and then below, they are tinted
with white. In the second column,
cadmium red, cobalt blue, and
hansa yellow light are mixed to
dull dark violet. In the third row,
alizarin crimson, cobalt blue,
and yellow ocher make a dark
magenta. The last column shows
a mixture of alizarin crimson,
ultramarine blue, and yellow ocher
to create the coolest, darkest
neutral.

EARTH RED

Earth red pigments refer to a general grouping of colors originally composed of
ground rocks and minerals, but which today are composed synthetically. The color
notes of earth red pigments move from rich bricklike hues to golden, orangey hues
to dark browns. The iron-oxide family includes such pigments as Indian red, Vene-
tian red, and red ocher (which tend to be opaque). The earth reds that have an
orange bias are pigments such as burnt sienna, red umber, or Mars brown (which
are semiopaque). Burnt umber, warm sepia, and van Dyke brown are examples
of the three darkest earth red pigments, and are also semitransparent. For other
specialty pigments, consider Williamsburg's collection of Italian earth pigments,
including terra rosa, Pozzuoli earth, and Pompeii red.

To understand this side of the neutral red palette, test your pigments with color
swatches. It's the best way to determine their potentials. Refer to the color chart on
the next page for discovering the color range of earth red pigments. For instance,
will van Dyke brown be most helpful when painting rocky coastlines, or is red ocher
the best pigment when depicting dry desert lands? Knowing a pigment's capabilities
guarantees you'll choose the best pigment when considering an overall color strategy.

Alternate Palettes of Earth Red

A limited palette of pigments can inspire a painter to become more inventive and move away from literal interpretations. The painter creates an internal logic for the painting where even a lime green sky can seem perfectly natural and credible. The adventure of stepping out of the expected leads to a discovery of more personal color sensibility that can be expressive or subtle.

A plein air, direct approach to painting demands a well-known palette of pigments that is most often based on combinations of R+Y+B. On the other hand, studio painters have the luxury of interpreting their subject according to the chosen toned ground and an alternate palette that can generate a broader expression of mood and atmosphere. A limited palette of secondary pigments—violet, green, and earth red—is one example of stretching an artist's abilities in color mixing from a literal to an expressive interpretation. A secondary pigment palette can be very effective for painting dusk and low-light conditions, or for marshlands or deserts scenes.

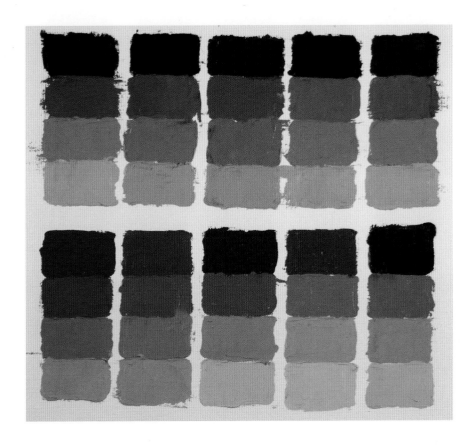

At the left of each row, you see the pure tube pigment, followed by tints with increasing amounts of white. The upper left column (from left to right): burnt umber (Old Holland), van Dyke brown (Rembrandt), Mars brown (Sennelier), warm sepia (Rembrandt), and red umber (Old Holland). The second row (from left to right): red ocher (Williamsburg), Pompeii red (Williamsburg), terra rosa (Williamsburg), pozzuoli earth (Williamsburg), and Italian rose brown pink lake (Old Holland). (A lake is a dye that has been transformed and fixed into a pigment.)

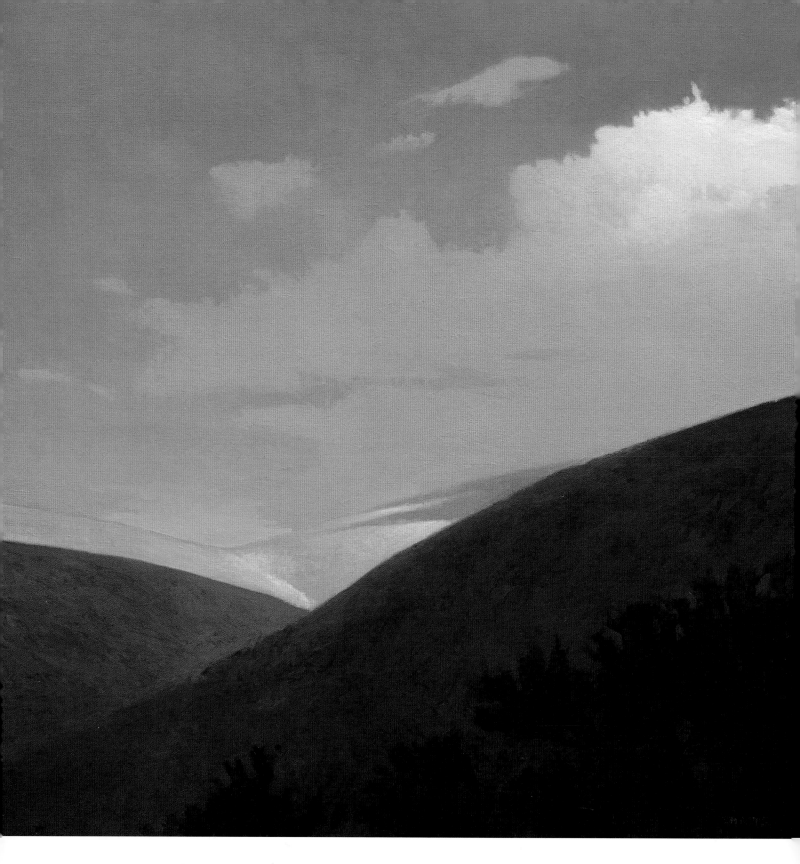

MARC BOHNE, *HILLS NEAR CHICO*, 2003,
OIL ON CANVAS, 36 X 36 INCHES (91.4 X 91.4 CM).

A bold composition of simple shapes plays off its bright colors
in the background against the neutral hills in the foreground.

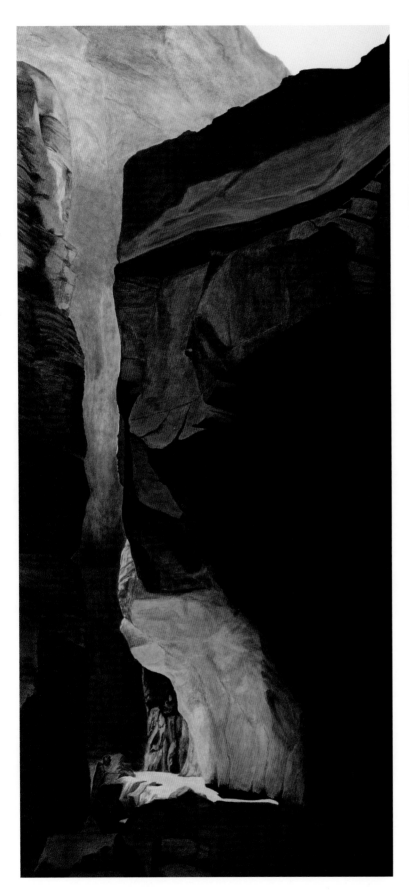

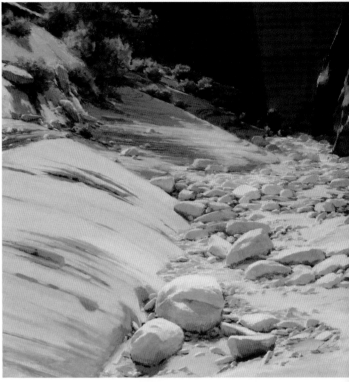

ABOVE:

KATE STARLING, *CLEAR CREEK BOULDERS*, 2010, OIL ON LINEN, 40 X 40 INCHES (101.6 X 101.6 CM).

Pink and coral-colored stones shimmer in the desert light. The path of small stones leads the eye in a zigzag path to the cool shadows of the background. Tints of earth red pigments may seem artificial on the palette, but when joined together in the context of the scene, they appear natural.

LEFT:

NADIA HAKKI, *ECHO SLOT CANYON*, 2008, OIL ON PANEL, 40 X 18½ INCHES (101.6 X 47 CM).

The vertical drama is heightened by a strong contrast between the lights and darks, without sacrificing a rich color palette in the dark values.

BRUSH TECHNIQUES

Conveying the various textures of the ground takes different kinds of brushstrokes—from smoothly blended to chunky, chisel-shaped marks. Experiment with the shape and firmness of your brushes to see how each brush performs when practicing with these brushstrokes.

CHISELED STROKES

Rough stones and cliff-sides benefit from brush marks made with a flat brush. Short strokes that move in a progression can lead the eye over the contours of the ground just as an abrupt change in direction can indicate a square or wedgelike formation. The results of long flat brush marks suggest flatness, especially with the square blunt end of the brush. You can indicate the direction of a rock face by the angle of your brushstrokes.

DRAGGING

Dragging a loaded brush tip at a low angle creates a rough textured deposit of paint that suggests a rough crumbly soil. When you hold the brush hand-over-brush, you can use a rocking motion to further scatter marks in an irregular fashion.

LITTLE C STROKES

You can best approach painting an intensely textured surface like a pebbly beach or small stones by first looking for the overall pattern. Look for places where shadows create a contrasting moment of detail and the random overlapping of their shapes. Placing equal-size dots of paint with equal spacing between the marks will have an instant flattening effect, making it look like pebble wallpaper. Begin at the background and work toward the foreground. That way you can build by over-lapping and increase the scale of the marks as you move along. Using the tip of a small filbert brush leaves curved marks when you draw the brush in tight C strokes. With a strong light direction, shadows appear on one side and somewhat under-neath. This shadow color mixture should be an oily dark that will appear transpar-ent when painted over individual stones. You can correctly place highlights on the opposite side where the rocks face up to the sun.

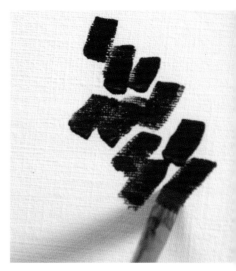

Wedge-shaped chisel strokes

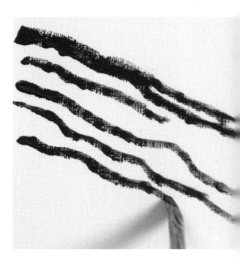

Dragging strokes

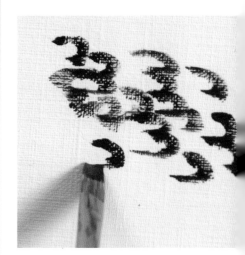

Little C strokes

VERTICAL ZIGZAG

Rendering grass is easy when you use the thin side of a flat brush to move vertically up and down in short strokes. Even long meadow grasses will have short, smaller strokes in the background, while those in the foreground appear longer and larger. When the brush moves horizontally, you can suggest the ground plane at the same time. If the grass extends all the way across the bottom edge of the canvas, try taping a piece of paper there so that your brush marks don't imply the grass grows from the bottom edge of the canvas. You can then use the pointy tip of a round brush to draw in any fine details like the bent leaves on tall grass.

PALETTE KNIFE

For a special effect or accent, you can use the palette knife to place thick paint toward the end of a painting. (The palette knife, however, is not a substitute for good brush technique.) When the palette knife is charged with paint on its side, you can pull a thin line by dragging only the edge of the knife along its side. The tip of the knife can also deliver a chunky pat of paint that can be dragged to suggest rocky shorelines and rough terrain. Scratching through thick paint (*scrafitto*) with the tip of a palette knife reveals the color layer below. You can use scrafitto drawn lines to indicate the texture of small pebbles or thin branches.

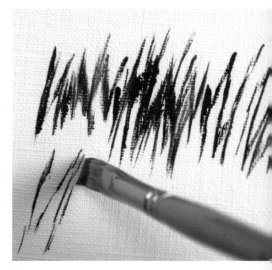
Vertical zigzag strokes

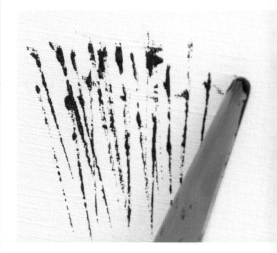
Lines with palette knife

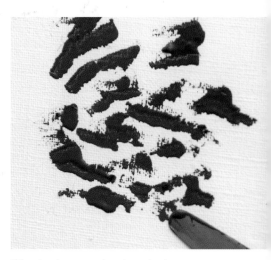
Chunky shapes with palette knife

Subtle to rough textures made with lighter pigment are applied over a darker color.

DEMONSTRATION PAINTINGS

Inspiration for painting the terrain can come from many sources, such as the beauty of a new countryside or the familiarity of a favorite landscape.

CROSSING WINTER MOUNTAINS

At North Ogden Pass in Utah, the wind bites cold and spring is still a long way off, even in April. Under the low-hanging clouds, the afternoon light creates a cool blue on blue over the sloping mountainsides. To paint the coldness of this scene, I planned on trying a dull rose–colored ground of acrylic paint rather than using a gray ground to stimulate the blue/violet palette.

On a horizontal canvas board, my first step is to block in the largest shapes of the mountains from my source image. I mix up three values of a blue-gray (using ultramarine and ivory black applied in a thin scumble) that allow the pinkish ground to optically alter the appearance of the paint. Once the basic proportions are established, I apply additional layers of my blue-gray paint mixtures, including one for blocking in the cloudy sky.

Next, I begin to reinforce the darks of the mountains, looking not just to add the details of the ridgelines, but also to suggest the a-cross contours. I study my source image carefully so that I can understand which slopes curve toward the light and which away, which slopes are angular and which are mounding.

I expand my limited palette to include green umber (perfect for the conifers that dot the hillsides), ultramarine violet, and raw umber. Ultramarine violet mixed into my blue-gray mixtures gives a cold but colorful feeling to the mid and light values. Raw umber mixed with the violet adds to the shadows' values. The slopes in the middle distance begin to emerge with their tree covering. When I paint those slopes, my brushstrokes flow across their contours, but when I paint the trees, my long flat brush makes short, vertical strokes. The trees in the foreground require more attention to render their silhouette edges.

At this stage of the painting, it's a good idea to sit back and study the overall effects: what's working and what needs more attention. I decide to strengthen the cloudy sky with additional blue-grays, while still keeping the pinkish glow near the mountain peaks. I'm not entirely happy with the mountain contours, so I begin to tweak their edges. Meanwhile, I also increase the darks with oily paint from my original color mixtures. By using an oily, semitransparent paint, I don't opaquely cover what was previously painted but enhance its color note or value. Using the tip of a soft filbert brush, the paint glides easily over the surface in a thin layer, so I can fine-tune the amount of detail in any area.

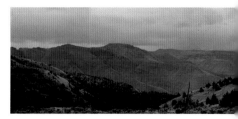

Cold winter light fills the scene with cool color notes.

OPPOSITE BOTTOM:
SUZANNE BROOKER, *CROSSING WINTER MOUNTAINS*, 2013, OIL ON CANVAS BOARD, 10 X 20 INCHES (25.4 X 50.8 CM).

A limited palette of cool colors—blues, black, raw umber, and violet—reinforces the cold winter scene over a dull-pink toned ground.

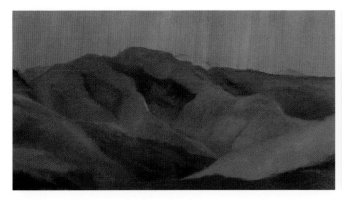

Create an underpainting of mountain forms in ultramarine violet mixtures.

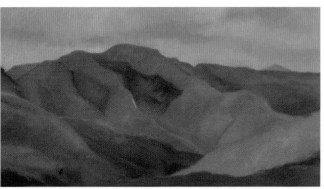

Block in the sky with pale grays.

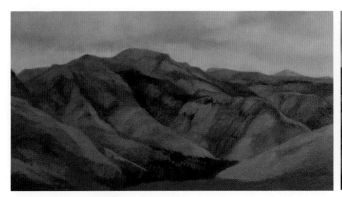

Begin developing midground trees.

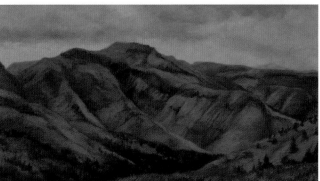

Define mountain slopes and details.

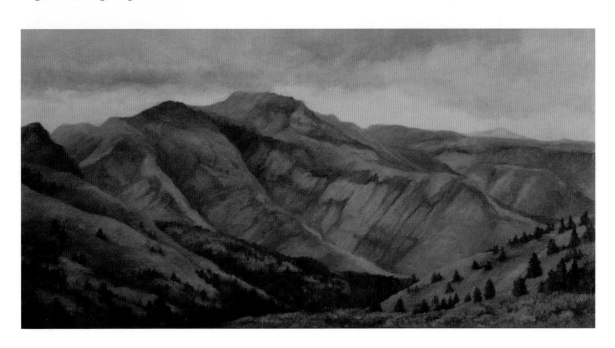

BELLA FIELDS

In summer, I love the scent of the dried grass, the sound of insects, and the quiet presence of the horses on the forty-acre horse farm painted here. Even in winter, the fields are a great place to seek out new views of snow patches, misty trees, and rain-filled gullies with the bent long grasses marking their borders. The coloring of the grasses suggests a double-toned ground as a way to include the coolness of the air and the warmth of the winter grass.

I first apply a cool mid value gray evenly on my canvas. Once the gray tone is dried completely, I use a cloth pounce to put on the second transparent, warm pigment of raw sienna for its cool straw-yellow color note. I draw into the wet paint to block in a rough composition. I continue to add or remove the tone with a large filbert brush, while the paint is wet and movable.

I next consider my palette by looking at my earth brown pigments. I choose warm sepia (Old Holland) and red umber (Old Holland) for their rich dark values; however, each has different tinting qualities: sepia is dull/neutral, while red umber is toasty. To connect the toned ground to the palette, I include raw sienna and ivory black, plus indigo blue for the water channel. For other dark or neutral greens in the long grasses, I mix indigo or ivory black with raw sienna. So in essence, this is a Y+R+B color schema.

To place the transparent dark values, I mix sepia with black to make a colorful shade. I pick out the pattern of the long grass using a large filbert brush for the bottom portion, and then switch to a smaller brush for the distant fields. I leave the toned ground bare in the areas of the lightest yellowy grass. At the top of the painting, I use black and gray values to loosely indicate the beginning edge of the tree line, which takes on an optical blueness over the toned ground.

I continue to develop the upper portion of the painting. I add a small dot of indigo blue into my grays to increase the cool color in the foggy background trees and bushes. This allows me to freely paint in the thin branches of the young alders in the upper field, using the tip of a new filbert brush and an oily dark sepia. It's also a good time for me to work some indigo blue and sepia into the water stream, since the foreground grasses overlap areas of the blue.

Returning to the far grasses along the roadside, I combine new variations of raw sienna, red umber, warm sepia, indigo, and white—from greenish gold to golden brown. The tip of a firm flat nylon brush allows me to scumble a thin layer of new color and continue painting into the wet paint. I drag the brush corner in a ragged drizzle that suggests the far grass texture. I freely mix or soften edges as I go, rarely cleaning my brush (as all my color mixtures are variations of the same pigments).

My next step is to build up the lower left-hand portion by layering in an oily mixture of indigo blue and red umber to reinforce the dark values while building

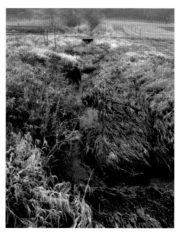

PHOTOGRAPHY BY HEATHER COMEAU CROMWELL. Winter grasses flow along the banks of the watercourse.

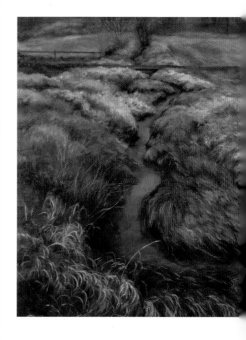

SUZANNE BROOKER, *BELLA FIELDS*, 2013, OIL ON CANVAS, 20 X 12 INCHES (50.8 X 30.5 CM).

A limited palette of warm and cool colors builds on a double toned ground. As a foreground-dominant painting, the overlapping texture of winter grasses and path of the watercourse lead into the foggy background.

Rub raw sienna over cool gray ground in loose thin-thick fashion.

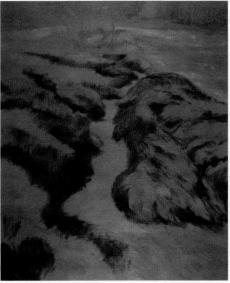

Block in the darks of the underpainting.

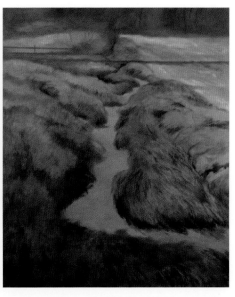

Scumble grays over the dry background and build dark values in foreground.

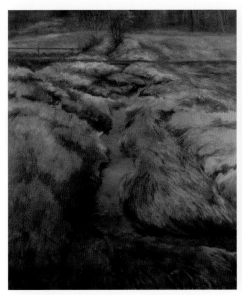

Develop the texture of the grasses in the middle distance.

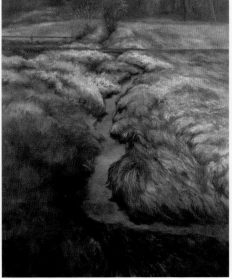

Define the pattern of grasses on the right bank with mid- and light values.

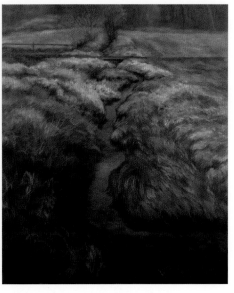

Overlap the grasses on the left bank with greater detail.

up the texture. On the right side, the grass becomes more defined, with a golden mixture of red umber and raw sienna plus white. The key is to see the overall pattern of the grasses rather than the details. Next, I adjust the values in the watercourse and darkening edges for the cast shadows of the overhanging grass.

When I return a few days later, I'm determined to tackle the foreground grasses. I place a few lighter golden strokes for the highlights on the grass with a sharp tip of a new filbert brush, as the finishing details.

COLORADO SCRUBLAND STUDY

At higher than 7,000 feet in the high desert scrublands, where the Ponderosa pines are fragrant in the summer morning heat, we take our trio of dogs out for a romp in the woods. The sun has already baked the tall grass golden, contrasting it to the minty sage greens that dot the hillsides and the pinks in the soil. The tilting ground is deceptive: one minute you're walking uphill, the next you're standing in a dry gully. I had an old canvas toned with fragments of color mixtures—mostly creamy yellows and violets, a mottled toned ground—that I thought would work well for this painting.

I begin the block-in drawing with raw umber, establishing the ground contours and the overlapping hillsides. The block-in underpainting is a mixture of yellow ocher and raw umber laid down in ragged, dragging strokes with a flat brush. I let the mottled ground color show through where its color note is useful. The brighter yellow mixtures emphasize the slope as it's turned upward toward the sun, in comparison to the cooler, pinker areas made of Mars violet and white.

I scumble a layer of umber green and apply it in a thin-to-thick manner to establish the tree line in the background. Once the ground is developed, positioning some of the small bushes dotting the hillside becomes easier. Employing a vertical zigzag stroke with the tip of a small filbert brush, I use an oily mixture of green umber for the long grasses. To maintain a sense of overlapping, I leave those more transparent and blurry compared to the crisper, detailed grasses to come. For the cool green color, I mix some white into green umber. But I add sap green lake extra (Old Holland) to my palette for the brighter greens. Using small dappled brushstrokes as I move from the transparent darks to the lighter values, I am able to add more definition to the bushes.

On the brighter, left side of the hill, I use raw umber (Old Holland) to suggest the distant grasses. Yellow ocher and white create the opaque highlights on the foreground grass. I use a tint of raw umber to draw in the pale tree branches as the final accent.

Golden grass and minty sage dot the hills and gullies of the high desert scrublands.

Establish rolling ground planes with block-in drawing over mottled ground.

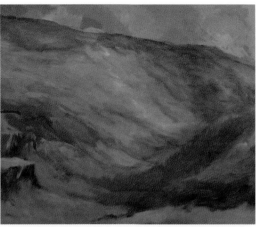

Define ground contours with thinly applied raw umber.

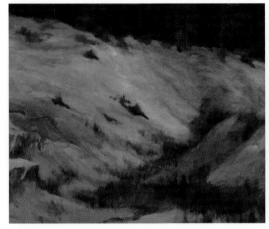

Establish the tree line using green umber.

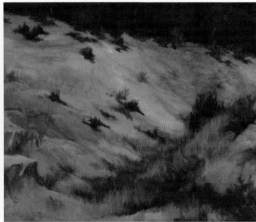

Develop overlapping grass textures.

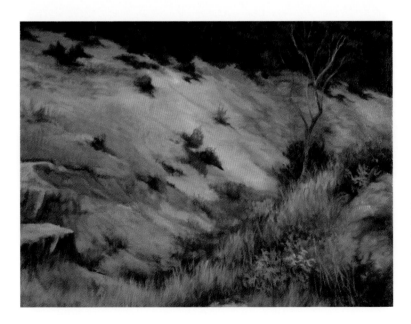

SUZANNE BROOKER, *COLORADO SCRUBLAND STUDY*, 2012, OIL ON CANVAS, 11 X 14 INCHES (27.9 X 35.6 CM).

Wet-on-wet painting techniques on a mottled ground generate unexpected results even when combined with a layered approach to scene development.

ALONG THE DESCHUTES RIVER

There are not many places to stop along this winding river road, so I only have time for a few quick snaps. The hillsides look like giant tilting stairs leading to the roaring river below. This abstract pattern of dark rocky ground against minty green grasslands catches my eye. My impulse is to paint this scene on a long-horizontal canvas. By toning my ground with an acrylic mixture of cadmium orange and burnt sienna, I saw the possibilities in a secondary palette—one using ultramarine violet and viridian plus van Dyke brown and white.

I begin by blocking in the sloping contours of the ground, editing out unnecessary details from my source image. A thinned mixture of ultramarine violet and van Dyke brown proves to be a good transparent dark over the orange ground, and helps me establish the darks of the hillsides. By varying the density of my paint, I change the value so that over the thinly scumbled areas, the orange ground illuminates the color note making it appear brighter. This layer dries completely before I add the next green pigment mixtures.

As a cool green, viridian's tint is hard to control. However, by adding violet or thinly scumbling it over orange, I can make it useful. At first, the complementary contrast of the blueness in the green pigment against the orange ground creates a disarming effect. But once the entire surface is covered, the orange becomes subdued. The sky—a very pale tint of viridian and white—completes the initial block-in underpainting.

Once the underpainting has dried, I go back to the sky and mute the flicks of orange with another thinly painted layer of sky blue using a pale tint of viridian. I suggest clouds by adding white pigment blended directly into the wet blue paint, while keeping all the edges defused. Next, I mix some more of my dark pigment mixture (van Dyke brown and ultramarine violet) to reestablish the dark edges. I first draw and then soften the mixture into a scumbled blur. It's important to keep a feeling of the orange ground alive, so I take care not to paint too opaquely.

Before beginning the process of brightening the greens, I oil up the canvas, since the first layers have sunk in and their true values have dulled. This sheer layer of linseed oil makes my strokes glide over the surface. With three variations of viridian and a short flat brush, I drag long strokes over the ground contours, and then blend their edges.

Sloping bands of light and dark create an abstract pattern.

OPPOSITE BOTTOM:

SUZANNE BROOKER, *ALONG THE DESCHUTES RIVER*, 2013, OIL ON CANVAS PANEL, 10 X 20 INCHES (25.4 X 50.8 CM).

The sloping steps along the riverside provide a motif for an abstract diagonal design. Using green and violet mixtures over the orange ground, I created a secondary color schema that enhanced the moody light.

Block in darks over the toned ground.

Apply an underpainting of scumbled greens and violet thinly.

Block in the sky with a tint of viridian.

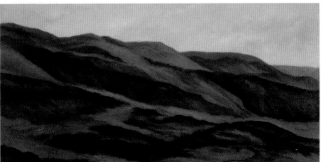

Build midvalues that form ground contours.

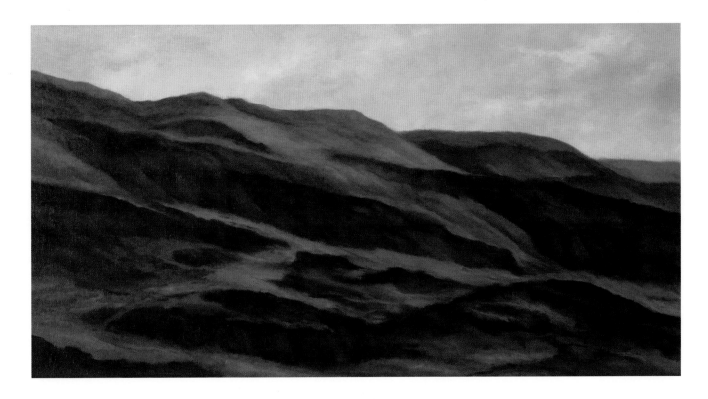

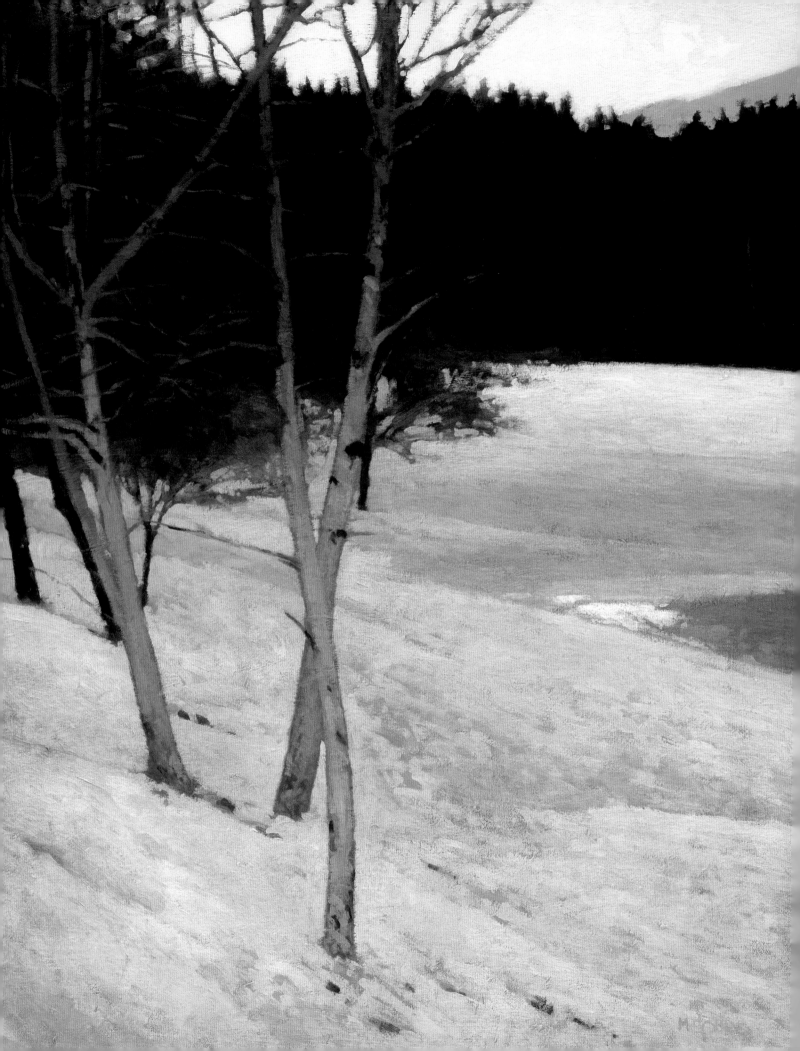

CHAPTER FOUR

TREES

Trees can appear as dancers lifting their arms in a sunlit meadow or as valiant soldiers on a cliff-side standing guard against the sea wind or as whispering cousins set deep in an old growth forest— in essence, they are characters in my paintings. I fell in love with trees when I was a child growing up in the woodlands on the eastern coast of the United States. I built tree forts in their branches, ate their fruit, and brought home their seed pods, pine cones, and flowers as my treasures. And, of course, I drew and painted them.

Trees seem so solid that you'd hardly notice how much they move—bending to the light, shifting balance with the growth or loss of a branch, and swaying in the wind. Trees help us track the seasons—as they parade through each one in grand costumes from vibrant new buds each spring to golden halos in autumn. Planting a tree and watching it grow is one of the sweet pleasures that allows me to witness nature at its best. Observing a tree's growing pattern carries over into my paintings—I paint what I know.

ABOVE:

KIMBERLY CLARK, *LEARY (DETAIL), WINTER–NEW YEAR*, 2012, OIL ON CANVAS, 24 X 24 INCHES (61 X 61 CM).

OPPOSITE:

MARC BOHNE, *WINTER EVENING*, 2002, OIL ON PANEL, 20 X 24 INCHES (50.8 X 61 CM).

The play of warm and cool color temperature is given compositional structure by the design of dark and light shapes.

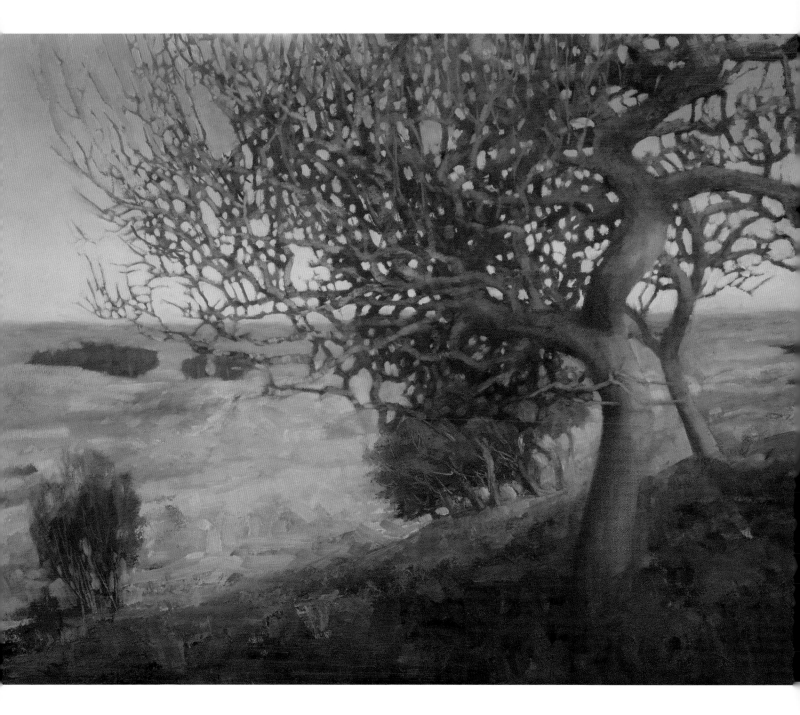

KEN BUSHE, *OLD OAK AT NORMAN'S LAW,*
2012, OIL ON CANVAS, 18 X 24 INCHES (45.7 X 61 CM).

A singular tree symbolizes the strength of age against adversity
and creates a vertical landmark in the landscape.

I love walking in the woods. My eyes awaken to the visual romance around me—the texture of bark, the pattern of branch nodes, and the color of emerging leaves—witnessed in each specific tree. For a painter, nature is more than the sensations of the actual world; it also includes the aesthetic moments that occur as relationships between line, shape, color, and form intersect.

In painterly terms, trees give us a vertical element that aids in establishing scale. Look at landscape painting from the Barbizon School. Notice how the wilds of the rustic woodlands are measured by the scale of trees lining the paths and roadways. Trees painted in the Fontainebleau Forest by such artists as Camille Corot or John Constable convey age and grandeur. A tree can also serve as a bracket or enclosure. In *Mont Saint-Victoire with Large Pine*, Paul Cézanne frames the rectangle with a single pine in the foreground, while the mountain glows in the background.

OBSERVING TREES

When trees and woodlands become a significant part of a landscape painting, artists can't help but want to learn more about how they grow: from seed to sapling to shady giant. In fact, the closer you get, the details of the tree fill your eyes—from the branching structure to the bark's texture to the shape and arrangement of the overhead foliage.

A tree's form is defined by its environment and its neighboring trees. Rarely are the trunks of trees perfectly straight; more often they tilt and bend so that each branch can display as many leaves as possible to the sun. Trees are not always symmetrical in shape—crowding, orientation to the sun, disease, and the hazards of weather all impact the growth of branches. A tree performs a delicate balancing act against gravity, and like a human skeleton, its inner structure spirals to allow greater strength and flexibility.

Imagine: what you see above ground of a tree is mirrored below in its extensive root system. As a tree extends from the ground, its roots condense or taper into the solidified form of the trunk. However, not all trees have a straight central trunk like the symbolic trees drawn in kindergarten—those notorious cotton-ball, smoking cigar trees. Some trees have a "clumping" structure, where many smaller trunks emerge from the same root ball. Small trees like serviceberries and shrubs like lilacs share this form of growth, producing a vase or V-like form.

Branches are arranged in a systematic manner around the column of the trunk that maximizes leaf exposure to the sun. Look carefully and you might notice how

a tree's branches seem to spiral around a 120-degree axis, alternating from one side of the tree to another, or radiating out like a wheel's spokes. Each branch is thickest in diameter where it emerges from the trunk, gradually tapering to finer branchlets. The golden rule here is "thick to thin." Branches drawn as evenly thick lines appear unnatural. It's a good practice to first begin by blocking-in/ drawing the underlying structure, regardless of how much the foliage actually conceals of the branches underneath. This will maximize the directional continuity between portions of the visible branches. When you paint branches as a second thought over foliage, they appear as floating toothpicks, disconnected from the kinetic energy of roots to trunk to branch. The demonstration paintings starting on page 132 will show you examples of this process in practice.

On a mature tree, the top branches grow upright, but the middle height branches grow laterally or sideways. Toward the bottom of the tree, the branches seem to sag and bend downward. Exceptions to this standard include columnlike trees, such as Lombardy poplars, whose branches grow close to the trunk in an upright fashion, or weeping trees like willows, where all branches sag or drape, with smaller branchlets hanging downward.

You can identify what type of tree you're observing by its bark texture: deep diagonal ridges for Douglas firs, shaggy texture for cedars, or smooth and mottled texture for alders. Bark texture also has a way of changing as a tree matures— shifting from a smooth surface to a deeper, thicker texture. To clearly see bark texture, keep the sun at the side of your head so that the light and shadow reveal not only the form of the cylinder but also enhance the contrast in the bark texture. In cooler, wetter climates, moss often disguises a tree's texture under its green pelt. Remember, first establish the volumetric form of the tree with light and shadow values, then paint additional details, such as texture and moss, later.

The color of bark is rarely just "brown." For instance, the shading from the tree's canopy of leaves often creates a cool shadow effect that can transform the dullest gray to a blue-violet. The bark of madrone trees is a challenge to paint— not only does its bark change from smooth to rough, but it also changes from intense red-orange to blue-gray. Trees like birches, alders, and aspens, have pale gray to white bark with dramatic black markings.

Foliage refers not only to the size and shape of each leaf, but to the leaves' placement on the terminating ends of branchlets. Leaf clusters can be dense bouquets (holly), starbursts (laurel or rhododendron), spread out side by side (big leaf maple), or airy sprinkles (birch and aspen). Dense foliage will seem easier to render (especially in plein air painting) when it appears as a solid form. That makes it easier to abstract into light and shadow shapes. In comparison, young saplings and airy foliage reveal a tree's interior structure. In order to

capture foliage on the far side, behind the trunk, it is better to approach it as a layered, indirect painting.

When you observe a grouping of trees, there are two places where the foliage's pattern is most noticeable: the contrast of hue and the contrast of value. The silhouette edge of trees against sky is one place to observe the contrast of hue—sky blue against foliage greens. There is also contrast of color temperature, such as minty green next to lime green. You can see this when a spruce is next to a maple. Compare a tree's deep, shaded interior to the lit surface of foliage projecting toward the light to see an example of value contrast. In the black-and-white photo to the right, you can see heightened contrast in the middle-distance trees, between the darker shadowed areas and brightly lit leaf groupings.

When painting outdoors, I recommend squinting your eyes, grouping similar values into simple masses. You can use this same technique for studying photographs. Notice how the brightest leaves are in front of the trunks and major branches? By emphasizing the contrast between the warm lights and the cool darks and sharpening the irregular leafy edges, you can suggest the projection of the foliage toward the viewer. In areas of relatively low contrast—between the middle-to-light values or the middle-to-dark values—it's important to keep transitions from appearing flat by painting them all the same value.

It's easier to notice the contrast of value and the sharpness of edges when color is eliminated. The lightest leaves seem brighter when next to areas of darker shadow. Think of the irregular shapes of foliage as "floating islands" in front of the main trunk and branches.

Sky Windows

When seen against a bright, blue sky, the silhouette of a tree is dramatically enhanced. Openings between the foliage, called *sky windows*, allow the value of the sky to contrast with darker values from the shadowed or backlit foliage. To keep these irregular shapes from popping forward, paint them with a slightly darker value or neutral blue. Sky windows have soft, blurred edges when surrounded by rustling foliage and straighter edges when they fall along major branches. It's always better to paint in more or bigger sky windows than you think you'll need, as you can easily paint over them if necessary. Painting sky blue over dark foliage rarely seems believable as it tends to pop forward rather than recede into the background of the sky.

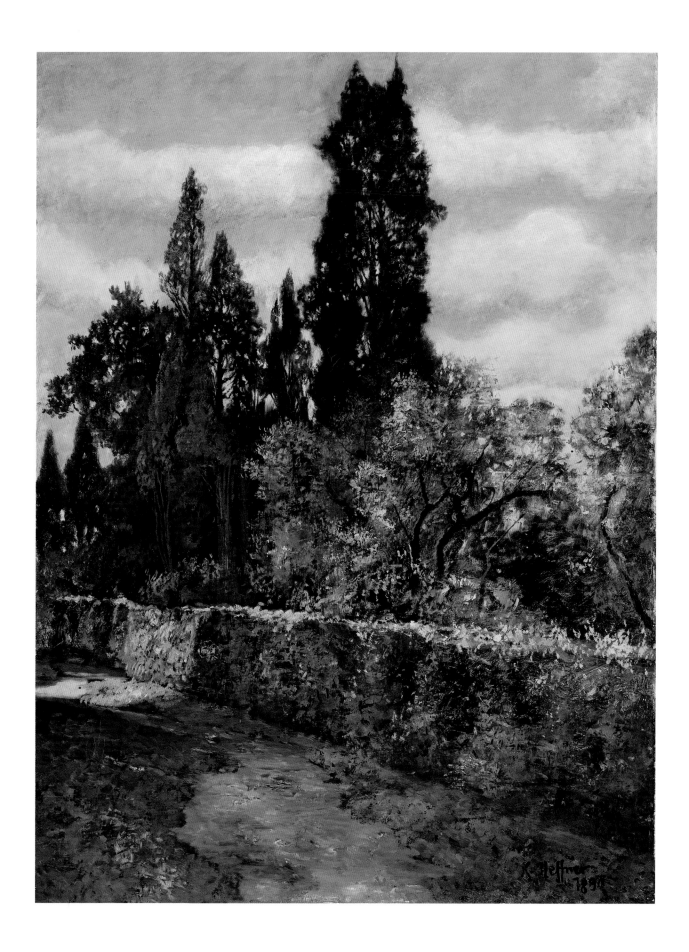

VIEWING DISTANCE

To avoid painting trees leaf by leaf, keep in mind that the viewing distance from your subject changes the level of detail and approach required. The following are three typical viewing distances and some useful guidelines for plein air and studio painting.

Distant Trees

Plein air painters enjoy simplifying trees into abstracted shapes of light and dark that suggest the overall volumetric forms of trees without having to depict foliage in detail. This strategy works well for all scenes with trees seen at a distance, from tree-covered hillsides to "across the lake" images. At this viewing distance, individual trunks or other details are rarely seen and instead blend into the overall silhouette shape.

At such a distance, the overall silhouette of a tree provides the best clues to its identity rather than its foliage. You can easily separate trees into general groupings, such as deciduous versus evergreen. Sky windows are indistinct, blurred, or reduced in scale, unless the branches are spaced very far apart. As the forest recedes, atmospheric (aerial) perspective continues to diminish value contrast—blurring edges and changing the true local color toward cooler blue-violets.

The viewing distances, from far to near, in the three photographs below demonstrate the varying levels of detail needed to render trees in a painting.

Middle-Distance Trees

In the middle distance, a tree's scale increases. Characteristic details become more apparent and require greater attention. Trees viewed in the middle distance are useful for connecting the ground plane from near to far. These trees create an "eye path" at the points where they touch the ground. Overlapping trees in the middle ground can also provide a sense of space or density of growth, such as trees along the edge of a river or along a roadside.

A tree in the middle distance shows part of its trunk and major branches, but does not reveal the same level of detail (such as bark texture) as a tree seen up close. In middle-distance trees, the foliage may appear as simplified shapes. However, some areas may seem clearly in front or behind the trunk or major branches, with sky windows at times noticeable next to larger branches. A singular tree in the middle distance can provide a contrast in scale to a grouping of trees in the distance. Look for one that stands alone to serve this function.

Foreground Trees

When viewed up close, a tree takes on the character of a person posing for a portrait with a distinct individuality included. Close cropping contributes to a sense of nearness. By eliminating the entire silhouette and the trunk's contact with the ground plane, the painter captures a feeling of being in the tree's embrace. The direction of the sunlight reveals the girth and growth of the trunk, including the patterning of cast shadows from the leaves and the branches above. Details like the texture of the bark or the specific shapes of leaves make the identity of the tree more definable.

Creating a studio painting from photographs and study drawings is the best approach for rendering trees up close. It requires a certain degree of planning to build up layers of details—the foliage implied behind the trunk, the location of major branches spiraling from the trunk, the texture of the bark, and the foreshortened foliage projecting forward. A studio painting allows for a full range of painting techniques, from thinly applied transparent paint to chunky thicker layers to finishing glazes used to render the complexity of a tree's character when seen at a specific time of day or season.

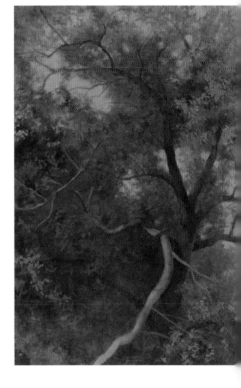

SUZANNE BROOKER,
FRAGONARD'S TREE, 2007,
OIL ON CANVAS BOARD,
24 X 18 INCHES (61 X 45.7 CM).

Numerous layers of transparent paint build up the delicate character of the foliage, which is further animated by the burnt sienna toned ground.

DRAWING CONCEPTS

The structure of a tree is best thought of as an underlying architecture of cylinders, while the foliage is an abstraction of small marks unified into ephemeral masses.

TRUNKS AND BRANCHES: A STUDY IN BENDING CYLINDERS

The architecture of a tree is based on the concept of cylinders made dimensional through the rendering of light and shadow over the subject's surface. When we artists study cylinders as a pure concept, we learn techniques that allow us to create the illusion of volume or "roundness." These techniques are part of the Western visual tradition, used to represent three-dimensional objects on a two-dimensional surface. This idealized concept of rendering light and shadow can be very difficult to witness in reality, especially when you observe a tree trunk in nature. Consider this: a tree's trunk and its branches bend or tilt in space, it has a textured surface, and sunlight is often blocked or filtered by the leafy canopy above. Therefore, you need to merge "what you know" and "what you see," in order to understand and interpret what you see as an artist.

Look at the illustration below comparing the shading of a cylinder to an actual tree. On the left side of the drawing is a plain vertical cylinder. Notice how the

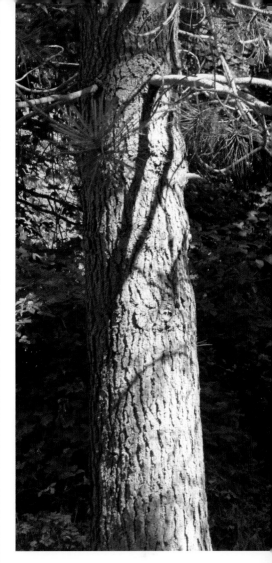

Core shadows or the terminating edge between light and shadow are often hidden in the deep texture of the bark. It helps to squint your eyes and look for the place where the light meets the shadow side.

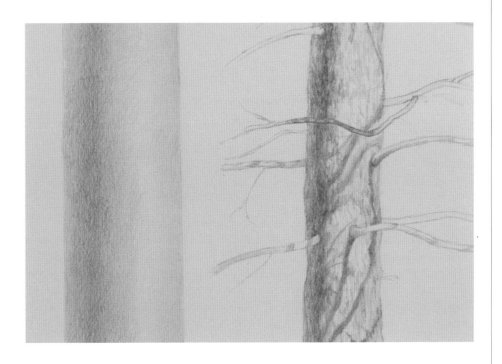

Compare the shading of a simple cylinder (demonstrating light and shadow on a pure geometric form) with the complex conditions shown on the tree trunk on the right.

brightest place is not on the contour edge, but slightly inward on the curve of the cylinder. For plein air painters, standing with the sun angled toward the sides of their heads, this bright spot represents late-morning, early-afternoon light. Now imagine that as the light wraps around the cylinder, it also gets less intense as it moves toward the shadow side, until it hits the widest place of the trunk's circumference. This "zone"—where the light meets the shadow side—is the terminating edge or "core" of the shadow, the darkest place on the curving surface. Notice how on a smooth object this zone has a soft, blurry edge compared to the textured tree trunk illustrated on the right side of the drawing.

When you observe trees outdoors, the darkest place on the trunk may appear to be at the far contour edge. (When your eyes see the brightness beyond the trunk, your pupils contract, and make the edge of the trunk appear very dark.) But if you darken the shadowed contour edge with a strong line, it will flatten out the form of the tree! The *reflected light* opens up the shadow values and keeps the shadows from blending into one single value of gray. (Again, a flattening effect.) If the values on the light side appear on the shadow side, that can suggest your tree is transparent or has a hole or bulge that catches the light. The core shadow divides the light side from the darker, shadow side. The darker or more pronounced the core shadow is (without becoming a dark line), the greater the range of value transitions on the shadow side.

When you think of branches as spokes on a wheel, you can sense the branches that grow away from the trunk even when you don't see them. Branches pointed toward the viewer are obscured by foliage, while branches that are parallel to the viewer's eye level create a clear silhouette of the tree's shape.

Practice observing the foreshortening of cylinders. Take a simple object like a paper tube or a pencil and slant it in different directions. When a cylinder leans away from you, the edge of the circumference tilts up so that the belly of the curve is higher in the center. When the cylinder is slanted slightly toward you, you can see the curve of the circumference belling out, and increasing as the cylinder turns and projects toward you.

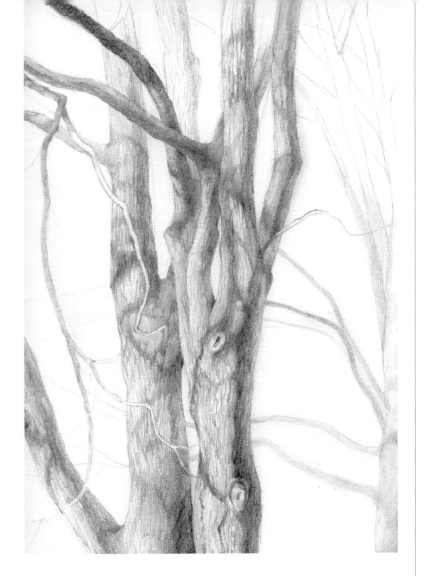

SUZANNE BROOKER,
STUDY OF YOUNG TREES, 2011,
GRAPHITE ON PAPER,
14 X 11 INCHES (35.6 X 27.9 CM).

Use study drawings of trees to
practice rendering the directional
thrust of branches in space, the
draping shadows of foliage and
branches above—plus the core
shadow seen along the vertical
length of the trunk.

On the right side of the illustration at the bottom of page 109, you can see light and shadow in action in the drawing of an actual tree trunk. The core shadow can appear hidden when bark texture is deep and grooved, so look for the place where the contrast is the greatest. Dappled light—falling between the foliage onto the trunk or cast shadows from branches above—needs to wrap around the trunk rather than be indicated as straight lines. When cast shadows fall from nearby branches, they have crisper, sharper edges. When they fall from higher above, the edges are softer. Linking up the dappled shadows or splashes of light along the length of the trunk indicates the location of the core shadow, even if it's weakened by bright, reflected light.

Let's look at shading branches that point in different directions. The branches that are easiest to see are the ones parallel to you. These create the silhouette outline of a tree and share the same light and shadow characteristics as the trunk. But branches pointed away from you also face up to the light and are therefore paler in value. Branches that are foreshortened (pointing out toward you) and above your eye level are darkest, because you only see their shadow sides or the surfaces facing away (downward) from the sun. Varying the values of major branches creates a greater sense of volume, reflecting the way trees actually grow.

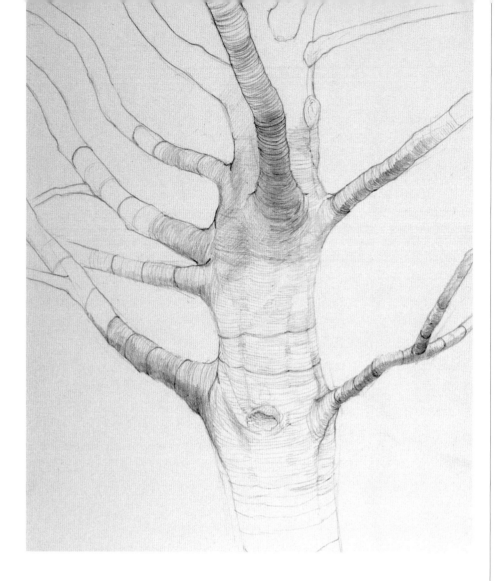

In my study drawing of an oak tree here, the tree's branches project in different directions. Notice how cross contour lines establish the degree of slant or tilt. At the same time, they also represent the surface undulation of the trunk. Cross contour lines are one method used to shade values over surfaces—the closer the lines, the darker the value appears.

CROSS CONTOURS AND FORESHORTENING

Deciphering the direction of each branch in space is the most difficult part of rendering trees. Branches that are parallel to the artist's point of view create the silhouette contour or outline of a tree. But what about branches that retreat behind the trunk, or ones that advance toward you? In the photographs of a tilting cylinder on page 110, a simple paper tube provides a model for considering the issues with foreshortening. You can also try holding out a pencil and imagine it's a branch of your tree. Tilt it so that it matches the direction of the branch. Then imagine if there were a ring around the circumference, would it seem to tilt lower toward you or rise up higher, bending away from your line of sight?

Circumference acts like a cross contour line. Cross contour lines are drawn from one side to another, *across the contour* or over the surface of an object. Look at the cross contour drawing shown above. Can you see how the cross contour lines suggest the direction of the branches as well as the bulging, irregular surface of the trunk? Cross contour lines are one means for building up values, suggesting

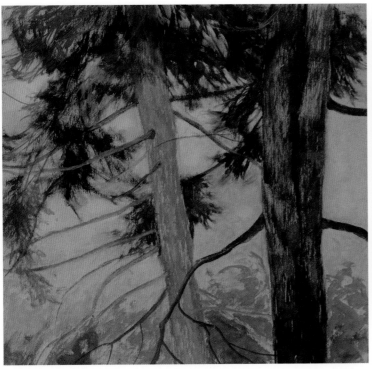
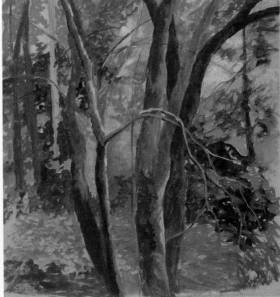

the volume of the form. Shading that follows along the outline repeats the same information of length and direction but does not describe the "around-ness" of the surface. As painters, we can take our cues from cross contour lines, to decide what direction to pull the brushstroke. Notice if your trees seem to be wearing striped pajamas when thick even lines of paint move parallel to the outline or contour edge, instead of wrapping around the cylinder of the trunk.

Atmospheric (aerial) perspective can also enhance the depth of space in a drawing or painting. Branches behind the center trunk appear lighter in value and have softer, blurred edges. Their vague appearance sends them farther back into space. Branches above your head or projecting toward you are darker, and have crisper, sharp edges. This has the effect of giving the foreshortened branch more focus and the implication that it's closer to you.

SUZANNE BROOKER,
VALUE STUDIES IN GOUACHE III & IV, 2010, GOUACHE AND INK ON BROWN PAPER, 12 X 12 INCHES (30.5 X 30.5 CM).

Using fluid media on a toned paper for value studies of trees creates a gestural interpretation based on careful observational study.

DRAWING A TREE

A step-by-step guide to drawing a tree unites the underlying structure with the shaded form and texture of the foliage.

The red leaves of a young maple in early autumn show an example of groupings of foliage positioned in front of a tree's trunk and branches. Compare the cool green leaves on the shady right side to the bright green leaves facing the sun on the left side. Find a good, simple tree where lights and shadows on the foliage groupings are clearly seen, and then draw that tree.

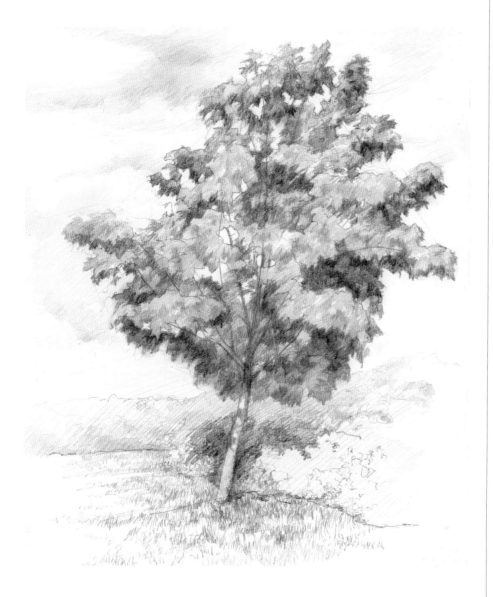

SUZANNE BROOKER, *FOLIAGE STUDY—YOUNG MAPLE*, 2013, GRAPHITE ON BRISTOL PAPER, 11 X 8½ INCHES (27.94 X 21.6 CM).

In this final drawing, you can observe the changes in value and the use of hard-to-soft edges that create the volume and texture of the foliage.

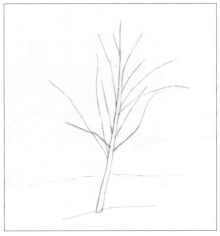

Indicate the growth structure.

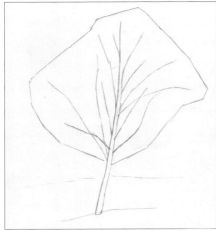

Draw the outline as a geometric shape.

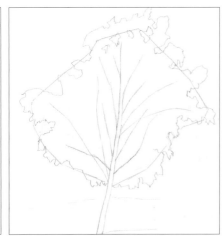

Detail the contour silhouette edge.

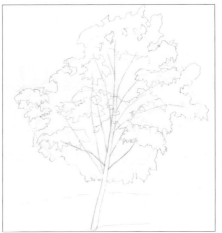

Use shapes for groupings of the interior foliage.

Shade the foliage in the shadow areas.

Erase tone to heighten the light values.

Begin defining the sharper contrast edge.

Build up value contrast in the shadow areas.

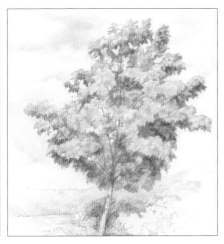

Develop the background details.

STRUCTURE

First, I observe the overall lean or tilt of the trunk—keeping in mind the question: In which direction does this vertical line lean, right or left? Once I have my answer, it becomes harder for me to "straighten" the tree into a perfect vertical line. Next, I think of the horizontal ground plane, where a tree's roots connect with its trunk. This horizontal line should be well above the bottom edge of my paper or canvas. I also make sure to allow for the foreground—the space in front of the tree, what's next to it, even what's behind it—farther back in space. If I start with the intersection between the base of the trunk and the ground, then I'm already considering the impulse of how it grows—from a broad gnarly or a smoothly tapering base. I place a short stroke near the top of the page to give myself a sense of the scale of the tree I'm drawing.

PROPORTION

Proportion, in this case, refers to the tree's width and height. Returning to the trunk, I mark out its girth and branching structure. By noting the distance from the ground to the first branch (or another landmark, such as a lost branch scar or bark marking), I can compare the width of the trunk to its height from the ground. If I draw a tree from the middle distance, I can see the entire canopy of its foliage as a large shape, which I draw in straight-line segments resembling a kite shape. I draw the true contour edge after I evaluate the width and the height of the tree's overall shape.

 At this point, it's easy to make changes. Judging proportions is as simple as asking yourself *Is this tree taller than wider?* In other words, have you squeezed the proportions to fit the tree on the page? If my tree is too fat, it will seem closer to me in space and squat in shape. I've run out of vertical space on my paper. If my tree is too thin, it will appear like a tall tree that's far away, spindly and stretched out. By changing the height-to-width proportions, I can remove these distortions.

CONTOUR

Once I've blocked in the overall shape, I can refine the contour edge by observing and drawing in the irregular silhouette edge. The lively, irregular quality of the silhouette outline with its positive and negative shapes helps to give a tree its character. I don't allow the silhouette edge to become smooth and bland. If I did, I would lose detail and visual interest. For a middle-ground tree, I know to look for its central branches and separate one tree overlapping with another. Sky windows also make handy landmarks.

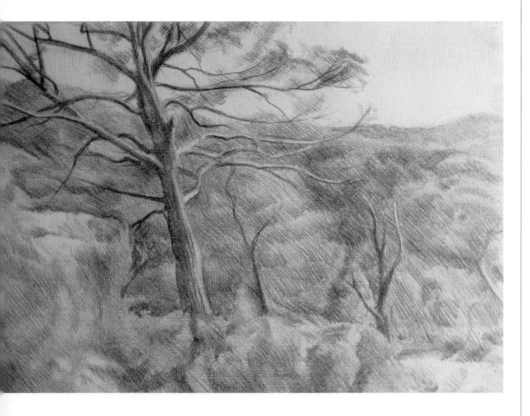

DOMENIC CRETARA,
LANDSCAPE NEAR CASSIS,
1980, GRAPHITE ON PAPER,
11 X 14 INCHES (27.9 X 35.6 CM).

Drawing from direct observation
trains the artist's eye to select
and organize visual elements from
among the chaos of nature.

FOLIAGE

When looking at the interior of the tree's shape, squint and notice the difference between shapes of light foliage versus the dark or shadowy spaces between leaf groupings. I think of the bright foliage in the light as "floating islands" that often link together to form curving diagonals around the trunk. Imagine a bike wheel with the spokes seen horizontally: some of the spokes point away, some are parallel like the silhouette edge, and some point toward you. Foreshortened branches and their leaves are the ones in front of the main trunk, and they project toward you.

SHADING

Use a one-directional line to quickly indicate areas in shadow. Keep the touch of your pencil even and make sure the strokes follow the same direction with similar spacing between them. This technique will create a neutral placeholder for detail to be added later. Placing lines closer together suggests darker values and placing them farther apart lighter values. On the other hand, tonal shading is applied with a circular movement—the side of the pencil tip held at an angle to the paper's surface. With an endless, overlapping grazing of the surface, graphite accumulates into an even tone of value, animating the texture of the paper. If there is not a sufficient amount of overlapping, the resulting surface will look like "woolly-balls." Create light tones of silver gray by using harder pencils (2H, H), and then move up to softer pencils (HB to 6B), which deposit greater amounts of black.

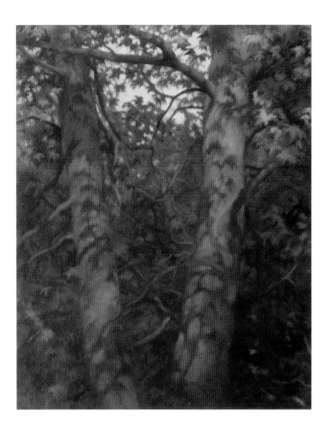

SUZANNE BROOKER, *PARTNERS,*
2008, OIL ON CANVAS BOARD,
16 X 20 INCHES (40.6 X 50.8 CM).

Two sweet gum trees leave a trail
of dappled shadows across their
trunks in this close-up portrait.
The toned ground of cadmium
orange and burnt sienna creates
the brightest light when it back-
lights transparent layers of paint.

TONED GROUNDS

Select the color for a toned ground based on the effect you'd like to achieve:
intense complement for maximum contrast to the green foliage, golden yellows for
backlit scenes, cool violets that support the shadow areas, and so on.

PROMOTING RED-GREEN COMPLEMENTS

To get the most intense color contrast, you'd think preparing your canvas in a pure,
opaque bright red would be the best strategy. But consider for a moment that a thin
layer of green pigment over a bright red will neutralize the green to a muddy brown
or violet. If you allow large spots of red to peek through the green paint, those spots
will jump forward. To gain the most from a toned ground, plan ahead: Where will
the toned ground help create a quality of light, a seasonal characteristic, or some-
thing distinct about the variety of trees in a forest scene? Notice in *Forest Edge*
(page 120) how the violet-red color note of the toned ground is used to energize
the green foliage.

A combination of red and orange (cadmium orange and burnt sienna) or an
orangey brown (Mars brown) creates an organic complementary contrast to the
green of the foliage. Other possible choices include a cool violet (ultramarine
blue, alizarin crimson, and white) for the luxurious quality of summer's deciduous

leaves, a dark warm blue (Prussian blue) for deep shadows in strong sunlight, or a cool magenta red for conifers in winter.

If you are just starting to work on toned ground canvases, it may take some experimenting to find what color works best for your palette. I'd recommend painting a few sample swatches on canvas paper that matches the toned ground on your canvas. This allows you to test out color mixtures before committing color to canvas. For a plein air painting session, you may want to take a few different toned grounds with you—selecting the one that works best with the motif and lighting. In the beginning, this process may take some trial and error. Choosing a cool gray ground for a strong sunlight may turn the painting dull, an orangey ground for pine trees might be better for the trunks instead of the foliage, and so on. For studio painting, you'll need to study your photographic source to determine not only what color to use for the toned ground, but also where to use it for maximum effectiveness. For instance, a warm golden ground (yellow ocher mixed with a touch of raw umber) may help depict light falling over a tree's trunk, since the luminous glow of the ground (backlit by the white gesso) will be greater than any opaque yellow paint mixture.

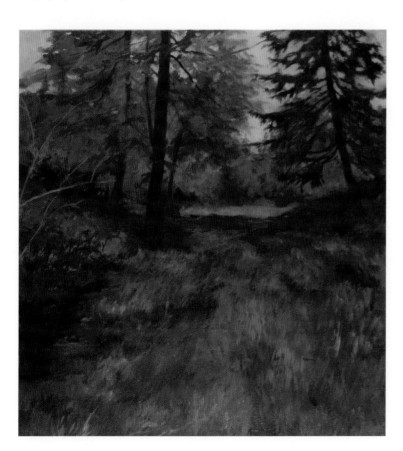

SUZANNE BROOKER,
SHELTON WOODS, 2012,
OIL ON CANVAS, 18 X 14 INCHES
(45.7 X 35.6 CM).

I used a metallic ground of copper acrylic—duochrome autumn mystery (Daniel Smith)—to provoke a complementary contrast between the cool greens and the bright ground.

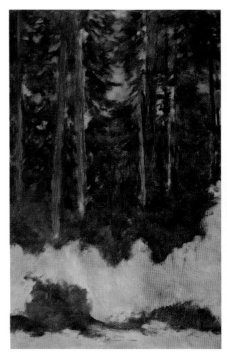

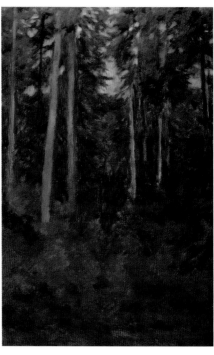

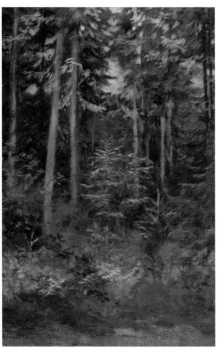

Transparent darks are applied to build up the background trees.

Dark cool pigments are worked into the middle ground.

The texture of brighter greens overlaps the dark values.

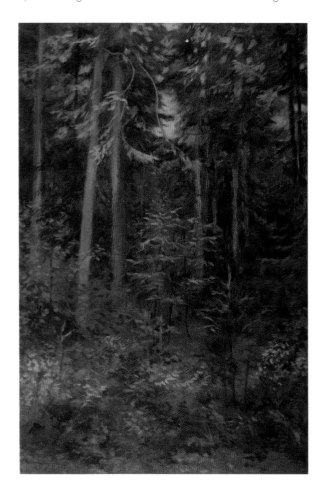

SUZANNE BROOKER, *FOREST EDGE*, 2010, OIL ON PANEL, 18 X 12 INCHES (45.7 X 30.5 CM).

Over a bright pink ground of rose madder (Winsor & Newton), this complex forest scene starts with background trees and then overlaps the foliage textures as they move into the foreground. The violet glow appears through the cool and warm greens that are applied in a thin-to-thick manner.

When used in toning a canvas, metallic acrylic pigments, such as copper and gold, can lend surprising color effects to a landscape painting. Copper acrylic (acrylic that mimics painting on copper metal plates) is best for secondary color palettes, while a metallic gold toned ground makes a backlit scene glow with shimmering light. Remember that these acrylic pigments need to be applied opaquely so that the light of their reflective surfaces illuminates the paint.

PALETTES

How can a painter mix enough variations of green to imitate the lush summer foliage or portray the differences between cedar and willow? Here are two strategies for generating a range of greens that have both variety and harmony.

MIXING GREENS FROM SCRATCH

When mixed together, yellow and blue pigments make green. But not every yellow can mix with every blue to produce a beautiful green. Let's see how color temperature influences color-mixing outcomes. In general, artists think of yellow as a warm color and blue as a cool one. However, there are yellows that are cool because of an inherent tendency of blueness within the yellow pigment, which makes cool yellow pigments appear dull like straw (yellow ocher, gold ocher, raw sienna). There are yellows (like cadmium yellow medium) with an orange cast, indicating a hidden red tendency. Warm blues (phthalo, indigo, Prussian), those with a bias of yellowness, are often dark in value when taken straight from the tube, hiding their warmth until white is added. After white is added, these blues turn turquoise or teal. On the other hand, cool blues with hidden cool red notes tend toward violet when white is added. Ultramarine blue is one such example.

So what happens when you mix a specific yellow with a specific blue? First, let's take a warm lemony yellow, like hansa yellow or cadmium yellow, and mix it with a warm blue, such as phthalo blue. Notice how the yellow tendency is reinforced from both pigments, and the resulting color mixture is bright and intense. If either pigment had a hidden red element, then the final mixture would appear more neutral. Why? Because you would be mixing three primaries together, the same as mixing complements (Y + B = G, but a hidden R is the complement of G and is therefore neutralizing).

Try mixing a cool yellow (yellow ocher or gold ocher) and a cool blue like ultramarine blue. Notice how this creates a duller green. This occurs because the cool yellow is not intense and more neutral and because of the presence of a red element

in the blue. French ultramarine blue would increase the neutral quality of the green, since it has a greater tendency toward cool red. A yellow pigment that tends toward orange has a bias to red. This also increases the neutral quality of the green mixture.

Comparing transparent and opaque pigments also shows how they affect green mixtures. Consider what happens when you mix two opaque pigments (cadmium yellow and indigo) together: neither pigment consumes the other, as they are equally dense. However, if you mix a transparent or semitransparent pigment with an opaque color, then you need to adjust the ratio of opaque to the transparent pigment so that the more delicate pigment is not overcome. For instance, you may think ultramarine blue is a strong color because it is inherently dark when taken straight from the tube, but in fact, it's a semitransparent pigment and low tinting.

Tinting strength is a physical quality of a pigment like opacity and transparency, rather than a visual quality like intensity or dullness. Indian yellow is a transparent pigment and appears dull on the palette but it's high tinting and generates intense yellowy-oranges when mixed with white.

When I test out combinations of yellow and blue pigments, I first mix a tiny portion to see if I'm heading in the right direction. By mixing this small portion, I can gauge whether I'm nearer "willow" or "hemlock" green. I can also create three variations of green by simply changing the ratio between the yellow and blue pigments: moving from a more yellowy-green to a more blue-green. By changing the warmth (+yellow) and coolness (+blue) of my greens, I end up with something that best represents the foliage in the light or in shadow values.

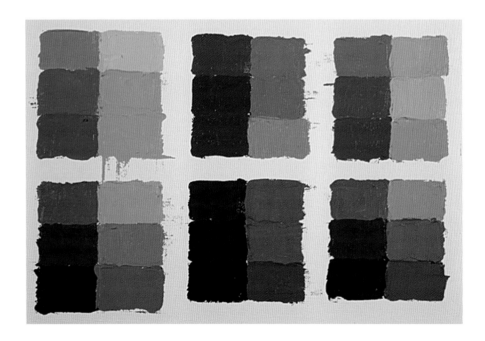

This chart compares how two blues and three different yellows create variations of green. In each square, the left-hand side shows the pure tube pigments mixed together. More yellow is used in the top mixture and more blue is added to the bottom block. On the right side of each square, white has been added to lighten the color note. The top row of squares is mixed with turquoise blue (Rembrandt) and the bottom three squares use Sennelier blue. In the left column, both blues were mixed with hansa yellow light (Utrecht), the center column with yellow ocher (Daniel Smith), and the last column with cadmium yellow medium (Grumbacher).

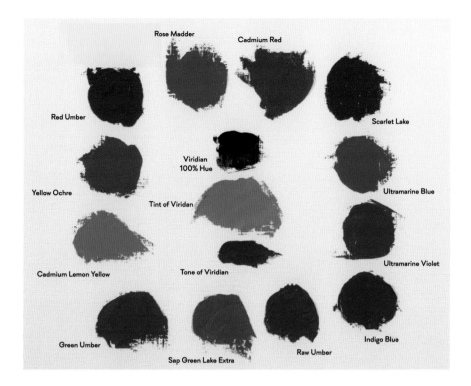

Labels on image: Rose Madder, Cadmium Red, Red Umber, Scarlet Lake, Viridian 100% Hue, Yellow Ochre, Tint of Viridan, Ultramarine Blue, Cadmium Lemon Yellow, Tone of Viridian, Ultramarine Violet, Green Umber, Indigo Blue, Sap Green Lake Extra, Raw Umber

You can keep the results of your color mixing organized by using the format shown here. Notice how the color variations are placed so that they mimic the layout of the palette: yellow to the left, red above, blue to the right and green below. This chart is a useful way to test out creating variations with any pigment.

MIXING VARIATIONS OF VIRIDIAN

In the center of the image to the right, I've mixed a tint of viridian to midvalue, above that is the hue at 100 percent, and below a tone of viridian neutralized with a black-plus-white gray. On the outside ring, I've mixed several variations of a midvalue viridian tint using yellows, reds, blues, and a few green pigments. Viridian is a transparent pigment and not often considered a useful pigment: when it's mixed with white it becomes a minty toothpaste color. However, when viridian is mixed with ivory black (shade) or raw umber, its transparency can be useful for painting conifers or deep shadows in water.

As a cool green, its strong bias to blue can be exploited or adjusted by the addition of other pigments. Look at what happens when a cool red is added to the tint—purple! Only a strong presence of yellow, either a yellow pigment or another warm green with yellow tendencies, can change viridian's temperature bias. In a secondary color palette (G+V+O), a pale tint of viridian can make a beautiful teal sky.

MIXING VARIATIONS FROM GREEN PIGMENTS

For landscape painters, green is the fourth primary color that opens itself to a range of mutations, as each of the other primaries warm, cool, or neutralize it. Even though many painters would agree that most out-of-the-tube greens are not organic or natural colors, those colors do serve as handy shortcuts for building palettes. When you place tube greens on your palette, notice how there is a visual range of inherent value, intensity, and color temperature between the green pigments, in addition to their physical opacity or transparency. Here is a technique for adjusting or dirtying up tube greens to make them more effective for painting foliage.

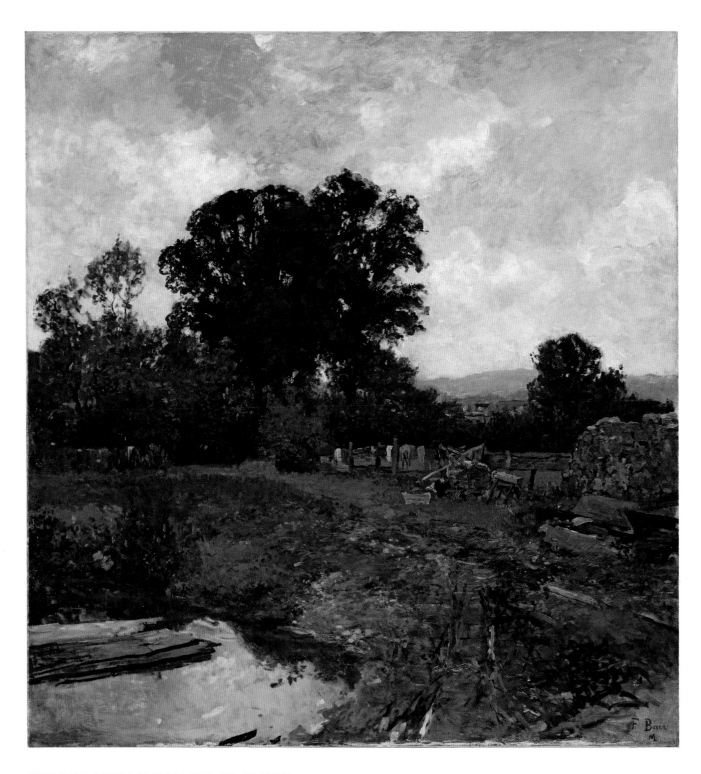

FRITZ BAER, *WASH DAY*, CIRCA 1880, OIL ON LINEN,
35¾ X 33¾ INCHES (90.8 X 85.7 CM), CHARLES AND EMMA FRYE COLLECTION,
COURTESY OF FRYE ART MUSEUM.

A rich palette of greens, from the dark trees placed against the sky to the
saturated green of the grass, provides unity and variety that keeps our eyes
circulating throughout the painting.

First consider viridian (Sennelier), which is a transparent midvalue green straight from the tube. Even the smallest addition of white reveals its cool tendency, creating a toothpaste-minty green. To reduce this effect, add a small amount of a warm red, such as scarlet, to neutralize, making the result useful for foliage at a distance. However, adding a cool red, such as alizarin crimson, will create a violet (the blue tendencies of each color join with the stronger tinting quality of the red pigment). A violet made from cool greens and reds is a good choice for indicating shadows on tree trunks or foliage on the shadow side of a tree.

Sap green is a warm, semitransparent green that mixes well with semiopaque whites to create a yellowy leaf green, as seen on young willow leaves. This pigment tends to appear and behave differently depending on the quality of the pigment color, changing its transparency, tinting strength, and color note. You may need to try out a few brands to find the one that works best for you. I prefer sap green lake extra (Old Holland), which is a lake color (originally a dye converted to a pigment). It is warm, but not as yellow as other sap greens. Like viridian, you can alter sap green by adding warm reds that generate a toasty brownish hue or adding raw umber (Old Holland) to help cool and darken the color note. You can also cool sap green by adding ultramarine violet (Rembrandt), which helps maintain the transparent quality of each pigment.

Green umber (Old Holland), like Courbet green (Williamsburg), is practically pine-trees-in-a-tube! This is a handy pigment to have for a rich, cool, and dark green. Adding white to it creates a neutral cool green. However, the addition of yellow tends to muddy the color, rather than create a warm variation. Try orange instead to sour the color note. Further addition of a blue pigment can increase the sense of deep shadows in dark conifer trees.

Raw umber is a subtle hue that belongs on the green side of the palette. Unlike its cousin burnt umber, raw umber retains the organic green elements that give it a cool, neutral green effect. Raw umber (Old Holland) is one of my staple colors. It allows me to scumble in a transparent brownish-green that changes from warm to cool depending on its context, even during the underpainting. Raw umber is also useful for drawing branches, either during the block-in over the toned ground or later as I add fine branchlets.

What about terre verte or green earth colors? Transparent colors like terre verte are better used as glazing colors, since any mixtures of (even transparent) white will consume the color note. Opaque green pigments, such as opaque chrome oxide green, are exactly the opposite. These are valued because you can add almost anything to their color density and, as a result, generate many subtle changes in color, while retaining opacity.

SUZANNE BROOKER, *ALONG THE WOODS (FOLIAGE STUDY)*, 2013, OIL ON CANVAS PANEL, 12 X 9 INCHES (30.5 X 22.9 CM).

Strategies for mixing green variations also need to include plans for placing darks next to lights, intense against duller color mixtures to maximize the palette based on one green pigment.

BRUSH TECHNIQUES

There are a number of brush techniques that will help you move from basic shape thinking into a more detailed depiction of a specific tree. These will allow you to gain maximum textural effects for rendering foliage.

FOLIAGE: DAPPLED MARKS AND DIRECTIONAL FLOW

If you've been frustrated while trying to render the leafy canopy of a tree—one leaf at a time—then you'll be glad to know that foliage is just a combination of abstract patterns and symbol recognition that characterize each type of tree. Foliage is not painted leaf by leaf! In fact, painting each leaf will result in a painting that feels stiffer or more awkward than if you had painted the movement or feeling of the foliage. If all the foliage in your painting is the same size and shape, or if it simply looks like abstract dots of green, then you're no closer to rendering the diversity of nature.

Unlike the solidity of the trunk and the architecture of the branching structure, for trees viewed from the middle distance to the foreground, the foliage of trees appears as ephemeral but dimensional forms (like lumpy green clouds of broccoli), rather than as flat, solid shapes. First, I look for the character or pattern of the foliage—how it's organized: Is it tightly bunched, or like shelves with shadowy spaces in between, or does it appear in airy sprinkles? Next, I locate areas of stark contrast: along the silhouette edge or light-to-shadow edges, where the foliage projects outward in front of the trunk. If I can see the shape of the leaves at these places of high contrast, then I know where to put the greatest amount of detail. By using the movement of my brush rather than drawing and filling in shapes of individual leaves, my foliage seems spontaneous and filled with lively energy. Practice creating different kinds of marks (varied by size and shape) and get a feel for the flow of the pattern by using leftover color mixtures and some canvas paper.

Begin by choosing a brush that is the right size and shape for the mark you intend to make. A filbert or long flat brush of medium firmness is useful, as long as the tip does not splay apart. You'll want the edge of the brush to make a sharp point. Second, adjust the viscosity of the paint mixture so that it glides easily over the canvas surface but is not too soupy. Soupiness is caused by the addition of too much linseed oil or other mediums. By holding the brush at the far end of the handle, you can twist and press, or lift the tip with greater freedom. Once you

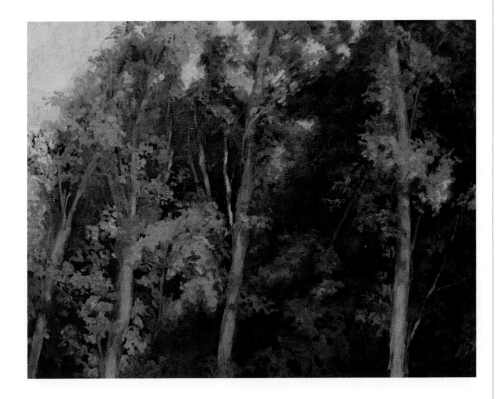

get the movement of the brush coordinated with the amount of paint loaded onto your brush tip, you'll be able to establish foliage patterns much faster.

Overall, I recommend using a dark-to-light approach for foliage. Start with a thin scumble of dark shadow values, followed by a thicker layer of middle values, and then transition to the lightest, most opaque values. You should paint the dark areas of the foliage (the shadow side of the tree or the space toward the center of the tree) in a dark green, cooled with blues or violets. The darker the shadow areas, the less tempted you'll be to make the light values screaming yellows for contrast. You may also want to use both a warm and a cool middle value to represent a play of temperature and to transition into the light values. (See the painting *Blue Trees* above.) Avoid adding too much white to the light values. Remember, white is a cooling and dulling agent that does not suggest stronger warm light.

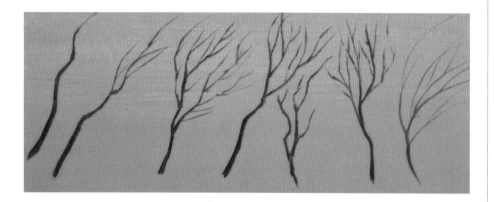

ABOVE LEFT:
This practice sheet shows drawings of thick-to-thin branches made using fine-tipped brush and oil-thinned pigment. Drawing small branches or branchlets with a brush requires pressing firmly (for a wider mark) and fluidly pulling in a direction while you lift up pressure on the tip to create a thinner line. Although major branches are usually drawn with a defining line on each side, this approach is too awkward and thick for finer branches. At first, you may want to practice pulling a straight line that changes from thick to thin (change of pressure) and then attempt to change angles (pivoting the brush tip by gently rolling the brush handle with your thumb across the knuckle of your middle finger).

LEFT:
SUZANNE BROOKER, *FOREST AT HORSTEN ISLAND*, 2011, OIL ON CANVAS BOARD, 18 X 12 INCHES (45.72 X 30.5 CM).

Paint a tangle of overlapping branches with lines pulled from thick-to-thin brush strokes.

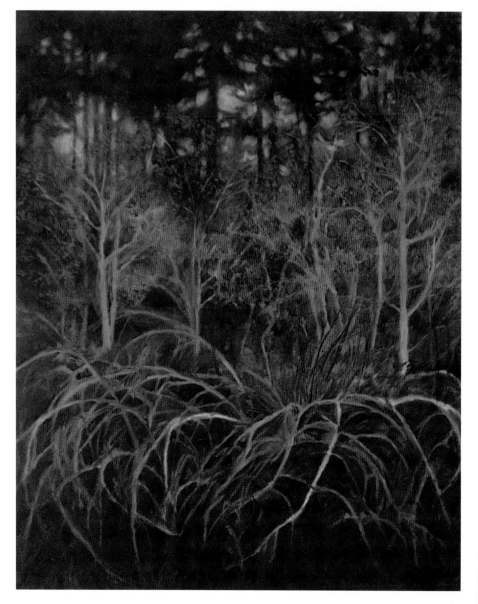

OPPOSITE:
Here's a sampling of various leaf shapes and textures, from lobe shapes to spikey needles. My collection of photographs serves as a resource library, providing a visual reference that helps my visual memory recover details.

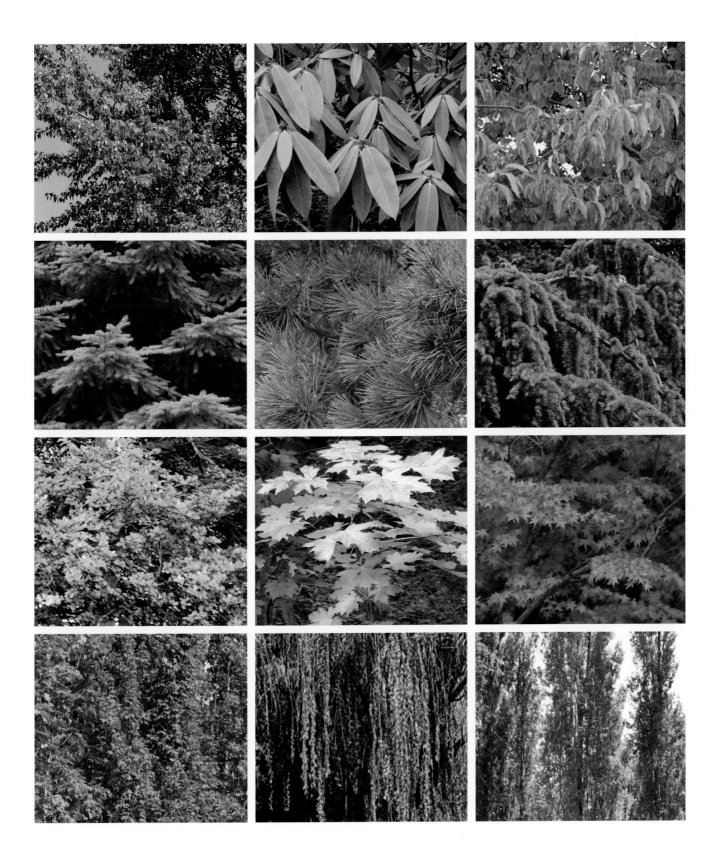

FOLIAGE BRUSHSTROKES

Look at how the stroke of the brush can contribute to the symbolic recognition of different leaf types. Remember, however, that the degree of detail needed depends on how near or far groupings of trees are viewed in a scene. Trees seen at distance are rendered with attention to their shape and their texture is blurred. For middle distance trees, the texture of the foliage is abstracted into a dappled pattern of brush marks. When trees appear closer, more attention is required to render their individual foliage types.

Dappled

Deciduous trees seen from a middistance convey a leafy texture. However, they do so without distinct details of leaf shapes. Use short broken brushstrokes that move side to side to accumulate a pattern suggesting leafy-ness. A firm flat brush, loaded with paint on its tip, deposits small touches of paint in an irregular pattern.

Leafy Ovals

For lobe or oval-shaped leaves (rhododendrons, hydrangea, and so on), choose a filbert or round brush and charge the tip of the brush. When you touch the canvas surface, begin with a light pressure—even as you move the tip in a short stroke, pressing slightly firmer in the middle, and ending with the same light pressure. Avoid "flicking" the brush tip in the same direction so that your foliage looks like green water. Overlap individual strokes to build up a cluster or arrange them on a branchlet for compound leaves (such as on a locust).

Hanging Teardrops

For thin, sword-shaped leaves that drape in a weeping or umbrella-like cascade (willows), use the sharp tip of a new filbert or a round brush with a pointy tip. Press the tip more firmly to the canvas, drag it, and then lift so that the tip leaves a pointy end. The foliage of a weeping tree hangs from its branching structure—so paint the draping branches first. Build up a repetition of small strokes that flow along the branches. Most of the detail will be seen at the ends or fringed along the bottom edges. For weeping cherry trees, add a small amount of pressure to the brush in midstroke to widen the leaf shape.

This same technique also renders spadelike leafy shapes when the pull of the brush is shortened to end on a squat shape. Practice this stroke so that you can move and place the brush mark pointing in any direction.

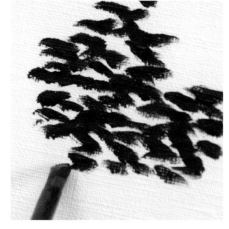

Dappled sideways strokes

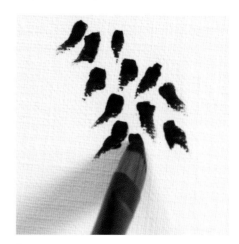

Short teardrop stroke

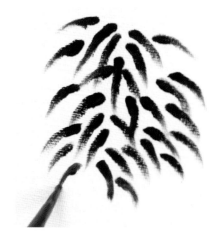

Hanging teardrop stroke

Pointy Gloves

For jagged-edged, downward-bending leaves that grow laterally in larger palmate (handlike) shapes and jagged edges (maple, oak, bay), use a sharp filbert brush. First, deposit the paint in the center of the leaf cluster by pressing downward and then drag the paint outward in sharp, pointy marks. Use the side of the brush to create a sense of spiky fringe.

Needle Stars

Needle clusters (Ponderosa pines, Douglas firs) can be difficult, because you have to foreshorten the needles as they spiral around the branches. However, with some patience, you can build up from darks to brighter lights with thin strokes from the tip of a new brush, or you can use the blunt end of a flat brush to "stamp" out needle patterns. By holding the brush tip at a high angle over the canvas surface and then using the slightest pressure to stroke outward from a central point, you can paint a grouping of needles in a rapid fashion.

Fringe

The secret to painting fanlike leaves (cedars) comes from observation of their zigzag patterns of light and dark values. Unlike deciduous trees where leaves grow sideways, cedar leaves tend to grow in a shaggy up-down fashion. If you look closely, you'll notice how cedar branches curve downward, away from the trunk, with smaller branchlets repeating the same curving, descending angle.

Pointy glove stroke

Needle star clusters

Shaggy fringe

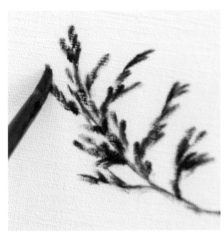

Short-needle star strokes along a drawn branch

Small lobe strokes on upward branch

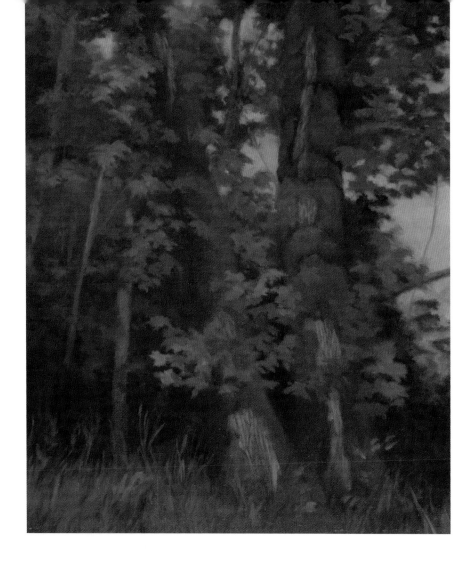

SUZANNE BROOKER,
JUST PASSING BY, 2012,
OIL ON CANVAS BOARD,
10 X 8½ INCHES
(25.4 X 21.6 CM).

A fast painting done in the studio
can have all the fresh qualities of
a plein air, on-site painting when
the goals are the same: capturing
inspiration and passion.

DEMONSTRATION PAINTINGS

Regardless of your approach—studio or plein air—capturing the play of light
and shadow is key to giving foliage a correct sense of volume. Therefore, the first
priority in a painting is the development of shadow areas. For plein air painters,
this is a good test of their ability to gather the shadow values together into larger,
interesting shapes that seem to capture the play of light and shadow across their
subjects—before the light changes! For studio painting, remember darks and
especially dark greens are "sinkers" (see page 31), and will change dramatically in
appearance once dry. Resist the temptation to repaint the darks!

Building up the shadow areas begins with a transparent application of paint that
still suggests foliage even though this area of the painting lacks detail. Making the
shadows appear flat (all the same value) or positive (by using thick paint) is just
as bad as not making the shadows dark enough! Painting foliage in the shadows
requires changing paint density. Thinly painted areas will appear more transpar-
ent than thickly painted ones. Attention to sharp-to-soft edges helps create focal
moments in conjunction with value contrasts with later paint applications.

JUST PASSING BY

For a fast painting session, start with three value mixtures of green, a sky blue, and an earth red (for the ground or branches). Think of these premade mixtures as a jump start for your painting. When working outside, I also load up the perimeter of my palette with small lumps of tube pigments that modulate or adjust my colors to suit the scene's specifics. Since oils become sticky and can make any wet-on-wet paint applications difficult, I use solvent as my painting medium to keep the paint movable in the heat of summer.

You can create a fast painting of a small scene in the studio, with all the feeling of a plein air painting. You can still see the orange toned ground through the first thinly applied coat of dark pigment on the background foliage. Raw umber calmed the intensity of the orange over the trunks, while a tint of indigo brightened the sky.

Before the dark layer dried, I applied a cool midvalue green, wet-on-wet for the leaves in the middle distance. I added definition to the trunks with raw umber and yellow ocher, along with a quick scumble in the foreground.

You can generate a brighter mixture of green from the middle value with a small touch of white and yellow ocher. I used this mixture to paint the leaves over the trunks and parts of the background foliage. More yellow was added into the green mixture to paint in the wild grasses. Notice how the painting progresses from the distant elements to the closer ones.

Begin thick-thin scumble that describes background foliage.

Build up middle values and define trunk.

Develop foreground and details.

THE OLD GRANDFATHER TREE

The bleached-out bones of an old Douglas fir appear stark when contrasted to the verdant greens of the forest behind it in *The Old Grandfather Tree*. The twisted branches create numerous positive and negative shape relations that contrast with the vertical quality of the tree's trunk. Instead of depicting the flat winter light of the photograph, I chose a soft, cloudy light source from the left.

The block-in begins with a "wipe out" method using an earth red pigment over a dried, cool midtoned gray ground. I first thin red umber (Old Holland) pigment with a mixture of linseed oil and odorless mineral spirits, and then apply it with a large soft brush, leaving only a veneer of pigment. The resulting color note is a flicker of warm red over cool gray. When I add paint to draw in details, it appears darker. Likewise, when a rag or clean brush is rubbed over the surface, the lighter cool gray of the ground is revealed. The "wipe out" method allows me to make easy corrections by blurring the drawing into the background with the original red brush.

The dark, middle, and light values I create in the block-in are placeholders that help me focus on the composition. Where do the background trees touch the ground plane? What pattern do I notice in the sky windows? I look to the photograph

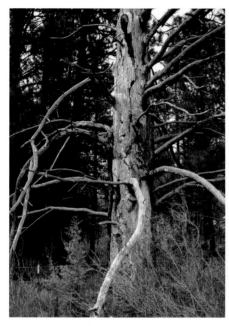

The bleached trunk of a Douglas fir on Orcas Island made an interesting contrast to the wall of green young firs.

Wipe out sky windows from wet ground.

Paint white pigment into wet ground, and add branches.

Begin background scumble of the sky and trees.

Increase background dark values.

Start adding details on the trunk and branches.

Heighten value contrast, refine details, and add foreground grasses.

for insights into the background space, even though bushes in the foreground may obscure my view. If I can't see what's going on, I invent details from memory and experience. Once the structure of the tree is established, I can let the block-in dry before applying any color, or I can paint in light values with white pigment, fusing the white directly into the color of the wet ground.

For the background trees and sky, my palette of green umber, indigo blue, and viridian creates a number of color mixtures from dark olive to cool green for the conifers. Indigo and a little viridian make a bright teal sky color, when mixed to a high tint. With a few drops of linseed oil on my palette, I can modify the green mixtures into slightly more transparent viscosities, which I scumble over the dry "wipe out," using a thick-and-thin approach. I keep the background trees slightly blurred and out of focus with few details, while softening the edges of the sky windows.

While the background dries, I work on the detailed surface of the bare tree, using a finely pointed brush. Raw umber mixed with a little ivory black and a dot of linseed oil makes a semitransparent dark. If this dark paint is too opaque, then the fine lines will float, appearing more like black worms than cracks. I start at the top of the tree and work my way down, picking out only the most interesting details. For the branches, I sharpen the edges and brighten their top surfaces with some white pigment mixed into my oily, dark mixture. I keep the branches darker or duller if they are behind the trunk.

When the painting is entirely dry, I return to the background with a glaze of green umber and a touch of burnt umber, not only to oil-up the dark of the foliage but also to build up the textural pattern. Dark green pigments are known for being pigments that dry to a matte appearance or "sink in," losing both their color note and value. An oily or glaze layer of pigment helps restore dark values, leaving a wet surface for new paint to blend easily over previous dried layers. Reinforcing the background darks also helps sharpen the edges of the white branches, pulling the foreground tree into focus. The ground plane receives a layer of oily burnt umber that increases the dark contrast for the bleached out, weedy foreground plants that are painted last.

SUZANNE BROOKER,
THE OLD GRANDFATHER TREE,
2012, OIL ON CANVAS BOARD,
14 X 11 INCHES (35.6 X 27.9 CM).

The level of detail you apply is a matter of individual preference and patience. A painter's challenge is found in achieving a balance between areas of painterly gesture and refinement of finish.

YOUNG ASH TREE

A photograph of a young ash tree on the edge of a golden grass meadow provides a detailed reminder to me of the experience of painting at this same site during many summers.

The ash tree with its open leaf pattern against the summer sky provides a lively subject. Because it doesn't appear as a solid form, a young tree with its airy foliage can also be very tricky to paint, resulting in either too much detail or overly simplified as an abstracted shape. If you haven't taken them yourself, photographs can appear deceiving. For instance, plant forms may appear sharper in focus even when farther away, like the small trees and shrubs on the left side of the tree in the example to the right. Similar local color seems to blend together, as seen on the shadowy right side of the ash and the big leaf maple in the distance. Remember, your job as a painter is not to copy literally every element of the photograph, but to interpret, edit, and elaborate as necessary, to maximize artistic expression.

Photographs serve to tickle our memory or supply details, but should never become a replacement for observational or felt experience. For instance, what I love best about this tree is how different it looks from this angle, compared to a view from the other side. From this point of view, the branches feel like a big yell of Yes! as they reach for the sky. From the other side, the branches reveal a spiraling pattern, like a woman lifting her long skirts to dance away.

To begin, I select a bright orange toned ground (cadmium orange and a dot of burnt sienna) made with acrylic paints applied in a thin, transparent manner. I start in the same way I would for drawing a tree (see "Drawing a Tree" on page 114), only this time I use a thinned paint mixture (raw umber plus a drop of solvent). I position the main trunk of the tree a little off center, and increase the diagonal slant from the base of the roots to highest vertical branch. I use a simple sloping horizontal line to indicate the base of the tree, reminding me to leave room for the foreground meadow grass. Another line behind my tree marks the middle ground and the base of the farther-away tree line. If this feels right, I can move on to placing the branches.

The drawing stage is the "composing moment," where the design of the painting takes place. If the relationships between the positive and negative shapes, the overlapping of the near and far grounds, or my understanding of a tree's structure is weak, then the painting will lack focus. Because I'm only using thinned paint, it's easy to erase or adjust the drawing.

Using a tint of indigo blue, I start painting in the sky—scumbling or rubbing the paint into the canvas surface, leaving a thin veil of blue while filling in the deep texture of the canvas board. At this point, I define the shape of the foliage negatively, leaving space for the green mixture to follow later, before the blue can

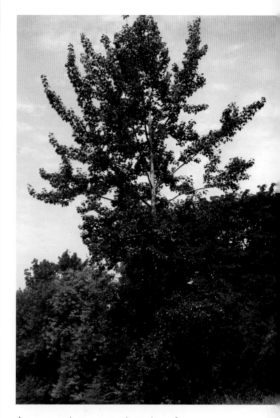

A young ash grows at the edge of a meadow.

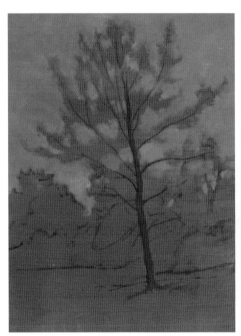

Block in the sky to define the tree's shape.

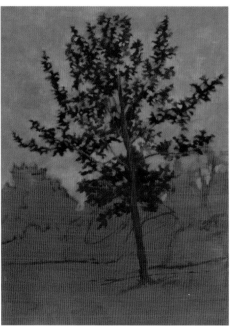

Begin pattern of foliage with dappled brush marks.

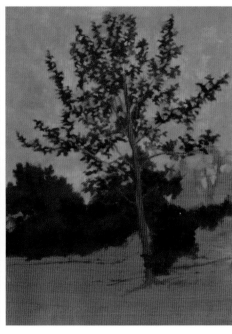

Apply background foliage with thick to thin paint.

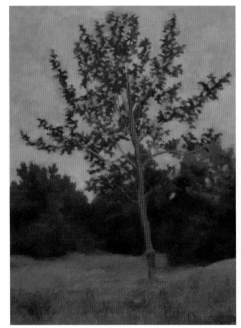

Block in the grass texture with vertical strokes.

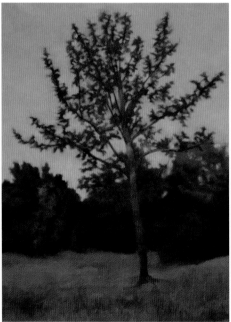

Develop the foliage and sky with additional layers of paint.

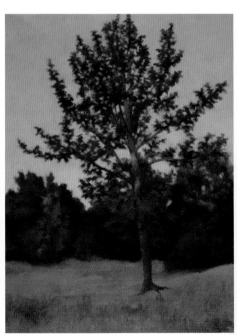

Apply foliage middle values and glaze darks.

dry. (On a large-scale, complex scene, I could paint the entire sky to the horizon, let it dry, and then paint the tree foliage over the sky. This method makes painting feathery, small leaves much easier.) Notice how I've placed the sky windows now, linking these small fragments with the overall sky area.

I begin painting the foliage by modifying viridian green with a bit of indigo to produce a cool, dark green. I also add a drop of linseed oil to my paint mixture to increase the flow of brush marks across the dry surface. I focus on picking out the pattern of the leaves growing close to the branches themselves, rather than on the smaller branchlets. Using a small filbert brush, I press and lift while twisting the tip with each stroke, to make small wedgelike or triangular marks that overlap one another. The resulting pattern combines random variations and order, creating a "leafy" feeling. Before the blue sky can dry, I finish my first pass by moving the paint with my blue-sky brush right up to the dark green, leaving soft edges.

I paint background foliage as a wet-on-wet mixture of green umber and yellow ocher applied in a thick-to-thin manner so that the toned ground affects the color mixture in the thinly painted areas. I use a dappled brush technique to lay down the paint in scattered brushstrokes that appear leafy but without detail. In the same session, I also block in some ground planes by indicating the grass texture using raw umber, yellow ocher, and white. Notice how my spiky, up-down strokes move horizontally or diagonally across the canvas.

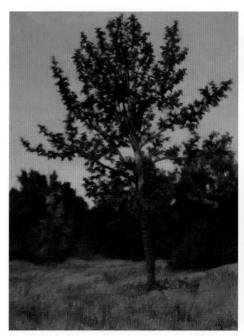

Add light values and build up foreground grass texture.

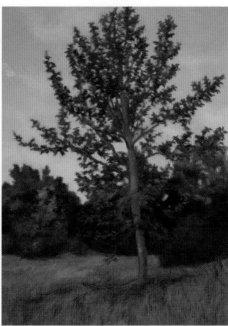

Adjust values and final details.

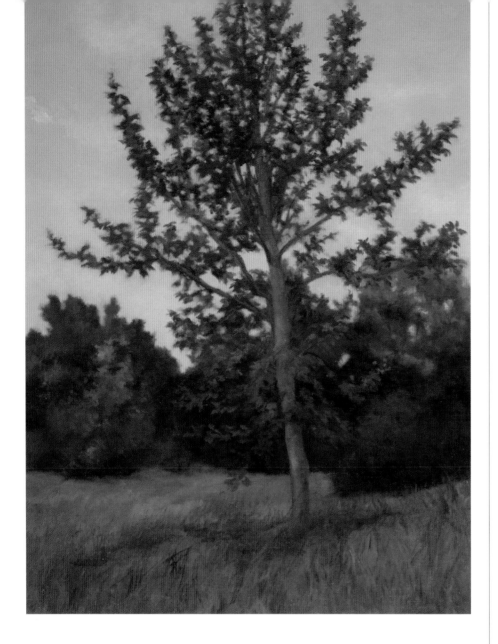

SUZANNE BROOKER, *YOUNG ASH TREE*, 2013, OIL ON CANVAS PANEL, 14 X 11 INCHES (35.6 X 27.9 CM).

Painted from a middistance, this young ash tree displays its upward turning branches that require a certain level of detail—too much detail and it appears closer, too little and it recedes into the background.

Once the entire painting is dry, I return to the sky. I quickly paint in another layer of the sky-blue paint mixture to subdue the orange ground and to brighten the color note. While this paint is wet, I elaborate on the foliage, using the middle value warmer greens and brighter highlights. Imagine the sunlight on the left side of your face: you can see how the foliage turned toward the light is not only brighter but also appears more yellow. The undersides or areas turned away from the sun seem bluer, greener, or darker in the shadows. A thin layer of raw umber plus white and yellow ocher subdues the orange branches and trunk, while indicating a play of light and shadow.

At this point, the painting begins to come together as a whole, so balancing the relative values, details, and textures between different parts of the painting takes priority. This part of the process includes developing the ground plane, as it helps move the viewer's eye from near to far. To create overlapping grass texture, I apply the straw yellows in a few color mixtures of golden to orangey yellows.

I blur in the background grasses with my brushstrokes, gradually becoming more distinct in the foreground by using a thin, pointed round brush. For the shadows underneath the tree, I mix raw umber and ultramarine violet together and wiggle some shaggy lines where I imagine the branches above cast shadows onto the sloping ground.

Little by little, I make the entire image come together—adding a few scattered clouds, clarifying the lower foliage of the ash tree from the background, and correcting any areas that appear flat. Once the entire work is finished and dry, I add the last application of oil medium. Winsor & Newton Artists' Painting Medium (a mixture of stand oil and a quick-drying medium) is lightly rubbed over the surface to guarantee uniformity of the reflective surface and refresh any of the pigments that may have sunk into the canvas.

COTTONWOODS AT MAGNUSON

A small grouping of cottonwood trees in the distance provides a good image for practicing the wet-on-wet paint application techniques you might need for plein air painting. This example was done at midmorning on an overcast summer day, with the sun over my right shoulder. The long, marshy grasses provide a nice lead into the background space.

To begin, I select a small 8 x 8-inch canvas prepared with a layer of acrylic paint tinted to a pale rose color. For my palette, I use a R+Y+B schema of indigo blue, cadmium lemon yellow, raw sienna, and red umber, plus a mixing white of zinc and titanium. The yellow pigments alter the color temperature and intensity of the greens, while the reds dull or neutralize them—securing the ground plane. I mix three green values—cool dark, a minty middle value, and a bright, warm green—so I can work nonstop, fusing one color into another.

Once I extract my composition from the general view (as seen in the source photograph above), I mix some red umber and white—drawing in a quick sketch, placing the verticals of the trunks and locating where they touch the ground. Even though the trees' trunks appear to play peek-a-boo with the dappled foliage, I draw their entire lengths and their branches to keep upward movement continuous. At a distance, trunks and major branches are more sensed than visible.

Next, I squint and look for the shapes of shadow values that I want to paint first, using a thinned mixture of darkest blue-green. If I find the shadow shapes and paint them in very quickly before the light changes, then everything else will be either middle or light values. If you've painted outdoors, then you know the first thing that changes is the relationship between the light and shadow shapes—the sun always moves! Next, I apply the sky blue, leaving a gap so that I can alter the

Bright indirect light in a plein air painting demands that the artist impose a stronger light direction based on the sun's position.

Establish the composition with a block-in drawing on toned ground.

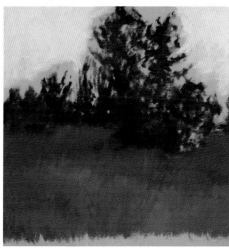

Block in the tree shapes and the sky, followed by grasses.

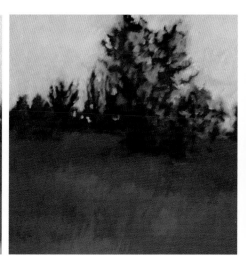

Paint the foreground grasses with short-to-long vertical strokes.

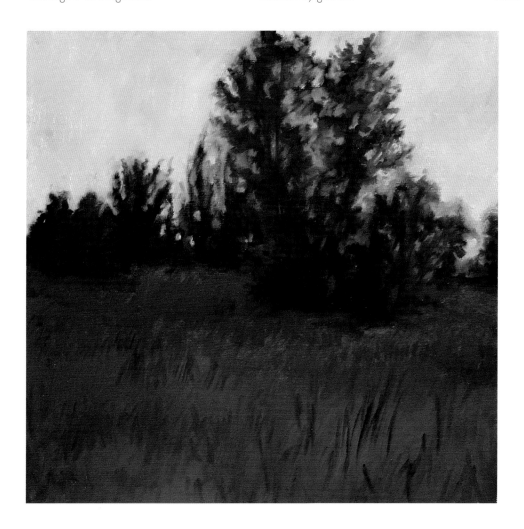

SUZANNE BROOKER,
COTTONWOODS AT MAGNUSON, 2011,
OIL ON CANVAS BOARD,
8 X 8 INCHES
(20.3 X 20.3 CM).

A scene of distant trees set past a field of long summer grasses makes a good image for plein air painting. Simplifying complex forms and details is essential to capturing the first impression.

dark green of the trees without "greening" the sky. My middle green is my foreground color with additions of red umber and lemon yellow used to intensify the color. I apply it in an up-down movement across the canvas board.

While the paint is still wet, I work the cool middle values in a dappled pattern, keeping the brushwork open so that I don't cover all the dark areas of the trees. I try to keep my brush tip loaded with paint. After three touches, I go back to refill the tip with more paint. When I notice there are some areas of warmer middle value, I simply pull out some of my ready-made color and mix it with a dot of cadmium yellow. Notice how I don't try to mix a large amount of color—that's a job better suited for the palette knife. I simply make small, discreet changes in my color mixture with my brush.

Once I've established the trees, I return to the sky with my sky-blue brush, and pull the color to touch the edges and fill in the sky windows, softly blurring the edges. (The blurred edges make the trees look like they're moving in the wind.) So far nothing is really in sharp focus, but the overall feeling of the scene is present. If I'm lucky, less than an hour has passed, and I won't have to chase the sun.
I add some more paint to the foreground grasses, step back to catch my breath, and look at what I've got. Plein air painting requires grabbing the first impression as quickly as possible, with the fluid calligraphy of the brush. It needs swift decisions for both color choices and for the placement of paint onto the canvas surface. You need to have realistic expectations for the style and scale of these paintings. Consider that perhaps one in five paintings may be "keepers" as they come off the easel. Others have to be brought back to the studio for a little fix-up. Before adding further details to my small painting, I prefer to let it dry and then I approach tightening up its edges without painting onto the wet surface.

When moving rapidly from one color to another, painters get confused about when to "wash" their brush in solvent, or awkwardly clasp too many brushes, one for each color. Working quickly means using the same brush for the entire painting, and wiping it with a rag between colors, if needed. At most, choose three brushes that will serve different parts of the painting: a sky-blue brush used to paint sky or water; a large filbert or a firm long flat brush that can be used on the broad side for large areas, turned on its thin side for thinner blunt marks, or lifted so just the tip makes small touches; and lastly, a finer brush for thin lines as seen in branches or tall grasses.

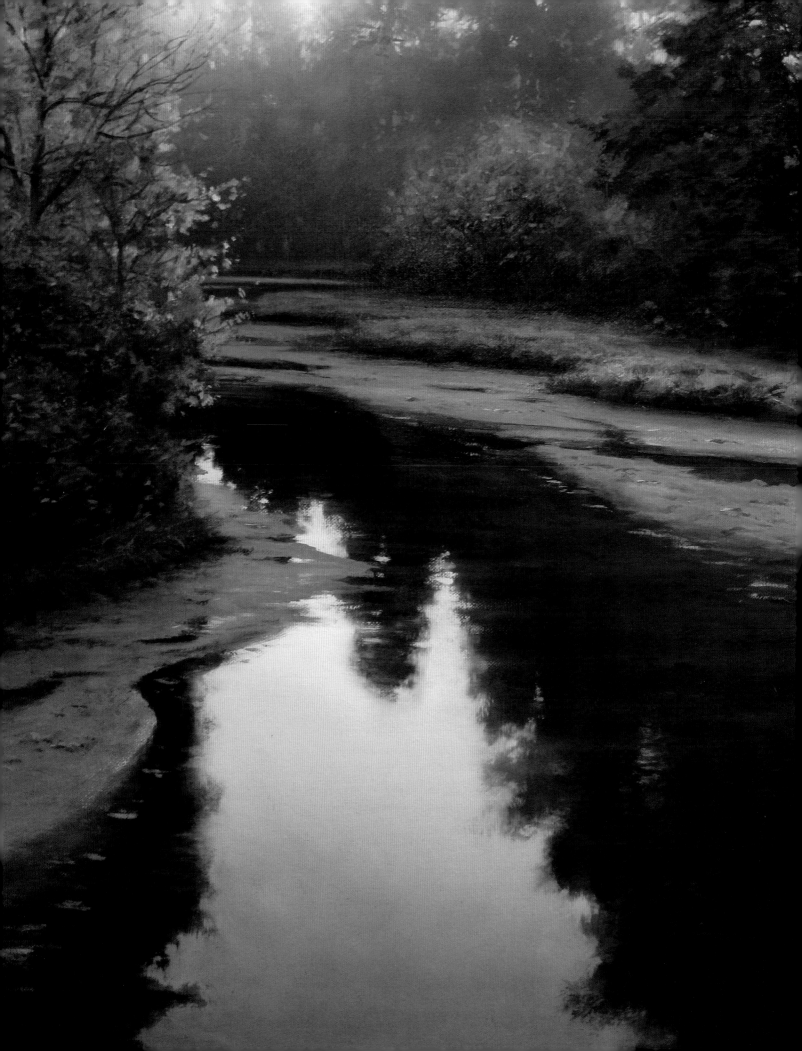

CHAPTER FIVE

WATER

There are places here in the Northwest where the water is cold and emerald green as it crashes into cedar roots and vaults over boulders on its journey downstream to find the ocean. I watch the flow of the water, looking for hints of a repeating pattern in the glinting highlights and curling foam. When I imagine painting a scene like that at Tinker's Creek, is it really the water I'm painting or the constant movement of this elemental force?

Water is like a thief—it steals color from what's around it. Water has the ability to transform from a liquid to a solid and back again, like a magician. It's an elemental presence that unifies all living things.

When you live in a wet climate, you become familiar with water in its many guises—from boggy meadows, lakes, marshlands, ponds, forest streams, and rivers to coastal shorelines. True, this not the epic scenery of crashing waves on rocky shores, but it is a quieter version of water that fills a landscape with its own charm.

ABOVE:
SUZANNE BROOKER,
LAKE SHORE, 2011,
OIL ON CANVAS PANEL,
20 X 16 INCHES
(50.8 X 40.6 CM).

OPPOSITE:
RENATO MUCCILLO,
CONFLUENCE AT DAWN,
2013, OIL ON CANVAS,
16 X 24 INCHES (40.6 X 61 CM).

Still water reflects its environment above the waterline even while the bed of water is revealed in its shallow edges.

Artists have faced the challenge of painting water and it environs through their individual approaches to the subject. For Gustave Courbet, the stark coastlines of Normandy were enhanced with his muscular paint handling. This in comparison to Claude Monet who flicked dapples of colored paint to capture the light on the cliff-sides. Joaquín Sorolla's wet-on-wet paint handling of figures at water's edge conveyed the energy of dazzling light and water reflections. Eugène Boudin's depictions of society at the seashore were restrained even as he rendered them in thick patches of abstractly painted shapes. George Bingham's diffuse luminous approach of portraying the humble fur trappers in the swampy green waters of the Missouri River can be contrasted to Thomas Eakins's sharply focused scullers on the Schuylkill River.

OBSERVING WATER

Several interacting conditions influence the appearance of water: brightness of sky, air flow, current, depth of the water body, and the bed of the water, all contribute to the visual character of water.

Since water has no color of its own, the sky is the greatest influencer for shaping the general impression that water is blue in color. However, on a cloudy, overcast day notice how the very same water appears more steely gray-green as it reflects the clouds rather than the blue sky. Likewise at sunset, the water surface can appear gilded in gold and saffron from the lowered angle of the sun.

Reflections on still water produce a mirrorlike image. However, when the air flows over the water's surface, it pushes it into small rolling curves or ruffles. Now, the reflection is broken into ellipses-shaped ovals that bend away from the wind. On a small body of water, like a pond, the foliage at the shoreline blocks the air, making the water still in comparison to the center—where the air flow swoops downward over the surface. In strong windy conditions, the water surface will show animated peaks and gullies as it is pushed in front of the air flow.

Water current is an internal force that moves water bodies. In mountain streams, the sloping angle of the water bed—moving from a higher source to a lower outlet—drives the water along a faster watercourse. No wind is needed here to create the foamy agitation of the water's surface. Gravity pulls the water downhill, bouncing it from stone to stone along the bank. The force of the water carves out inlets or shallow recesses, allowing the water to regain its reflective qualities. Tides created by the gravitational pull of the moon also create the impression of

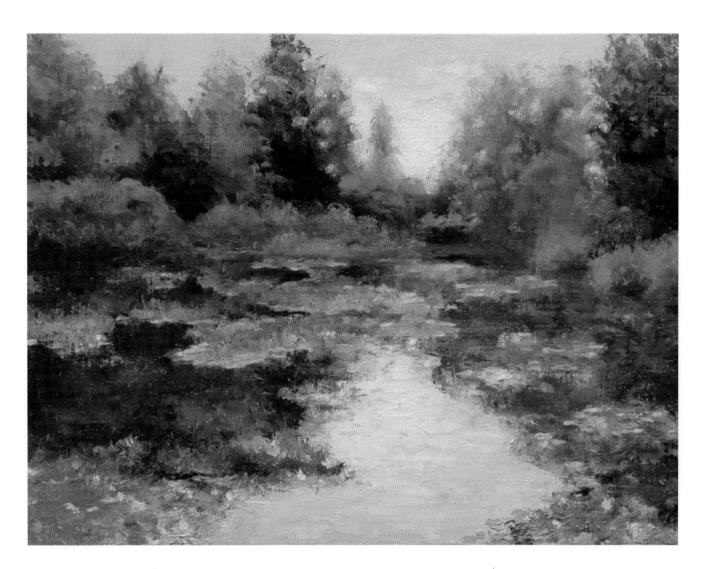

current. Water flows in and away from the shoreline, especially in larger bodies of water, such as bays, inlets, or sounds that are linked to the ocean's tides.

When you observe a marshland, the shallow water reveals the influence of the murky bed and darkens its color. Shallow water over a white sandy beach has the opposite effect, brightening the reflected blue (sky) of the water. So when the water layer is shallow, the transparency of the water is more influenced by the bed of the watercourse than the place where the water is deepest.

You can divide different types of water situations into categories that help you decide which approach will be most effective for rendering them: indirect studio painting (underpainting and multiple layers) or a direct/*alla prima* approach (wet-on-wet painting). Indirect painting approaches executed in the studio will give you the most success in rendering complex water conditions, such as transparent thin water where the bed of the water seen below is separated from the water reflections observed above. Painting fast water, on the other hand often requires using the flow of wet paint for a look of spontaneity.

CHRISTINE GEDYE,
LILIES IN DRIZZLE (GIVERNY),
2008, OIL ON PANEL,
8½ X 11½ INCHES
(21.6 X 29.2 CM).

A lush subject on a small format challenges a painter to quickly capture the feeling and atmosphere of the scene through freshness of deft brushwork.

STILL WATER: REFLECTIONS AND SHORELINES

Calm water reflects the shoreline and surrounding vegetation in forms from an inverse mirrorlike image to one that is diffused and blurred, depending on air flow and current. Keep in mind that the value contrast seen above the waterline is reduced in its reflection so that light areas like the sky, appear slightly darker, and bright foliage appears more neutral. The darker areas like shadows in the trees are a bit lighter in value. By preparing a quantity of paint mixtures, you'll not only be ready to paint the upper portion of the painting, but also will have a surplus of paint that needs only minor adjustments for painting the water.

It's often more practical to paint what is above the waterline first so that any deviations from the motif are not carried into the water's reflections. For example, if you edit out or move something in the "upstairs" portion of the painting, the reflected "downstairs" image must match exactly. Notice how a sloping bank will produce a smaller reflection than one that is steeply vertical. You must also carefully observe objects that project or hang over the water's edge: Are their reflections longer or shorter? All reflections (except objects tilting over the water at an angle) are vertically aligned with the source of the reflection. Air or water currents may seem to break the reflection up into oval shapes, but their alignment must still be vertical. Surprisingly, it's this vertical alignment that conveys the flatness or horizontal character of the water itself.

To create a sense of distance on a blue plane of the water, observe how the ripples or choppiness of the water's surface is blurred at a distance. As the surface pattern moves closer, the size and frequency of the ripple pattern becomes more apparent. By changing the size of your brush marks and the thickness of your paint, you can keep the water from appearing as a flat blue wall.

Taking Photographs of Water

Photographing moving water allows you to capture the pattern of movement and reflections on the surface. If you place yourself so that the water faces you head-on, then the incoming water appears as static, horizontal bands. Instead, photograph water from a side angle so that the surface movement is at a diagonal, increasing the dynamic quality of your image. Remember than diagonals lead the eye back into deeper space.

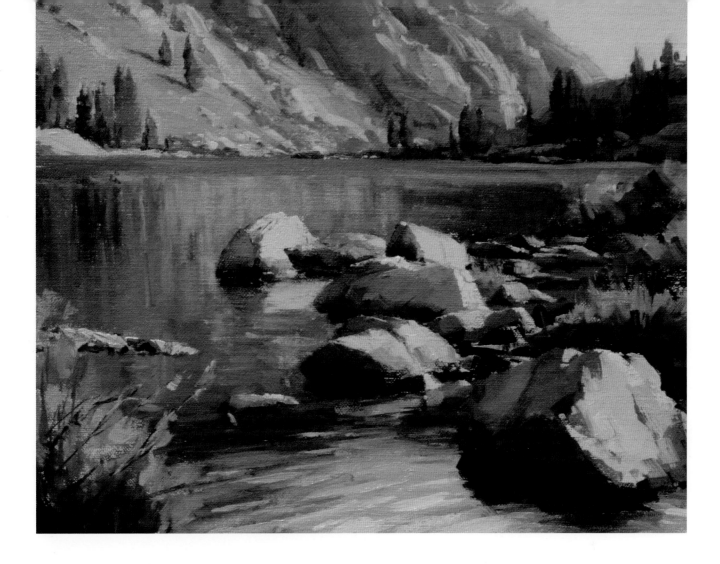

SHALLOW WATER: MARSHLANDS, LAKES, AND SMALL PONDS

The appearance of shallow water is more often affected by the bed (or what lies underneath) than it is by surface reflections. This effect gives a brown-green color note to the water, especially where it seems transparent. A thin layer of water is usually more convincing when a transparent underpainting of burnt umber or van Dyke brown is used to first establish the bed of water. You can then add sap green dulled with burnt sienna to suggest vegetation under the water in a shallow pond.

First, consider the contours of the ground—the sloping sides of a gully, slough, or canal are blocked in before the water is painted. Attention to overlapping at the waterline and receding curves of the shoreline helps you create a successful recession of the horizontal plane from near ground to the distant background.

Once the underpainting is dry, transparent "water" can be painted by modulating the thick-to-thin application of pigment or glaze. Elements like pond scum, water lilies, or sparkles of light are best painted over previous dry layers so that any changes can easily be removed or modified.

KATE STARLING,
EDIZA LAKE REFLECTIONS,
2009, OIL ON LINEN MOUNTED
ON PANEL, 11 X 14 INCHES
(27.9 X 35.6 CM).

A high mountain lake takes on the reflections of it surroundings. Notice how the strong chiseled brush marks of the rocks contrast with the supple water surface.

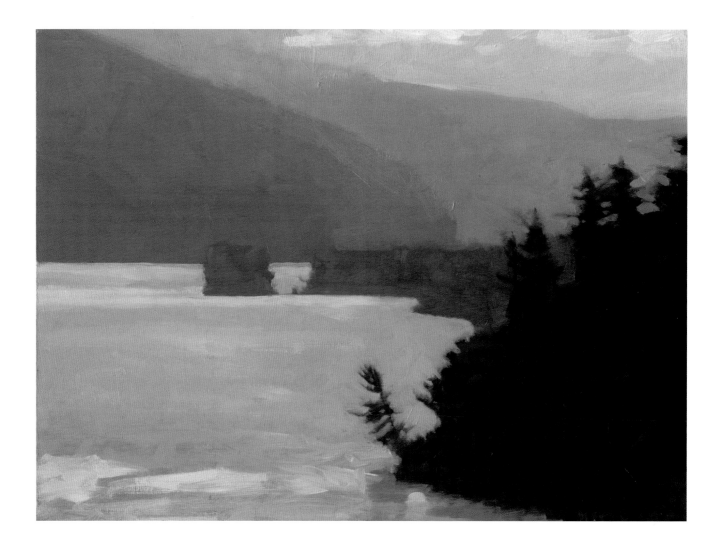

FAST WATER: RIVERS AND FOREST STREAMS

Think of the contrast between the solidity of boulders and shorelines against the fluid nature of the path of fast-moving water. It often helps to first block in the water channel and prominent boulders, and then loosely sweep in the pattern of the water using wet-on-wet painting techniques. (See page 77 for details on rendering stones.) Because a fast-water painting focuses on the spry movement of the water, careful attention is needed for perceiving and painting the continuous, connected flowing pattern of the water.

The best approach is to paint the dark of the water first, then apply the middle values, with the highlights (such as the opaque white, swirling foamy bits) placed last. Fast water in the open air will be more influenced by the color note of the sky first, and then by submerged stones. Forest streams surrounded by trees will tend to be greenish, making Prussian blue or viridian good pigment choices.

MARC BOHNE, *HILLS BEYOND LAKE GEORGE*, 2003, OIL ON PANEL, 8 X 10 INCHES (20.3 X 25.4 CM).

A small study of a fast-moving river uses an economy of brush-strokes to convey the action of the water.

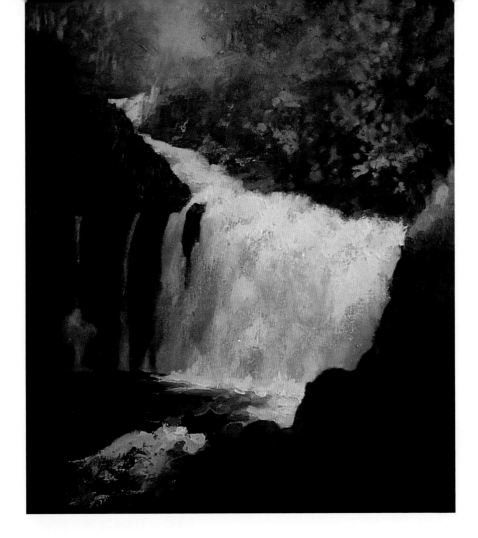

This plein air painting at a site familiar to the artist began with a tonal underpainting of burnt umber and cobalt blue and was then finished in the studio with additional layers of white pigment.

A warm neutral tone of burnt umber and ultramarine blue was used in the underpainting to establish the composition and value structure. Then a series of semitransparent glazes and thin layers of titanium white were used to gradually build up the pulsing rhythmic quality of the waterfalls. The artist paid careful attention to the subtle temperature differences within the largely neutral color field and his limited palette.

FALLING WATER

Falling water is depicted as a curtain of constant movement, making it difficult to capture in a static image. But if you study the pulse of the water flow, the pattern of lights and shadows becomes clearer through the haze of water vapor. For instance, look for outcroppings of stone that briefly stop the water flow, bouncing it outward or dividing it into several streams that eventually merge together again.

The easiest approach for painting falling water is to begin with a very dark ground of phthalo, indigo, or Prussian blue for the watercourse or used as an overall toned ground. The next step is to apply pure white pigment from thin to thicker layers, which will appear gray-blue to very white as the pigment gains opacity. In this way, you can avoid creating a light blue waterfall—where the blue and white pigments mix together—and still indicate the important shadows within the waterfall.

A second approach involves a transparent toned ground of earth red, such as Mars brown or burnt sienna, that's mixed with a tiny portion of burnt umber. When the white pigment is thinly applied, a gray-blue value is created by simultaneous contrast. For a bluer color note, you can apply a sheer layer of glaze once the underpainting is dry.

DRAWING CONCEPTS

Water is predominantly a flat plane, except in the form of mountain rivers that run downhill or in falling water. Your eye level and point of view strongly influence the perspective of water. Imagine the differences between sitting on the shore looking out over the water compared to looking downward from a cliff above. The lower the angle (point of view), the greater the foreshortening of the water plane—what is near and far away seem closer together. The higher your point of view, the more you'll see of the water's surface.

WATERLINE

The waterline divides the horizontal surface of the water from the surrounding vertical elements (such as the bank or reeds). This transition line is often marked by a dark line that indicates where the shoreline and the water's edge meet. Notice that when a coast or shoreline curves away into the distance, the waterline must act like stairs stepping up and back into space. Without an indication of the receding and overlapping planes along the shore, the waterline seems to tilt upward, as if it were flowing in the air. Even the bank at the water's edge needs to be considered as composed of two planes, the angled downward slope and the top plane. Look at the image opposite that outline these concepts.

DESCRIBING THE RECEDING PLANE

Looking out over the surface of water, think of it as a blue floor. Unlike the ground plane, it is often moving in an undulating fashion. You can apply the same use of atmospheric (aerial) perspective reviewed in chapter 3 (page 80) to depict the receding plane of water. Look for things such as the reduction in the scale of marks, the decreased spacing (frequency) between marks, the low contrast of value and details in the distance compared to greater contrast, and sharper edges in the foreground water pattern.

When water is choppy, the pattern of peaks and gullies is difficult to interpret. Imagine casting a net thrown over the surface of the water. Look at the image at right. Unlike a checkerboard grid (or the floor tiles in a Renaissance painting), this image shows no horizontal edges parallel to you. What you see is a series of diamond shapes created by intersecting diagonals that recede into the distance. To make it more naturalistic, add a slight bending to your net pattern: now the tide is coming in! You'll find it's helpful to draw with a white pastel pencil over a digital

The quick surface of undulating water presents a complex surface that can be understood once a diagonal net is imposed over it. Now you can observe the pattern of hills and valleys over the water surface and translate it into your painting.

print or to use tracing paper over a photograph to mark the big overall pattern rather than getting stuck on infinite details.

You can avoid the confusion of multiple details in water patterns by moving from larger shapes to smaller details. For instance, you can think of the larger wave action like rolling hills on the ground plane, and the smaller details like grasses bending in the wind.

SHAPE OF THE WATER

When water is an important element in a composition, the shoreline becomes a significant eye path as it leads the viewer through the image. The more you can keep this edge as a diagonal versus a flat horizontal line, the greater the visual dynamic. Take care, however, to notice the receding planes of the shoreline. The closest part of the shore may need greater contrast and texture, whereas the distant part of the shore will require lighter values and more neutral color mixtures. Look for places where the banks along the water edge overlap to achieve a depth of space. A change in eye level will affect the curving shape of the coastline. When you stand at the shore, you observe the water contour (where water touches the land) as an ellipse or oval shape. But the same shoreline when viewed from a higher elevation seems wider (more circular than oval), as you look down on the water surface. The foreground from this vantage often needs a visual clue, such as tall grasses or cliff stones, to reinforce the higher eye level.

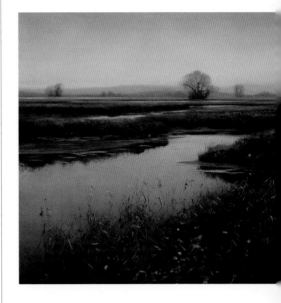

RENATO MUCCILLO, *OCTOBER TOWARDS GRANT NARROWS*, 2011, OIL ON LINEN, 11 X 11 INCHES (27.9 X 27.9 CM).

Note how the dark edge of the waterline indicates the change from vertical growth to the horizontal planes of water and the muddy shoreline.

Compare the waterline shape in the color photo to the drawn concept of staggering or stepping along the edge to keep the receding plane level.

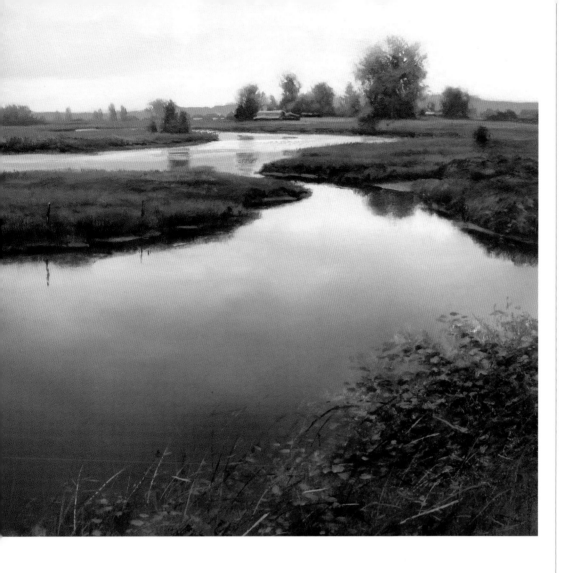

RENATO MUCCILLO,
MCNEAL SIDE ROAD,
2012, OIL ON PANEL,
11 X 11 INCHES (27.9 X 27.9 CM).

The artist's careful depiction of the wandering watercourse leads the viewer's eye into the distant space of the scene. Notice the treatment of the reflections broken by the ruffled water in the background in comparison to the still water reflecting the cloudy sky in the foreground.

Over a ground of dark indigo, thin layers of white pigment build up from a steely blue-gray to a more opaque white value. On the right side, white pigment is applied in a thin-to-thick manner that suggests the flow of water. Once dry, a sheer glaze of Sennelier blue tints the white for a strong color note.

TONED GROUNDS

The choice of toned ground can provide support for the atmosphere and mood of a painting. When water appears under a moody sky, it has a silvery quality that you can capture by not painting it on a gray ground but using one that is a warm orangey-brown. Applied as a thin stain over the gesso canvas, Mars brown (Old Holland) or quinacridone gold (Daniel Smith) are potential pigment choices. Now the cool color notes over the warm toned ground results in a greater dynamic by creating optical blue-grays. As with painting skies, if your toned ground is a brighter orange—like alizarin orange (Williamsburg)—then it increases the complementary contrast, changing the mood from a feeling of autumn to one of spring.

A dark ground of indigo, phthalo, or Prussian blue is utilized to capture the dark values of the water—as in falling water in a forest scene. Now you can apply the mid-to light values of the water pattern directly into the wet ground, or apply them later after the ground has dried completely. You can also scumble white pigment in a thin-to-thick manner to create optical gray-blues, and then

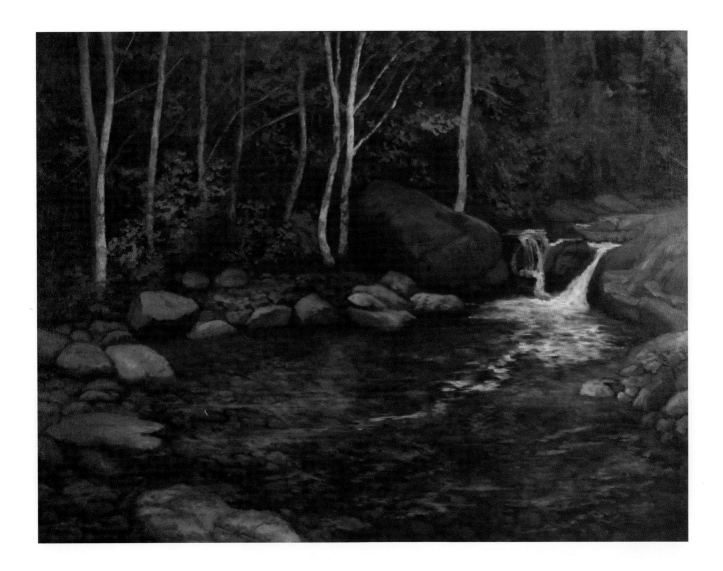

overglaze for a more intense color note as shown on the right. A toned ground of midvalue cobalt blue and white also gives a stunning blue cast, suggesting cool moisture in every part of the scene.

When burnt umber or van Dyke brown is employed for painting shallow water at the shoreline or fast water over stones, try first mixing a portion of ultramarine blue or cobalt into your dark brown pigment to create a richer undertone of color. To test the undertone, take a small portion of the pigment mixture and add white. Once the dark value has been opened by the white, you'll perceive the bluish tendency in your dark brown. Applied as a thin stain over your white canvas, the ground will provide the cool darks for the bed of the water.

SUZANNE BROOKER,
POOL AT GOLDMEYER, 2011,
OIL ON CANVAS,
16 X 20 INCHES (40.6 X 50.8 CM).

Painted over an orange toned ground, the underpainting of raw umber, burnt umber, and ivory black establishes the stony bottom of the river course. A series of glazes of manganese blue, Sennelier blue, and ultramarine blue are then painted over the dry underpainting to establish the water plane.

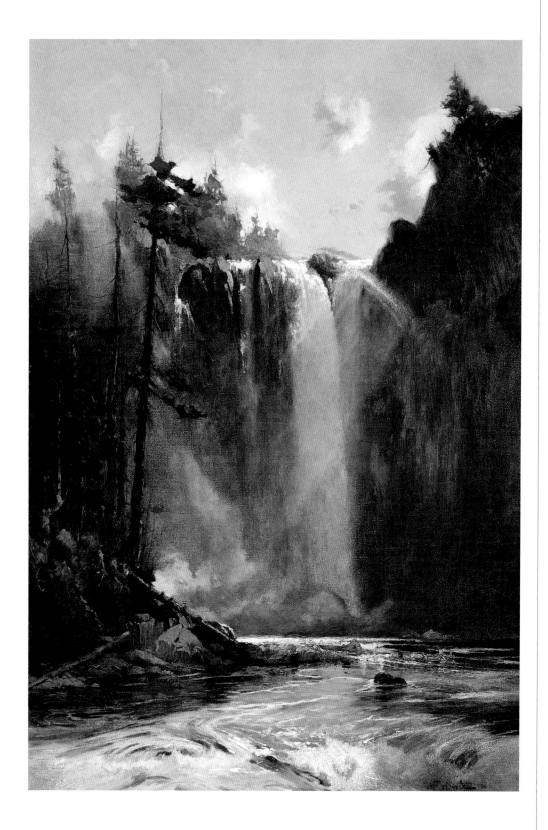

SYDNEY LAURENCE,
SNOQUALMIE FALLS, N.D.,
OIL ON CANVAS,
30¼ X 20¼ INCHES
(76.8 X 51.4 CM),
COURTESY OF THE
FRYE ART MUSEUM.

Notice how the artist used the
warm transparent toned ground in
the cliff-side, building up the fall-
ing water in sheer layers of paint
in contrast to the more opaque
swirling water that advances into
the foreground.

1

2

3

4

1

SUZANNE BROOKER, *FAST RIVER STUDY I*, 2011,
OIL ON CANVAS, 21 X 13 INCHES (53.3 X 33 CM).

On a golden yellow toned ground of raw sienna, the river rocks underneath the water are implied as the wet-on-wet blue pigment mixtures are painted over their contours. This painting began with a block-in drawing of raw umber used to establish the visible stones and the shadows in the watercourse. Next, three values of blue were used to define the flow of the water with a thicker white dragged over the surface to suggest the foamy trail of the watercourse.

2

SUZANNE BROOKER, *FAST RIVER STUDY II*, 2011,
OIL ON CANVAS, 21 X 13 INCHES (53.3 X 33 CM).

On an ultramarine blue toned ground, a sequence of white pigment—from thin oily layers to thicker applied paint—creates the movement pattern of a mountain stream. The thinly applied layers generate a paler blue as the ground optically changes the color note. A soft-tipped filbert brush moves the pigment in a curling, swish motion, capturing the sense of the animation over the water surface.

3

SUZANNE BROOKER, *FAST RIVER STUDY III*, 2011,
OIL ON CANVAS, 21 X 13 INCHES (53.3 X 33 CM).

The earth red toned ground of burnt sienna and burnt umber supplies the local color for the protruding boulders in this high mountain stream. Van Dyke brown is first used to draw in the rocks' forms, creating landmarks for the watercourse, and then is used to develop values of burnt umber and black. Once dry, white pigment can be applied in a thin-to-thick manner creating optical blue-grays and pure white notes of the water.

4

SUZANNE BROOKER, *ROCKY SHORELINE AT SHARK REEF*,
2009, OIL ON CANVAS, 24 X 18 INCHES (61 X 45.7 CM).

You can re-create steely water at the coastline when you apply warm pigments thinly over a cool gray toned canvas for a double toned ground. First, a sheer layer of warm Mars brown is applied over the entire surface and allowed to dry. Next, oily mixtures of burnt umber are used to block in the shapes of the rising stones. Then mixtures of gray (ivory black and white) develop their contours. Similar tints of gray are used to create the water pattern, allowing places for the toned ground to appear.

PALETTES

In chapter 2, I talked about the characteristics of blue pigments and how you change them as tints and tones. These same color mixtures are also bound to appear in the water (though in a slightly darker or neutralized version) when the sky is reflected there. However, water also takes on the colors of its environment. For instance, a trout stream surrounded by tall conifers will have a distinctly green color note. Red-gold colors show up from surrounding autumn trees. Mossy green can be reflected from an overhanging willow tree. In these cases, additional pigments are mixed into the water pigment mixtures or worked in with wet-on-wet brush handling. In fading evening light, the color of water may not be blue at all, but may take on the rose-peachy color notes of the sunset!

However, when you want to keep the blue color clean and pure, you can glaze blue pigments over an underpainting. This approach begins with an underpainting using a range of neutral grays that provides the value structure and detail for the transparent glaze. You can develop the underpainting in a gestural, wet-on-wet paint approach or with exacting details as needed. (See demonstration painting *Inlet at Moses Lake* on page 170.) Over an earth-red toned ground, this approach is also very effective for depicting shallow water, where the bed of the watercourse—muddy or stony—is perceived underneath the water.

A second method for underpainting is scumbling a thin layer of lighter pigment (pale gray-blue or white) over a darker color (burnt umber, van Dyke brown, or Prussian blue) as shown in the color chart on page 163. In fact, any lighter color thinly applied over a darker value will appear cooler in temperature. You can think of this approach as working in a "negative" fashion: the dark ground provides the dark values while thin layers of white pigment create optical blue-grays. Unlike glazing, scumbled pigment mixtures are applied in a thin manner to achieve transparency rather than thinned with oil or odorless mineral spirits. The thicker the paint becomes, the brighter the value. This method is utilized when painting falling water, but can be equally effective for rendering choppy water waves or swirling mountain streams. (See demonstration painting *River Run Study* on page 173.)

Often the results of working on a dark toned ground, from dark to light, are useful for painting snow and moonlit scenes. Although paintings developed in this way can also serve as underpaintings to be glazed later with color, they are often satisfying in their monochromatic beauty.

A small study painting on the opposite page shows the impact of glazing over a developed underpainting. This painting begins with a dark toned ground of burnt umber and a dot of indigo blue. On the dry surface, I first thin white pigment with

odorless mineral spirits to establish the block-in drawing leaving the major trees forms dark. The optical gray values appear as the results of thinly scumbling white over the ground; no black, oil, or odorless mineral spirits was added to the white pigment. I make brighter areas of the painting with thicker, opaque layers of white paint. (If the dark ground is covered by mistake, I can repair it by using the same color mixture as the tone ground and allowing it to dry before any further white is applied.) Since even the sheerest glaze will have a darkening effect, it is important to keep the value contrast distinct as the glaze color appears only in the light values.

Glazes can be multicolored, if needed, to create the right effect. In this study, I apply sap green lake extra (Old Holland), green umber (Old Holland), Sennelier blue (Sennelier), raw umber (Old Holland), and clear oil where no color is needed in the darks. I paint additional details into the wet glaze surface, as seen in the foreground rocks. The finished glazed painting dries horizontal with good ventilation.

ABOVE:

LOUISE BRITTON, *MOONLIT CREEK*, 2008, OIL ON CANVAS, 16 X 34 INCHES (40.6 X 86.4 CM).

A low-key night scene provokes a moody light of silver gray. The strong shape of the watercourse dominates the composition as the viewer follows its wandering track.

BELOW:

SUZANNE BROOKER, *CREEK STUDY*, 2013, OIL ON CANVAS BOARD, 8 X 10 INCHES (20.3 X 25.4 CM).

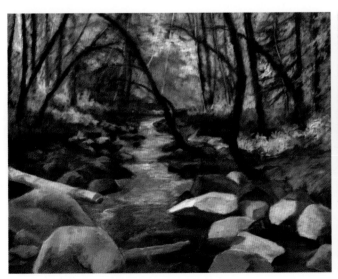

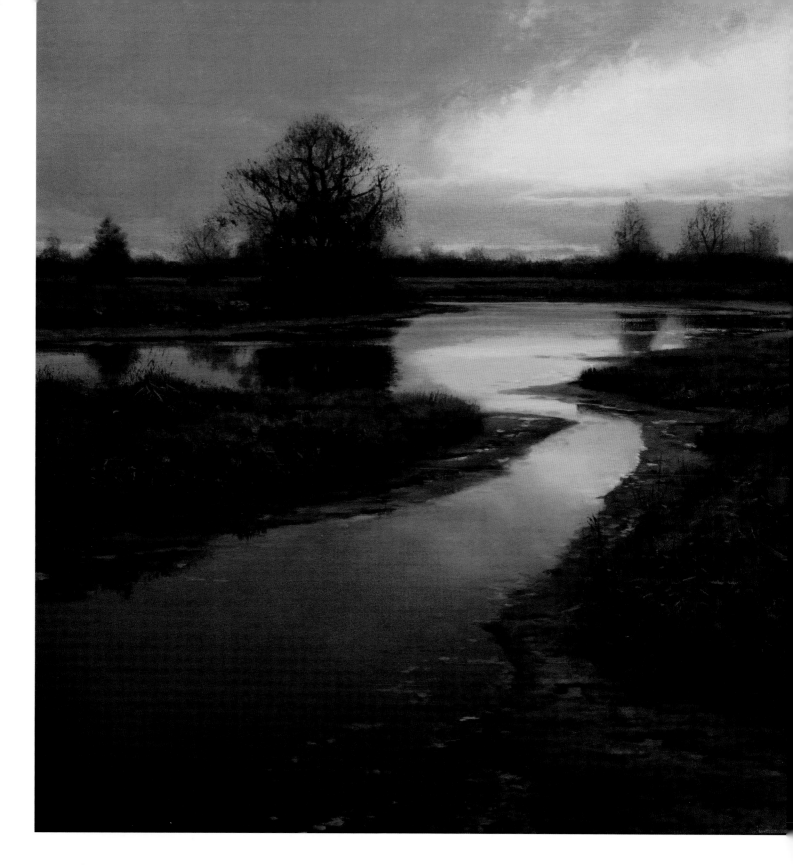

RENATO MUCCILLO, *SOUTHERN ARM CONFLUENCE*,
2012, OIL ON PANEL, 11 X 11 INCHES (27.9 X 27.9 CM).

A dynamic flare of light at the end of the day warms the muted
neutral palette.

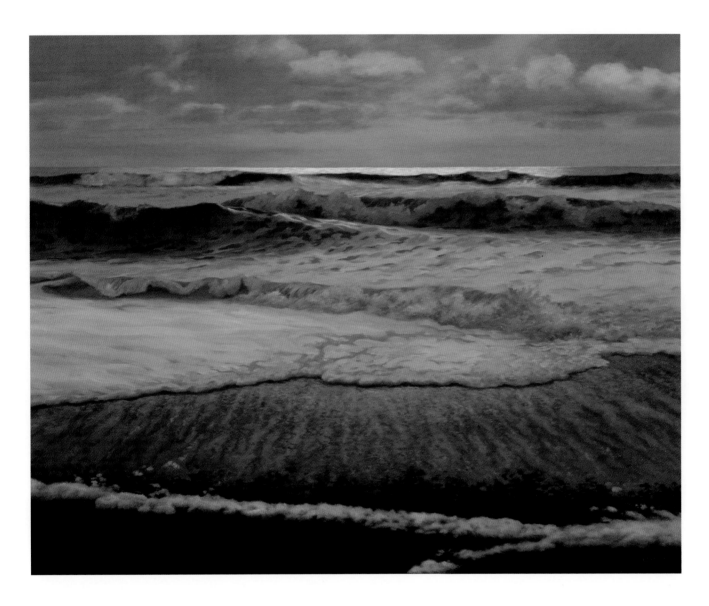

LOUISE BRITTON, *GRAY SEASCAPE II*, 2008,
OIL ON CANVAS, 28 X 36 INCHES (71.1 X 91.4 CM).

This deceptive gray painting is not the result of simple mixtures
of black and white, but is instead filled with subtle temperature
and color notes.

Glazing

Glazing involves using a sheer (ultrathin) layer of oil with a small amount of transparent pigment that you can apply with a soft brush or lintless rag pounce for big, overall applications. It should never be thickly applied like gooey syrup. Not only does this delay drying, but it invites hairs and bugs to become glued to your painting! Glazing results in a finishing layer of "fat" oil over multiple layers of completely dried paint.

Glaze is traditionally made with *stand oil*—the most durable and most flexible linseed oil medium—and a thinning agent, such as odorless mineral spirits, pure gum turpentine, or a small portion of a quick-drying resin like Galkyd (Gamblin) or Liquin (Winsor & Newton). Used as a means to tint light values in an underpainting, glaze can also alter color temperature over small or large areas of a painting. For example, it can increase the warmth of light or coolness of shadow areas. Glazing can enrich a painting's surface with a jewel-like layer of pure color—such as the transparent blue glazed over the sky. Glaze is not a means to establish details nor should you confuse it with oily paint used for fine semitransparent details. Technically, multiple layers of glaze can be applied on a

painting; however, this often results in muddied colors unless previous testing has been done to establish the effect of the staining strengths of a pigment or the neutralizing effects of complements, such as yellow glazed over violet.

Glazing is also one way to colorize a monochromatic underpainting of warm grays or raw umber. Glaze color is most evident in the lightest to the midvalue areas of a painting. All glazes (even transparent yellow oxide) have a darkening effect, so planning ahead is necessary to retain a higher key in value where a glaze will be applied. If an area of the painting becomes too dark, then you can apply a semitransparent white or pale tint to adjust the value and then reglaze with care.

A separate white Plexiglas palette or a spare sheet of glass with white paper underneath is a good place to mix glazes, keeping the oil puddles out of your paint box. First, mix the stand oil and thinner together thoroughly with a palette knife to a brushable consistency, using less than 25 percent thinner. Next, divide the thinned oil into smaller puddles keeping in mind how much quantity is required for any specific area.

The best approach is to mix many different colors or strengths of glaze, some bolder and others with barely a breath of color, using only transparent pigments. White is never added to a glaze mixture (that is, glazing with a tint). But you can paint zinc white directly onto a wet glaze surface to suggest the gleams of water or the highlights on leaves. If you acquire a set of transparent red, yellow, and blue pigments, then you can mix any color you'll need for glazing. Some helpful pigments might be terre verte (Sennelier), viridian (Sennelier), rose dore or rose madder (Winsor & Newton), transparent yellow oxide (Rembrandt), genuine lapis ultramarine (Daniel Smith), and ultramarine violet (Rembrandt).

Before applying a glaze, make sure the painting is dry—past dry to the touch (the surface does not feel cool to the touch). Cleaning the surface with a mixture of diluted ammonia water (1 part ammonia to 5 parts water) with a lintless rag will help you avoid any "beading up" of the glaze on areas that resist further oil. If the painting has been oiled up once or twice during the middle stages, the dried paint surface may have developed a resistant skin that

can be "opened" with the chemical abrasive in the ammonia water.

Always test your glaze colors on a discreet part of the painting surface or on the side of the canvas. If the color is right and the density or strength of color is correct, then you're ready to go. Paint freely (as long as the oil is not thickly applied). You can wipe off changes with a clean rag or brush. Wherever the color glaze is not painted, apply clear stand oil, keeping the oil layer even throughout. At the end, look across the surface of your painting, making sure that there are no dry spots without oil or areas where the oil is obviously thick. You always want to keep the oil layers even over the entire surface to avoid any ridges that may cast shadows. Now the painting must dry flat (with good ventilation) for five to ten days to avoid any drips from the weight of the stand oil.

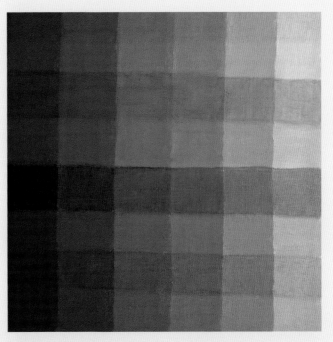

Glazing over values of gray from low middle value to very pale gray using ivory black on a white gesso ground: notice how the layer of sheer glaze changes in value, but the denser glaze overcomes the underpainting.

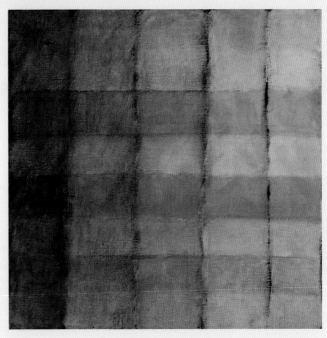

Glazing over scumbled white pigment on a dark toned ground of burnt umber. Glaze colors are applied with denser color first, and then with a greater proportion of oil to pigment for a sheer color note.

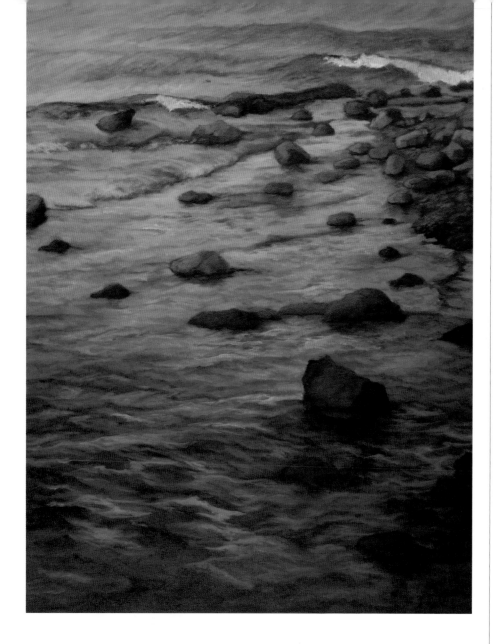

SUZANNE BROOKER,
LAKE SHORE, 2011,
OIL ON CANVAS PANEL,
20 X 16 INCHES
(50.8 X 40.6 CM).

A variety of brushstrokes were used to create the sense of movement over the undulating water surface.

BRUSH TECHNIQUES

Painting water tests your bravery: you have to make confident brush marks even when you want to run away! One trick is to treat the fluid nature of paint as if it were water gliding over the surface. And of course, the second trick is to practice! A piece of canvas paper provides a quick surface for practicing the brushstrokes described ahead. Check the firmness of your brush: Does it have enough spring to bend with the pressure of your stroke? Is the tip soft enough not to drag the paint off? Next, check your paint: Does your paint have a "creamy" consistency, or is it tough to pull across the surface? Remember to adjust the mixing white pigment with a dot or two of oil, before you add in your blue color.

Success in rendering the flat plane of water comes from keeping the brush tip moving in a horizontal fashion. Any flicks where the brush mark lifts will suggest your water is flowing uphill, while any vertical marks will create a blue wall.

WET-ON-WET PAINT APPLICATION

One of the most challenging tasks is painting on a wet (paint) surface. Without attention to the pressure and angle of the brush tip, the new paint color becomes mixed with the first layer, resulting in a flat value.

For the best results, begin by working the entire horizontal length in bands—from the waterline toward the bottom of the canvas. First, a thin layer of paint (usually the darkest value) is scumbled evenly across the canvas, covering the toned ground and leaving no "chicklets." (See page 56 to review this brush technique.) This approach moistens the surface with paint—like a thin layer of "peanut butter"—so that the next "jelly" layer of paint glides easily. Next, load the brush tip with a good nugget of paint and pull it over the surface using the brush at a low angle to the surface using hand-over-brush technique. Position the brush in a side-to-side manner that keeps the paint marks horizontal.

Resist the temptation to overwork the paint, stretching it too thinly or raising the brush angle. Recharge the brush tip frequently so that there is always some paint between the brush and the canvas. You can use a soft-tipped filbert brush with moderate firmness on its side to make small marks, and then turn it to a broad width to make larger strokes.

Horizontal side swish

OVALS

Water that is undulated gently by wind or current breaks the surface reflections into lozenge (or oval) shapes. The parts of water ripples that face the sky appear brighter and bluer, the places where the water faces the shoreline take on the coloring of surrounding foliage, and the darks show the depth of the water.

Creating these ovals shapes is a matter of controlling the pressure of the brush tip with the brush held at a high angle to the canvas surface. If you pull a horizontal line using even pressure, it results in an even, thick line. But if you begin with a lighter touch, increasing the pressure slightly and then lightening the pressure evenly as you pull horizontally, it results in an oval-like shape. Linking oval shaped strokes together produces an undulating line and a sense of movement.

It may take some experimenting to find the right brush type. Because filberts have a rounded tip, they prove useful when beginning to master this technique. However, long flats used on their narrow sides can be made to behave like blunt round-tipped brushes, making them useful for rendering oval brush marks. Like painting wet-on-wet, the brush tip must be loaded with a sufficient amount of paint for every stroke.

Oval strokes

ZIGZAG

When the movement of water is sensed but not in focus (as in open bodies of water, such as lakes), another approach that's useful for rendering water is the zigzag stroke. In this technique, the brush tip is charged with paint and swished horizontally from side to side. By stepping it down (like stairs), you leave a zigzag pattern. Linked together, zigzag strokes can suggest a diagonal flow—as when the wind lightly moves across the water's surface.

RIPPLES

When oval-shaped marks are linked together, they produce an undulating rhythm that can extend over the curving hills of incoming water. A well-charged filbert brush tip pulls a long line of paint, alternating light and firmer pressure. The key is to stagger the pattern so that the thick and thin shapes are not aligned directly underneath each other. For distant water the brush marks are smaller, and they increase in scale as the water pattern moves into the foreground, with greater spacing.

CHOPPY PEAKS

Choppy water occurs when both current and air push the water surface into animated peaks and gullies. To achieve this effect, first angle a flat brush or a filbert with a sharp tip upward in a U-shape, pivot on the brush tip to create a triangular top point, and then pull downward into the next U-shape. Increase pressure on the brush as it reaches the peak, then decrease as you pull the brush downward. By rotating the brush handle with your thumb over your middle finger, a slight curve in the upward/downward strokes allows you to control the depth or width of the gully.

Zigzag strokes

Ripples (formed from oval stokes linked together)

Choppy peaks (created by curving zigzag stroked linked together)

DEMONSTRATION PAINTINGS

Although a photograph can aid in capturing the movement of water, it is a static image—water is best conveyed with fluid paint and lively brush handling.

STILL WATER REFLECTIONS

A shoreline scene at the edge of a small lake provides a view of early morning reflections on a still-water surface. These distant trees are treated in the same way as a forest woodland scene with an emphasis on the silhouette and the rhythm of positive/negative shapes. Notice the lack of specific details: no trunks or branches, even the large shoreline bushes are reduced to simpler shapes.

I begin on an orange toned ground with three variations of green umber: darken them with the same blue as the sky pigment (Sennelier blue), then warm them with some raw sienna to a brighter middle value, and then use hansa yellow to create the warmest green. The block-in drawing establishes the waterline and shapes of the trees. Scumbling in the darkest blue-green in a thin application of paint allows for the orange tone to affect the color note, which I sometimes keep. In other places, I cover over it with more paint. I quickly block in the sky with a simple midvalue blue tint that I also use to soften the edges of the tree outlines.

As the block-in develops, I notice how I need to move the waterline away from the midpoint of the canvas so that there is more room for the water reflections. It takes another painting session to complete the shoreline foliage and add another layer onto the sky (including the beginning of some wispy clouds). This all is done before I begin painting in the water itself. In order to know just where my darks or brighter greens will appear in the water, I must first resolve their position in the upper portion of the canvas.

Since painting water uses wet-on-wet techniques, I first prepared some large puddles of paint that are used for rendering the vertical portion of the painting and then adjust them for the water areas. For the sky reflected in water, I use the same blue-sky pigment mixture but dull it with van Dyke brown into a midvalue tint and then a second mixture that is lighter in value. Returning to my greens, I adjust the darkest color with a touch of black-white gray to slightly lighten but also dull my deep green. The middle greens get a dot of van Dyke brown and some raw sienna for the lightest green.

To begin painting the water, I first test out my color mixtures on the edge of the painting. I know that the water farthest away near the shoreline will be lighter in value, but its brush marks will be smaller and blurred. In some places, the dark green from above may appear in the water, so I use at least three brushes: a green

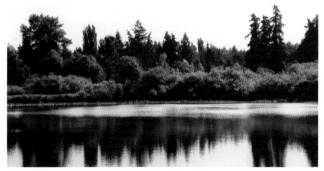

A bright morning creates bold reflections on the water.

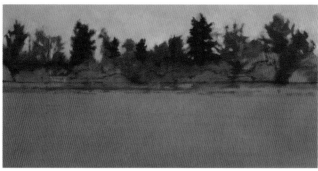

Begin block-in of the trees with transparent dark green.

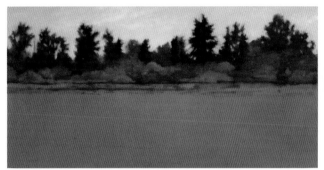

Brighten foliage close to shoreline with midvalue greens.

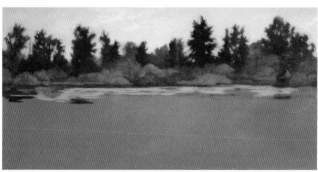

Begin painting the water at the shoreline.

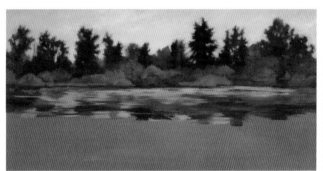

Start the water reflections with a thin layer of paint.

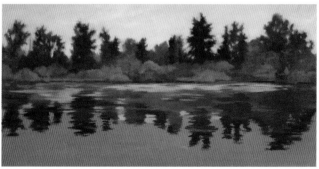

Plan tree reflections in a vertical alignment.

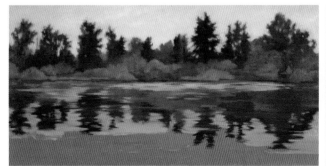

Use side-to-side swish strokes of blue that meet the tree reflections.

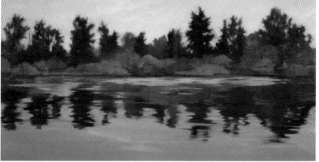

Add foreground water, and refine the details.

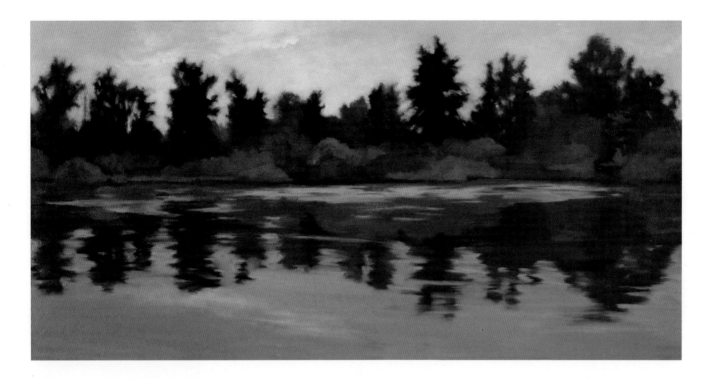

brush, a water-blue brush, and a clean filbert as a quick blender/smoother brush. I choose firm but soft-tipped nylon brushes in a filbert shape that will be able to pick up a nugget of paint on the tip but also glide smoothly over the surface, responding to the pressure of my touch.

I start off painting in a horizontal direction across the length of the canvas, trying to keep the same scale and frequency in my brush marks. This captures the reflections close to shore or the ruffles from the spring inflow moving near the shore. My approach is to always work laterally across the surface, which allows me to stop without losing my place or leaving an abrupt edge.

As the painting advances downward, I begin to align the tree forms and their reflection on the vertical axis, blocking in first the darks and then the midgreens of the trees and shrubs. It is also helpful to turn your canvas upside down or even sideways in order to check the alignment, making sure the reflections are not drifting at an angle.

Using the darkest green color, I block in the treetops, leaving space for the sky-on-water color mixture to fill in and soften the tree edges. Notice how the brush marks—swishing side to side—also increase in size and spacing. Soon all the orange will be covered with the slightly deeper sky-blue mixture. Before the paint dries, I blur the edges and then stand back to check that no shapes in the reflections pop forward. If I go back now to lighten the clouds or change anything in the "upstairs" portion of the painting, I also need to adjust the water reflections.

SUZANNE BROOKER, *STILL WATER REFLECTIONS*, 2013, OIL ON CANVAS BOARD, 10 X 20 INCHES (25.4 X 50.8 CM).

A predominant blue-green palette gains additional brightness when it's painted over an orange toned ground.

INLET AT MOSES LAKE

We had been driving all day across Eastern Washington and it was a relief to get out of the car and take in the landscape near Moses Lake. An hour before sunset, a brisk wind drove endless layers of clouds across the sky and stirred the water to the shoreline—giving me just enough time to take some photographs. The challenge of this painting was in capturing the quietly dimming light in contrast to the activity of the wind.

I begin with a handmade canvas (21 x 13 inches) stained with a thinned mixture of burnt sienna to achieve a warm toasty cherrywood color. Because burnt sienna is an earth-red pigment, sometimes it acts like orange and sometimes it behaves like red. My strategy is to use values of cool gray to provoke a contrast in the sky and water (a more subtle contrast than brighter blues against an orange-toned canvas). I use values of raw umber in the ground and shore, so they appear green over the burnt sienna. By keeping the values lighter than those seen in my photograph, I can build a strong underpainting ready for glazing at the final steps.

I start the block-in drawing with raw umber thinned with oil, since this painting begins with an oil-toned ground. (Using solvent would be a step backward: lean-over-fat.) I plot out the waterline and the diagonal shore on the bottom left, and then establish some landmarks in the water direction. With my mixture of ivory black and mixing white, I also plan out the baselines of the retreating cloud formations.

Using three values of gray—from midvalue to almost white—I begin to block in the clouds, scumbling thinly over the surface. At this point, everything looks brighter in contrast to the toned ground. Since this is the first layer of slow-drying pigments, I need to wait until the water is painted before I know how to adjust the contrast in the sky.

With a midvalue gray mixture, I start blocking in the water patterns by applying the paint in a thick-to-thin approach that reveals the effect of the burnt sienna underneath the thin layer of gray. At this point, I look even more closely at the shoreline for moments of overlapping and to see how to reinforce the staggering shoreline up toward the right side. My nylon filbert brush mimics the curve and pull of the water in flattened U-shaped strokes.

After a few days, the sky is dry enough (past dry to the touch) for a second pass of refining the cloud formations. My goal is to soften the lower cloud banks in the background and to increase the contrast of the nearer and higher clouds by introducing some violet into my gray mixtures. When I begin, I closely scan the surface for any dust or bumps of paint that are better removed now by a flick of my fingernail than to have them hardened into the paint film. These paint "nuggies" will become emphasized when the glaze is applied.

Low lighting at the end of the day lowers the value contrast but emphasizes the subtle temperature contrast of warm and cool colors.

Establish proportions with the block-in drawing.

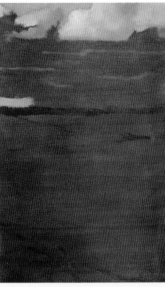

Begin the cloudscape with thinly painted white and grays.

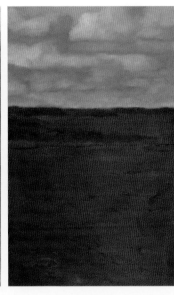

Block in the shoreline and water pattern design.

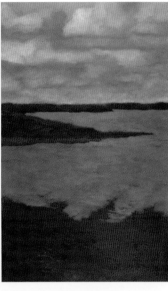

Thinly scumble pale gray values over the toned ground.

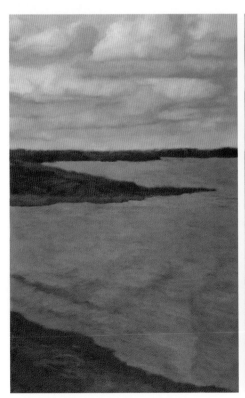

Build up water values with more opaque grays.

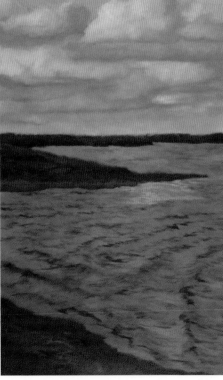

Mark the water pattern with darker blue-gray.

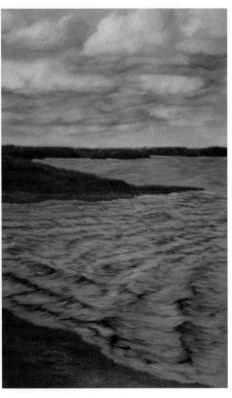

Build up the water movement from midvalues to lights with wet-on-wet paint.

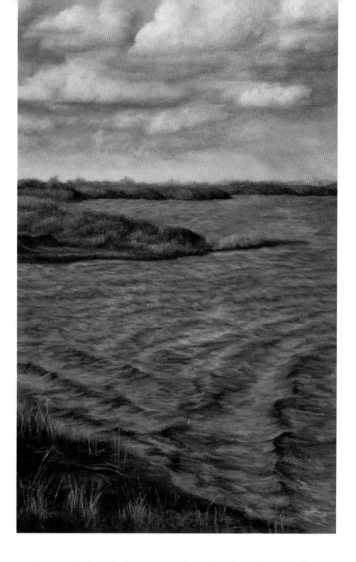

The complex pattern of the water current is first established with values of blue-gray and finished with a glaze of Sennelier blue.

I use a dark-to-light approach to develop the shorelines. First, van Dyke brown is applied thinly to sculpt the ground contours and the shadow values, then a mid-value mixture of raw umber and white for the distant tree line and grasses. Where the grass is brighter, I paint yellow ocher and white with small vertical strokes. In later sessions, I'll return to this area of the painting to make adjustments, sometimes blurring or adding greater detail.

Once the water block-in is firmly dry, I establish the dark and light pattern of the water movement. I mix ivory black with a transparent Sennelier blue, one that's warm and dark but not as high staining like phthalo or Prussian blue—plus three other values of lighter gray-blues for the mid- and lightest values. Moving water is a challenge to paint. Even as I begin the darks, I expect that I will refine this pattern as the painting progresses in a wet-on-wet approach. By placing my finger on the photograph, I can keep track of where I'm painting, so I'm less likely to get lost in the chaotic details when my eyes flick back and forth from the canvas to the photograph.

In order to take advantage of the fluid paint working from top to bottom, I work a section at a time. It takes at least twenty minutes before I get into the rhythm of the brush marks, as my brush swishes left and right, pulling from the edges of the dark paint. I stand back from the easel frequently to check the results and then come back to make adjustments. The final step is a sheer glaze of Sennelier blue over the entire water.

RIVER RUN STUDY

In a shaded ravine, I took a number of photographs of this bubbling river as it tumbled over the wet rocks. The sound of water filled my ears while the motion of the foamy current filled my eyes. I thought the best way to approach this complicated scene was to simplify its color palette. My approach was to build up the white of the water over a dark ground of acrylic burnt umber and ultramarine blue and then glaze a stronger blue color note over the underpainting.

A study painting is the best way to rehearse a difficult subject matter before committing yourself to larger format. By cropping my source photograph to focus on the water action, I can concentrate on studying the flow of water around and over the rocks as it flows into the main channel. The key to this approach is to save the dark ground to act as the darks in the water and the protruding rocks.

I begin by mixing white thinned with solvent to make a transparent outline drawing that helps me position the rock shapes. The first layers of white pigment are made up of an oily semitransparent mixture that glides over the lean, matte surface of the canvas board. This establishes the transparent water current over the stones that are slightly under the water surface. As the water appears brighter, I switch to a creamy white mixture that is more opaque. A soft-tipped but firm filbert brush moves the paint in curling strokes and blends it in featherlike touches.

Working wet-on-wet is a perfect way to utilize the fluid nature of the paint to mimic the flow of the water. Beginning at the top of the painting, my brush follows the flow of the water—at times moving in a smooth side-to-side swish or transparently falling over rocks. After I establish the flow of the current, I apply more opaque paint where the current makes the water crash together. The underpainting is done quickly in one session. Once dry, I can then evaluate if my values are bright enough for the darkening effect of the glaze and adjust as needed. I let the canvas dry completely for several days before applying the glaze.

I select Sennelier blue for my glazing pigment—warm, low-middle value, and low staining. This makes it a more useful glazing color than its high-staining cousins, phthalo blue and Prussian blue (which are hard to control). I mix two puddles of glaze, one stronger in color for the rocks and the other with barely a hint of color for the water.

On the cleaned canvas surface, I carefully apply the glaze with a brush to leave only a thin veneer of oil over the painting. The oily glaze restores the values of the darks, while the color painted over white areas tints the water. Once satisfied with color effect, I dry the canvas horizontally until it's completely dry. The next step involves developing the form of the rocks using burnt umber and burnt sienna plus white to create subtle highlights. I also add more opaque white foamy highlights to the water as a finishing step.

The rapid action of the water current is captured as it flows around and over the stony waterbed.

Apply transparent and opaque white mixtures over a dark ground to suggest the water current.

Glaze over the underpainting to refresh darks and tint areas of white.

SUZANNE BROOKER, *RIVER RUN STUDY*, 2013, OIL ON CANVAS PANEL, 9 X 12 INCHES (22.9 X 30.5 CM).

Highlights on water and rocks are the finishing touches to this study painting of fast water. The goal in this study painting is to perceive the dynamics of the current rather than to duplicate the still photograph.

MARSHLAND

Waiting for the ferry to carry us over to the San Juan Islands, I found a perfect moment to explore the marshlands beyond the shore. It was early spring, the last year's cattails rattled in the breeze alongside the calls of red-winged blackbirds. The shallow water appeared like a silver shield with fringes of new growth breaking the illusion of clouds floating on the ground. I took a number of photographs so that later, back in the studio, I could compose them together into a single wide-angle view.

To begin, I choose a red-orange toned ground to contrast with the neutral and dulled local colors. Working with an intense color is challenging: every paint mixture responds optically—with either a complementary or simultaneous contrast. I won't see my true color notes until much of the toned ground is suppressed, allowing it to flicker through areas of transparent paint only.

I start the composition with a block-in drawing using raw umber (Old Holland) thinned with a dot of linseed oil. I focus on the overlapping planes of the marsh, especially at the waterline. Everything is movable at this point, so I check to see how the shape of the sky works against the shape of the water area and make some adjustments before I add any darks. For my darks, I mix together raw umber with green umber (Old Holland), scumbling in a thin layer of pigment so that the presence of the toned ground can flicker from underneath the transparent paint.

I address the background of the painting first, working with three mixtures of ivory black and mixing white for the sky. I scumble this paint thinly over the orange ground and begin to design the cloud forms. Next, I mix some raw umber and white to block in the distant cattails, using vertical marks with a long flat brush. Once this first layer is dry, I can adjust the color mixtures and build up the paint texture from thin to thick.

In the next painting session, I brighten the lower sky while softening the edges of the far tree line. I don't want a strong dark edge to create too much contrast with the light value of the sky—pulling it forward rather than receding into space. I define the distant watercourse using a dark gray from the sky mixtures. The cattails on the right side are further developed using a lighter value of raw umber and yellow ocher (Daniel Smith).

Now that the background is taking shape, I begin blocking in the water values using the same gray values as the sky (which takes on a blue color note over the orange ground). This is the time to consider the waterline and the island of emerging growth. I'm not happy with the left-hand water edge and add some raw umber to reestablish the ground plane as a curving arc.

At this stage in the painting, the orange ground color is suppressed, but it still unifies the overall painting. It's now a matter of building up the texture of the

I collaged two photos of the wet marshland and the surrounding trees together.

Begin the block-in drawing with thinly applied dark raw umber.

Paint cloud formations in values of gray and add the background tree line.

Build up the sky and background paint layers.

Add mid- to light values in the background and define waterline.

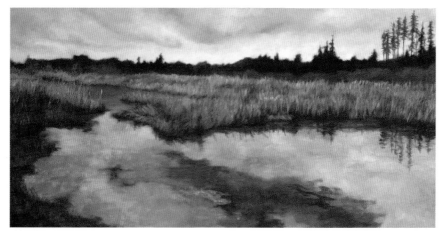

Develop the foreground water and reflections.

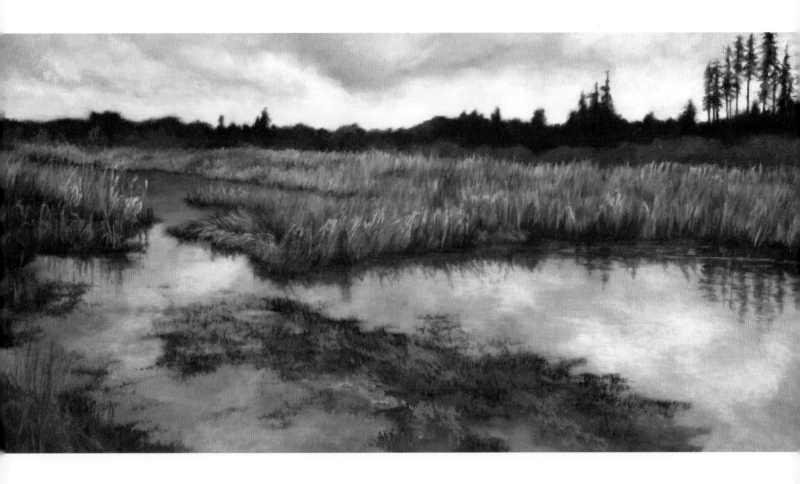

cattails, balancing the light of the sky with the water, and working in the dark reflections of the shoreline. When the painting is completely dry, I review the results before adding the final details.

The most difficult part of the painting process is determining when it's finished. I like to take a break from any painting, giving myself time to refresh my eyes to the work and therefore be more objective in judging its strong and weak points. Sometimes it's the smallest adjustments that pull a painting together.

When I come back to this painting, I discover that there are several places that need more attention. I begin with a glaze of indigo blue over the water and then blend in some zinc white with a soft-tipped filbert to brighten the cloud reflections. The reflections of the far-right trees need softening along with the cattails at the waterline. I apply a more intense orange-red of burnt sienna to pick out more colorful areas in the shoreline foliage. Then a mixture of sap green and raw umber, which I apply with the tip of small filbert brush, defines the small textural marks in the foreground island. Each of these changes brings the image closer to resolution without overpainting areas that already work.

SUZANNE BROOKER,
MARSHLAND, 2013,
OIL ON CANVAS PANEL,
10 X 20 INCHES
(25.4 X 50.8 CM).

A limited palette of neutral color and grays takes on a lively color effect when painted over an intense toned ground.

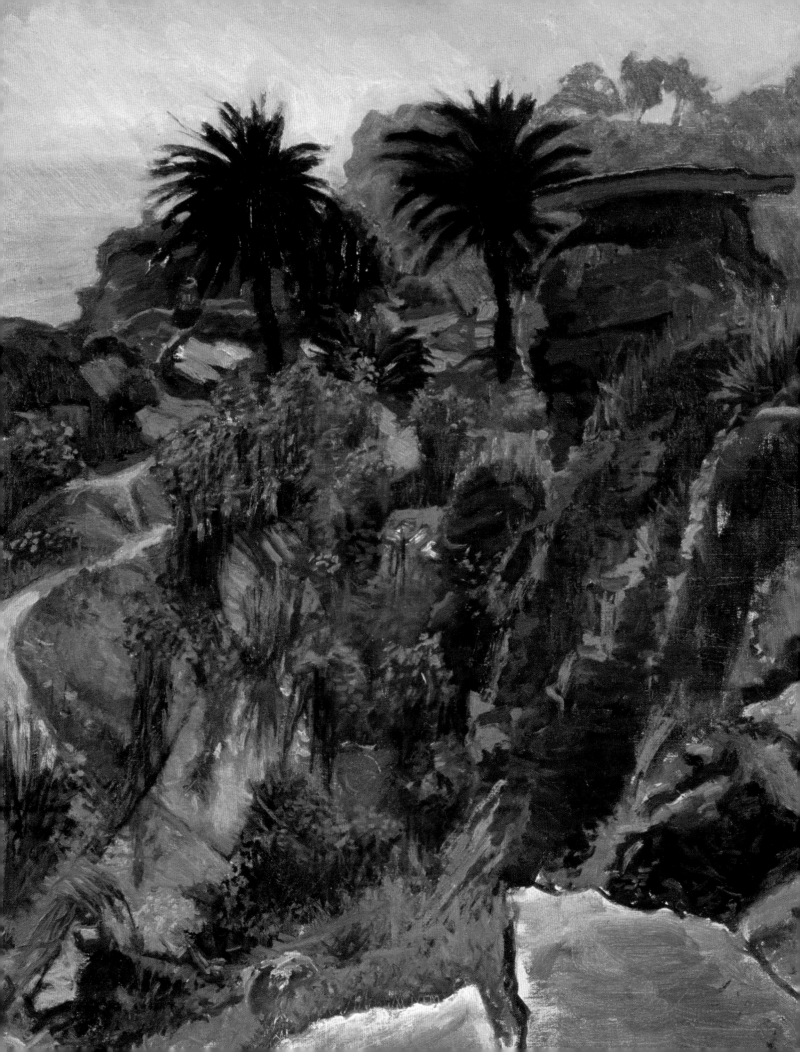

PUTTING IT ALL TOGETHER

P ainting is a challenging process, one that often takes more than skills or technique in order for a painting to succeed. Painting is also a multilayered process in which not only your hand and eyes need to be engaged, but also your intellect (balanced with imagination, memory, and intuitive responses). When you add perception and sensate experience into the mix, it's easy to appreciate the complexities of painting.

Think of it like this: if I gave the same image to ten painters and they all had the same surface, pigments, and brushes, I would still end up with ten different paintings. Each artist's individual sensibilities would drive the decisions regarding color, shape, space, texture, brush handling, and so on, toward greater realism or to abstraction. Style can be seen as an outcome of an artist's temperament rather than as something imposed in place of method. Developing a sound method toward rendering complex images guides a painter in choosing the best approach for capturing the atmosphere, mood, or visual expression in a painting.

ABOVE:

SUZANNE BROOKER, *WILDERNESS LAKE*, 2014, OIL ON PANEL, 18 X 12 INCHES (45.7 X 30.5 CM).

OPPOSITE:

DOMINIC CRETARA, *SUNKEN CITY*, 2001, OIL ON CANVAS, 28 X 22 INCHES (71.1 X 55.9 CM).

THINKING AS A PAINTER

Looking through the demonstration paintings at the end of the previous chapters, you'll notice how each painting has a method or approach behind it for constructing the painting. To bring all these ideas together, in this chapter I'll use a complex photographic image that includes all the landscape components and discuss the options for interpretations through the painting process—showing you how to "think as a painter" before the painting begins.

First, let's take a look at the painting progress for *November Snow on Slough* shown opposite. Notice the orderly progression from the planning of the underpainting to the final image. Although tweaks and adjustments occur throughout the painting process, the artist resisted rushing ahead to see the final results before each area had been carefully developed. The results are a fusing of the paint with the sensation it captures: the soft focus in the background, light flickering through the trees, the flow of water, and the pattern of melting ice.

WILDERNESS LAKE

For this last demonstration painting, I've selected a wilderness scene of Melakwa Lake in the Cascade Mountains on a clear summer day (see photograph on page 182). The chiseled rocky cliffs melt into curving slopes, large conifers dot the lowlands, a mountain lake winds it way into the foreground, and the foliage in the extreme foreground provides a clue that the viewer is standing on the near shore. This is a simple visual description of what I see, but what about my sensual response to the image? It's here that what I'm trying to convey drives my emphasis in pictorial decision making: Do I want the summer feeling of open spaces or the purity of a wilderness environment? Do I want this scene to feel nostalgic or romantic? Each of these choices is translated into the method of my approach: bright, pure color and sharp edges or muted colors and soft edges.

When I look at photographs, I always remind myself that I'm interpreting what I see, not merely copying the image. I think of this as the "3 E's" of painting: editing, elaborating, and emphasizing. These are especially useful when I consider the effects of atmospheric (aerial) perspective in a crisply focused photograph. For instance, at what point should the background mountain slopes on the right side fade into the distance? Will the trees in the distance need to be slightly lighter and grayer in color, even though they appear the same color and value as the mid-distance trees?

A photograph can also be deceptive when you want to reproduce color in nature. One way to check the overall color balance is to examine the sky—is it

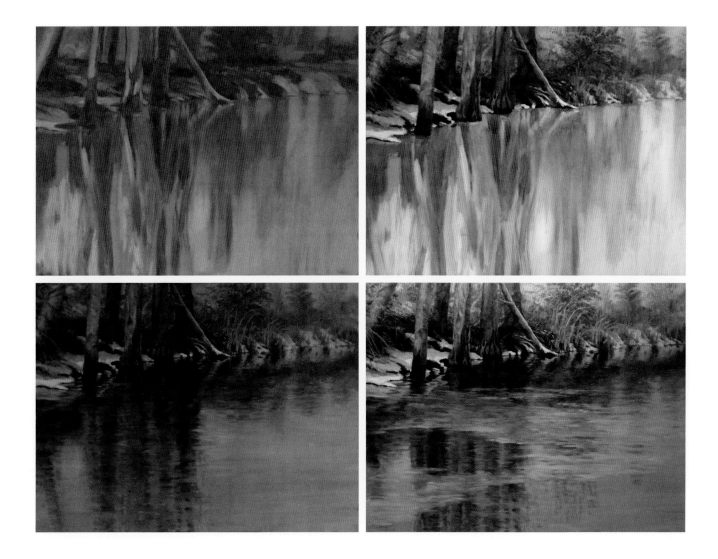

too bright, too dark, or is it oversaturated in color? Although I can manipulate the value and color information in a digital image, I ask myself, *What liberties can I take in interpreting or inventing the color I literally see?* If I intend on using a high-key palette—as in a more pastel interpretation—then the values will be no darker than midvalues. For a low-key palette, I keep the value compressed toward low values. A full range of values results when there is a balance of light or pure color, midvalues (warm, cool, and neutral), and transparent darks.

Noticing compositional elements is equally important: the diagonals and triangular shapes of the water reflections, the mountain slopes, and even the V-shape of the sky. This is the "architecture" underneath the visual elements that supports the abstract two-dimensional design. Some scenes suggest a stronger horizontal/vertical structure, such as *Heartland* on page x. Other views are built from curving arcs shown in *Confluence in July* on page 83. Without these underlying dynamics, the scene might still be beautiful or picturesque, but will lack a compelling structure.

HEATHER COMEAU CROMWELL, *NOVEMBER SNOW ON SLOUGH*, 2011, OIL ON CANVAS, 12 X 16 INCHES (30.5 X 40.6 CM).

The documented stages of this painting's development begin with a soft wipe-out block-in of the major masses, followed by the establishment of the woods and shoreline, then water reflections, and finally the addition of the details of the surface ice.

STUDY DRAWINGS

To begin analyzing the image for the *Wilderness Lake* (page 192) painting, I first start with a contour line drawing. It's here that I begin to plan an eye path in and through the depth of the scene. This simple drawing allows me to see the principal large masses: What are their proportions relative to one another? Are their shapes interesting? I can also begin to understand the overlapping of the big shapes or masses in the composition through linear perspective. Notice in the contour study drawing that the big shape of the mountain slopes on the right side has been divided into three overlapping planes.

Over this drawing, I add a-cross contour lines and re-create the ground surfaces. This exercise helps me understand what I glean from looking at the photograph and how I will need to translate that image into paint. For example, on the curving conelike slopes of the mountains, only one place can tilt directly into the sun, making it the brightest, most intense color. Other places will be parallel or will tilt away from the sun and therefore require cooler, neutral, or darker color. The logic of light and shadows is most helpful when combined with a-cross contours to interpret light that is overcast but bright. What facet of the ground has the greatest light from the angle of the sun?

In the third study, I focus on capturing the value differences between the lights and darks as blocks of tone with no details. You can interpret the entire image as groupings of light, middle, or dark values. There are no distinctions between dark rocks and dark trees—they are both dark values and therefore grouped together. By squinting my eyes, I can remove the details and perceive the values. This study helps me plan for contrast areas of light next to dark while linking the flow of the shadows together.

COMPOSITIONAL CONSIDERATIONS

Over the value study, seen opposite at bottom right, the red lines represent the dynamics underlying the composition. You can see how the diagonals create a distinct radiating pattern. As I consider the proportions and scale from my source image to the final canvas, it's important to identify the center of the image so that it doesn't become the center of my canvas. The center of any rectangle or square canvas format has a strong visual pull already. By placing the point of highest contrast—a geometric form or converging diagonals—in the center, I limit the viewer's eye path to one area of the painting. To locate this point, I use a white pastel pencil over a digital print and divide the image into vertical and horizontal halves as shown in the top illustration on page 184.

MELAKWA LAKE IN THE
CASCADE MOUNTAINS.
PHOTOGRAPHY BY
RALPH E. CROMWELL JR.

A photograph of the scene sharply in focus makes it the artist's job to interpret the atmospheric (aerial) perspective needed to create greater depth in the painted image.

The photograph has been manipulated in Photoshop to reduce the color saturation and lighten the middle values. Now it's easier to perceive details in the dark values.

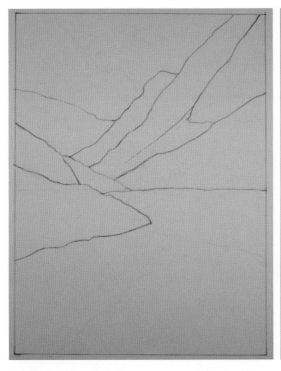

Indicate overlapping planes with a contour drawing of the major masses.

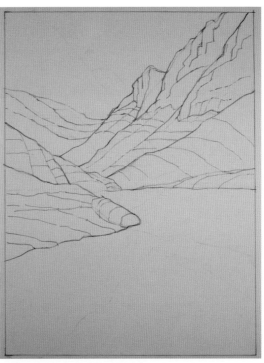

Study the changing ground planes with cross contours lines.

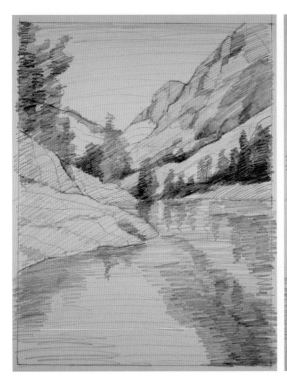

Indicate areas of contrast with a value sketch of light and dark shapes.

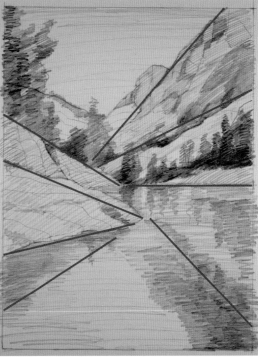

Note the underlying dynamics in the two-dimensional design.

To proportion my image for the canvas, I use a handy tool called a proportion scale (or wheel) and a ruler. My image measures 10¾ x 8 inches (27.3 x 20.3 cm) while my canvas is 18 x 12 inches (45.7 x 30.5 cm). That's a 150 percent enlargement, with an extra vertical two inches on my canvas not included in my photographic image. I return to my study sketch to add more space in the sky, and perhaps now there'll be enough room for some clouds. My adjusted drawing is now correctly proportioned to fit my canvas.

Transferring my image to the canvas starts with a one-inch grid drawn on my printout using a white pastel pencil. I also draw a one-and-one-half inch grid on the canvas (150 percent enlargement) with oil paint thinned with solvent and oil. This paint mixture should only be slightly darker than the toned ground or one that's slightly different in color, such as van Dyke brown over a burnt umber toned ground. You may be tempted at this stage to use a graphite or charcoal pencil to trace the grid on the canvas. However, the graphite will bleed through even opaque areas of paint, and the charcoal will blend into the wet paint and darken pale values.

Next, I use the grid to draw in the large shapes of the landforms, matching what I see in the one-inch square to the one-and-one-half inch square. The results should only be as detailed as the simple contour study drawing on page 185. Once this is done, I can add other landmarks, such as the verticals of the close trees or water reflections. Lastly, I wipe off the grid lines using a lintless rag or a clean brush moistened with odorless mineral spirits before the thinned paint has dried.

Not every painting will demand these steps for measuring to determine the composition and proportions. You can transfer simpler images directly with freehand drawing or by wiping out in a wet toned ground. In these instances, you employ your intuitive response and experience to locate and adjust the major elements in the image.

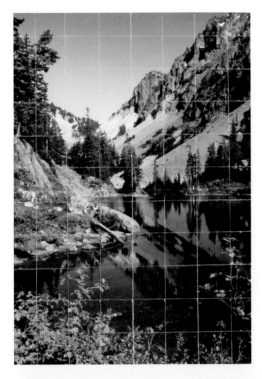

Digitally print a one-inch grid drawn with white pastel pencil. Using a grid transfer system entails two steps: finding the ratio of enlargement from the photo print out (here one-inch squares are enlarged 150% to 1½ inch squares on the painting surface) and also including any changes needed to adjust the proportional relationship. The adjusted drawing sketch seen below left has included two additional inches to the top of the composition increasing the space for the sky. The grid indicated with thinned paint on the panel (below right) shows both the contour information from the digital print and the proportional relationship in the revised sketch.

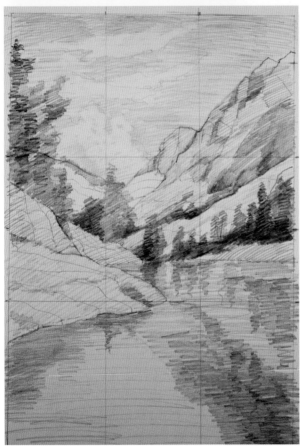

Adjust enlarged composition to proportions of canvas.

Use grid on canvas with thinned paint for block-in drawing to convey landmarks.

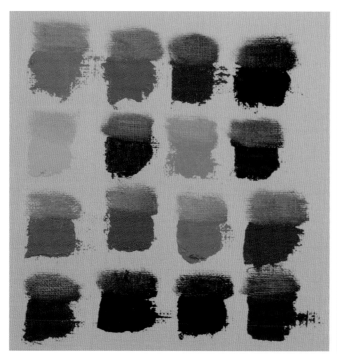

Color swatches on a tint of Mars black

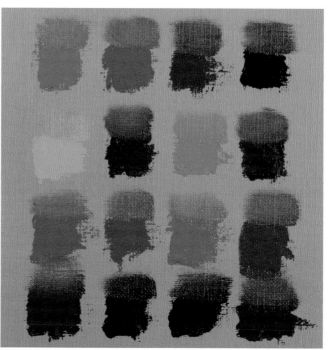

Color swatches on a tint of Mars black and ultramarine violet

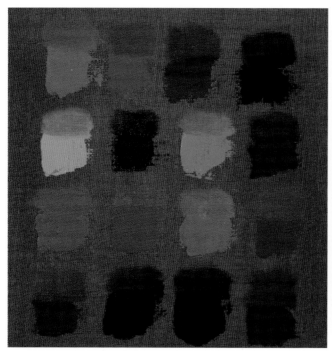

Color swatches on burnt sienna

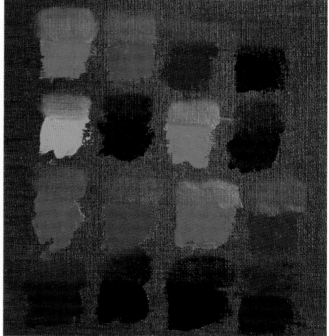

Color swatches on burnt umber

CHOOSING A TONED GROUND

Before thinking about a color palette, I first consider which toned ground can boost or support my color choices. A white gesso ground will backlight my colors and supports a high-key palette of pale tints; however, it will not generate any optical color effects with my palette. If I choose a light to midvalue gray ground of Mars black and ultramarine violet for a smoky gray, this will help define the sloping mountain sides, but will perhaps make my sky a little dull. Or I could choose a warm brown like burnt umber and achieve a subtle warm/cool relationship between the blue sky and water in contrast to the middle-ground shore. A brighter orangey ground of burnt sienna will provide a more intense complementary contrast when the blue sky and water are painted. But this ground will also cause any grays I paint on the mountains to turn optically blue as well, giving the entire painting a dominant cool color note. What about a golden yellow ground of raw sienna or yellow ocher? No, not very helpful, as that would dirty the blue of the sky and water, and fight the gray-violet color in the mountain. A magenta red ground of alizarin crimson would certainly spark up the dark cool greens of the conifers, but they are a minor part of my image.

TEST COLOR SWATCHES ON TONED GROUNDS

Here I apply color mixtures on four different grounds: a pale tint of Mars black, a tint of Mars black plus ultramarine violet, a stain of burnt sienna, and a stain of burnt umber. Each ground affects the perceived color notes. For example, the blue colors seem more vivid on the burnt sienna, but less so on the violet-gray. For each square, the color mixtures have also been scumbled to anticipate their effect when thinly applied over the toned ground.

Color mixtures for the mountains on the top row are variations of Mars black plus ultramarine violet; van Dyke brown and ultramarine violet; and Prussian blue and Mars black. In the second row, the sky and water blues are variations of Prussian blue; cobalt blue plus Prussian blue; tint of cobalt; and Prussian blue plus a dot of yellow ocher. The terrain mixtures in the third row include yellow ocher plus burnt umber; tint of burnt umber; tint of van Dyke brown; and yellow ocher plus van Dyke brown. The row of forest greens at the bottom are yellow ocher and Prussian blue; then more Prussian blue; yellow ocher and a dot of van Dyke brown; Prussian blue plus Mars black, cobalt blue, and yellow ocher.

STRATEGIES FOR THE PALETTE

Once I've considered a toned ground, I can now think of which pigments and color strategies will work the best. Am I aiming for a contrast of warm and cool temperatures, or for a harmonious feeling of linked analogous colors? Every color must play more than one role in the painting so that there is greater unity throughout the entire work. I look beyond matching the photographic color and consider how to create a more expressive statement within the limits of my pigments. Each color mixture is not a perfect match to the photograph. Instead I ask myself: *Is this color useful not only to a specific part of the painting but also mixed in combination with other colors in my palette?*

Experience in color mixing builds your visual memory for pigments. Color charts that you make are the best means for building visual memory. A tint chart that compares similar hues, as seen on page 186 is a good place to start. Comparing what secondary color will be created by two primary pigments, such as "What Y+B pigments yield what kind of greens?" (as shown on page 122) is another recommended exercise.

A basic strategy is to work with an R+Y+B palette, combining these pigments to create a multitude of secondary color variations. The fewer pigments, the more I have to extend my skills in creating nuanced variations in color mixtures. Even if I choose to use a tube green, such as green umber, for the fir trees, I still need a yellow to warm the light sides, a blue to cool and darken the shadow side, or a red pigment to create neutrals.

Think about the sky in this scene. It's a warm, clear blue that suggests-perhaps phthalo blue or Prussian blue would be a good start. But would it also be useful for painting the water and the deep shadows of the trees? Could this blue also be used to create a dull gray-violet for the mountains or shadows on the cliff rocks? Which yellow would you use for the blue to become the green of the conifers? Once I've begun mixing test colors, it becomes evident that Prussian blue and cobalt are the best for warm and cool blues.

The mountain slopes have a violet tendency, which I make with white, Mars black, and ultramarine violet. For the ground planes, I test out white mixed with van Dyke brown and burnt umber for their temperature differences. Already I can see that the mixtures of this triad of colors will work well together to generate a number of more subtle variations.

The next step is to prepare some sample toned grounds on canvas paper to test out the various color mixtures. This can be especially useful if you need more experience to anticipate the optical color effects of neutral color over an intense ground, lighter values over darker values, or the interaction of complements.

Begin with block-in of sky.

Block in overlapping landforms, plus add a second layer of sky blues.

STAGES OF THE PAINTING PROCESS

A complex or large-scale painting requires a strategy that is based on painting from the background, (sky, mountains), then the middle, and lastly to the foreground. In each of these stages, I consider the overlapping of elements at each distance in space. For example, the tall trees on the left will be easier to paint freely once the sky is set so that I am not stuck trying to paint sky windows between the branches. The same is true for the foreground foliage, which is best painted over the finished water.

THE SKY

I begin by painting the sky. The presence of the sun makes this area of the painting have the brightest value. My three value mixtures of sky blue range from cobalt and Prussian to only Prussian blue and white, which will take the longest to dry due to the high proportion of white pigment in it. I apply the first layer of paint in a thin scumble and then smooth it with a flicker stroke, using a soft-tipped filbert brush. At this point, the value of the toned ground influences the perceived color, making it seem darker—that is, until a second layer is added, increasing the paint opacity and brightness. This second layer of sky-blue paint also improves the color transitions, removing any blotches through smoother blending.

Generally, I wait to perfect my sky and let it dry before attempting to paint in the clouds. Since my photographic image has no clouds, I look through my resource file to find just the right kind of clouds that will animate the sky region. I use an image of high stratus clouds in a curving arc as the pattern motif for painting the clouds. When the surface is ready, I begin to block in the design of the clouds with transparent white (Winsor & Newton), coming back later in another session to increase the opacity of the paint.

THE MOUNTAINS

While the sky dries, I move down to begin blocking in the mountain forms. I concentrate on first blocking in the darkest values using oily paint mixtures of van Dyke brown and ultramarine violet to establish the shadow forms, which are darker than the toned ground. This stage of the painting resembles an underpainting where thinly applied paint not only helps to build the values but also to define the mountain contours. I readily change the outline shapes or adjust edges from my rough block-in drawing. (It's important to note that the "drawing" stage never

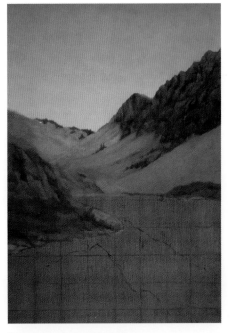

Develop mountain contours.

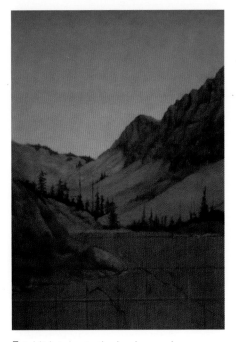

Establish trees in the background.

ends—I'm always considering the compositional design.) I plan to paint behind the trees in the midground and work all the way down to the waterline. My focus is on perceiving the overlapping planes of the ground that will enhance the sense of deep space.

I work the lighter, neutral value mixtures into the background mountains and soften the edges next to the sky. When I work on a wet-paint surface, I try to find the areas that will benefit from blending the middle values next to the darker values rather than creating texture with wet paint over a dry surface. Atmospheric (aerial) perspective dictates how much texture or how many sharp edges I can place in the retreating mountains in contrast to the lake's shores.

The vertical cliffs are painted with a dark-to-light approach, using four different variations of ultramarine violet and van Dyke brown. The low-middle values help me pick out the major masses, while leaving behind the transparent darks for the shadows. As the cliffs become more refined, the lighter midvalue color mixtures increase the sense of texture with broken and dragged brushstrokes.

The foreground lakeshore receives additional paint mixtures of red umber and yellow ocher drawn in horizontal short strokes with a flat brush. This ensures that the ground contours remain flat or sloping down to the waterline in contrast to the upright greenery. For the singular stones seen at the water's edge, I use the same dull violet color as I did for the mountains. Once this area is dry, I continue to establish the small groupings of the miniature bushes. First, I use dark green and then add brighter color notes. The texture of the bushes is created with small dappled strokes that suggest foliage without becoming too specific.

TREES

After a few days, the mountain area is dry and I can begin working on the tree line. Prussian blue and yellow ocher mix together to create the cool darks, while cobalt and yellow ocher produce the brighter green color notes. I begin with an oily mixture of the cooler darks to draw in the vertical trunks, planning for their heights and the spacing between the trees. Moving between a fine-tipped filbert and a small blunt round brush, I can create the right curving marks from the center line of the trunk. Where the trees overlap, I paint in each tree rather than a single shape, making the overlapping more convincing. Where singular trees are painted over the lighter values of the mountainsides, I pay attention to the design of the foliage silhouette where the contrast is greatest. This is very detailed work, so I have to summon all my patience and focus to get it right. Working on a dry paint surface, it's easy to make changes with a clean brush moistened with solvent. Standing back from the easel, I can see where I've deviated from the source image and how it will affect the water reflections below.

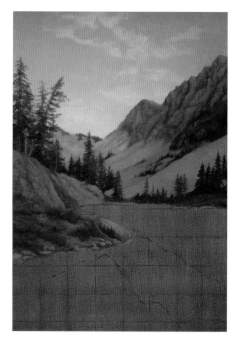

Continue development of trees with additional lights and darks.

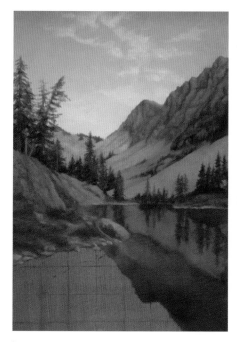

Lightly block in water reflections in the background.

WATER

I begin my underpainting of the water with a thin scumble of paint using the blunt tip of an old filbert brush. This thin layer of paint will be affected by the toned ground (like the underpainting of the mountains) with a shimmer of warm brown. Starting in the background waterline, I use the same color mixture to paint the reflected trees and plot out their vertical alignment to the trees above. The color mixture for the water reflections is made from mixing some "mountain" violet with the tree greens so that it relates to the color above. The scumbled paint is blurred by a side-to-side swish of the brush. As the water moves closer to the foreground, I freely mix color notes in the wet paint, adjusting for lighter or darker green areas. At this stage, I use the block-in drawing as my guide but am still aware that changes and refinements are yet to come in the second paint layer.

ADJUSTING VALUES

Now that there is some paint everywhere, I notice two things: the value scale has shifted (overall it appears darker), and my dry paint has sunk in and dulled the color notes. Before I begin adjusting the values, I need to "oil up" the painting. Oiling up a canvas has several benefits at this stage in a painting: it refreshes the color notes, reveals the values in dark pigment mixtures, and it gives an even, reflective surface to the overall painting. Best of all, the thin veneer of oil makes the addition of new paint flow easily over the surface.

On my oiled canvas, I begin with a transparent white pigment (Winsor & Newton) to increase the opacity of my wispy clouds. Next, I brighten the farthest mountains by applying a thin veneer of white paint over that entire section of the mountain cliffs. The relationship of dark to light is preserved, but overall it's slightly higher in value. I debate putting in snowfields but decide that if I want a lighter moment in the water reflections, I'll need a hint of the fields on the mountainsides.

Returning to the background trees, I build up the light sides of firs with the addition of a warmer dark green. This is also a good time to improve any silhouette edges that seem awkward. The larger trees on the left side receive additional dark and lighter paint, which I continue to add in stages until I'm happy with their forms.

At this point, I freely roam among different areas of the painting, making adjustments as needed. I consider the balance of the whole painting against individual elements. Because I've firmly established the drawing and design of the painting, I can paint more freely and quickly.

Returning to the water reflections, I begin in the background, once again working to balance the brightness of the water in relation to the mountain slopes.

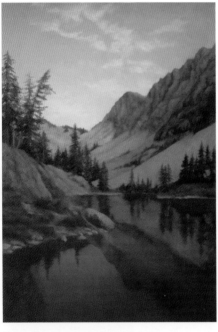

Extend the water reflections into the foreground.

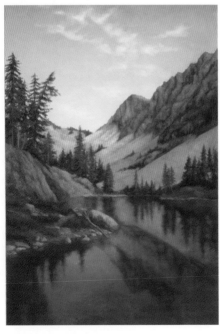

Balance values overall.

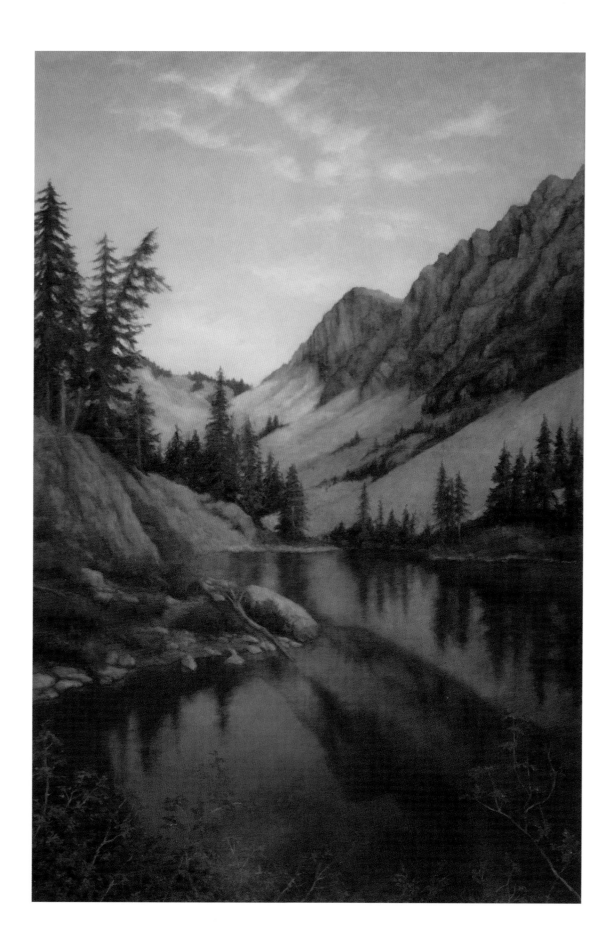

By turning my canvas on its side, I can better evaluate the placement of the angles of the reflections. As I move forward, the sky reflections are brightened and the left-side shoreline gets pulled into focus. I use an oily mixture of van Dyke brown to underline the rocks on the shoreline with a crisp edge. Red umber and yellow ocher mixtures enhance the light side of the rocks, including the boulder that juts out into the water. I go back and fuss with the small bushes, at times darkening their underlying shadows or adding brighter red-green notes.

I leave the foreground of water transparent and dark in preparation for the detailed foliage yet to come.

FOREGROUND DETAILS

To begin painting the foreground bushes, I mix some van Dyke brown and white for drawing in the branching structure. This gives me a logical place to "hang" the foliage so that it doesn't become too abstract—simply a blob of green dots. I choose a small brush to draw in the branches, keeping the lines as delicate as possible.

My plan for this area of the painting is to keep the feeling fresh and spontaneous, so the overall treatment is wet-on-wet—that way I can easily paint lighter values over darker areas. For the foliage, I return to my green tree color mixtures, and then I start picking out the growth pattern of the leaves, using a midvalue green and my fine round brush on the bottom left side. In some places, the shadowed areas are darker, so I add some van Dyke brown, using the same dappled strokes and fusing edges as I go.

When I stand back from the easel, I can see the whole painting at a glance. My foreground foliage is subtle compared to the source photograph, but for now it feels just right. Bringing the painting to a final conclusion will still take another few weeks: first, I take a break so that I can get a fresh eye, and then I make small changes after I've oiled up the dry painting again. Then my first impression as I view the whole painting will let me know where more work is needed. I think of this as the "what bugs me" stage. I'll come back and tinker with places that feel weak or that distract from the overall image.

This finishing stage demands patience and honesty on my part to evaluate what areas of the painting are weak or strong. For example, did I lose all the transparency by being carried away in the painting process, or does the paint surface look meager with not enough paint? I may have lost track of what I wanted to achieve in the final effect: a romantic interpretation versus a detailed description. At some point, the painting takes on a life of its own—it is what it is. It still may be a good painting, but not the one I intended. Attempting to rework a painting at the finish is a waste of my time. Better to begin again with a new version.

CONCLUSION

For painters, the goal is to learn from every painting. We are our own worst critics, with high expectations for every work. Accept that some paintings will be rehearsals for new brush techniques, palettes, or subject matter that build your skills and experience. Ask yourself, *What did I learn from this painting?* That's a good first step to take, instead of criticizing every flaw.

Sit down and look at your work, reviewing the stages as discussed in chapter one. This begins before you even lift the paintbrush. For instance, think about the scene you chose to paint: Was it familiar to you, drawing in your sensory memory? Were the elements of your image clear, not obscured by overly dark areas or blurred in areas of light? Was it "paintable," or did you choose an impossible lighting condition?

Now think about your preparation. Did you make a few study sketches to work out the composition and eye path, or did you solve the compositional problems as you painted? Were the scale and proportions of the canvas correct for the effects you were trying to capture? In other words, did you lose the pleasing aesthetic arrangement of the original image as you translated the scene onto the canvas?

Consider the color. Did you select the right color note for the toned ground? Was it beautifully applied to the surface? Was the color palette of pigments fully explored to ensure you had all the most useful color mixtures needed to paint the scene? If you found yourself obsessively trying to match "Kodak" color in the photograph, then you didn't consider the importance of interpreting color through a limited palette.

Now evaluate your brush handling. Are all the brushstrokes "homogenized," the same size and shape overall? Look closely at the paint surface. Does it feel

overworked or licked? Undoing bad painting habits is difficult unless you maintain a constant awareness of yourself at the easel. Can you find brush hairs, dried bits of paint nuggies, or evidence of the gesso texture appearing on the surface? Building a sense of pride in your painting craft cannot wait until you are an expert painter! The quality of your studio practices should enhance even the humblest painting effort. Are the thickly painted areas convincing re-creations of foamy water, leaves, or the edges of cumulus clouds—or are they just abstract blobs of paint? Remember that contemporary viewers are as in love with paint itself as they are with the image in the painting. Consider your image as an invitation to the viewer to step closer and linger over the sensation of the painted surface. Will they discover luminous color or brush marks applied with flair?

The craft of painting entails not only *what* you are painting, but *how* it is rendered within the traditions of the medium. Building your painting skills is critical for gaining the most control and power in expressing your pictorial content. Therefore, let every painting stretch your ability and challenge you to think as a painter.

Lastly, there are three qualities you need to develop as a painter: patience, persistence, and passion. Since painting is a complex process, you need to be patient with yourself as you learn to master the craft. Your persistence is important, in order to move pass your failures and frustrations. And finally, it is your passion for nature, the landscape, and the practice of painting that propels you forward. As I remind myself, if painting were easy, anyone could do it well!

RECOMMENDED READING

Albala, Mitchell. *Landscape Painting: Essential Concepts for Plein Air and Studio Practice.* Watson-Guptill, 2009.
> Excellent guide to painting principles.

Carlson, John F. *Carlson's Guide to Landscape Painting.* Dover Publications, 1973.
> One of the original treatises on landscape theories and practice.

Cole, Rex Vicat. *The Artistic Anatomy of Trees: Their Structure and Treatment in Painting.* Dover Publications, 1965.
> Intense botanical study of tree growth and pattern.

Curtis, Brian, *Drawing from Observation: An Introduction to Perceptual Drawing.* McGraw Hill, 2002.
> Instruction on measuring, perspective, foreshortening, and other concepts key to drawing.

Hamm, Jack. *Drawing Scenery: Landscape and Seascapes.* Perigee Books, 1972.
> Concepts for landscape drawing with easy-to-follow techniques.

Roberts, Ian. *Mastering Composition: Techniques and Principles to Dramatically Improve Your Painting.* North Light Books, 2007.
> Introduces compositional structures for direct painting.

Sibley, David Allen. *The Sibley Guide to Trees.* Alfred A. Knopf, 2009.
> Reference for identifying trees in North America.

Walker, Claire. *Nature Drawing: A Tool for Learning.* Prentice Hall, 1980.
> Drawing techniques for sketching outdoors, including plants, animals, and birds.

Wilcox, Michael. *Perfect Color Choices for the Artist.* North Light Books, 2002.
> Color palettes combined with historic images demonstrate the effect of pigment choices.

Natural History: The Ultimate Visual Guide to Everything on Earth. DK Publishing, 2010.
> Heavily illustrated reference text and resource for images.

ACKNOWLEDGMENTS

My many thanks go to the friends and family who make such a project come to fruition, especially my partner, James Maloney, who has suffered my grumpy moods and obsessive character with his charm and humor. Without the generous support of the Gage Academy of Art and my fine students, where would I be?

To fellow artists, who so generously provided their inspiring paintings within these covers, my lasting gratitude. Special thanks to Tamalin Baumgarten, Isabelle Bosquet-Morra, Chi Chi Stewart, Madeline Crowley, and Heather Comeau Cromwell for their help without question.

INDEX